More Praise for *Art Collecting Today*

"This book is an engaging, practical guide to navigating the art market. . . . Even seasoned experts will enjoy Woodham's perceptive writing style, clever tips, and entertaining anecdotes."

—ARTNET

"An intelligently written and insightful book on the art market, this fascinating read is relevant to both newcomers and seasoned collectors alike. I know of no other comparable book. It's an instant classic."

—DON MARRON, Trustee and President
Emeritus of the Museum of Modern Art,
Chairman and Founder of Lightyear Capital

"This thoughtful volume is one of the few that explores the entire ecosystem of the art market—auction houses, art fairs, advisors, galleries, artists, and museums. Woodham aims to make the market more accessible and rightly foregrounds passion, quality, and connoisseurship as the jumping off point for collecting."

—ADAM WEINBERG, Alice Pratt Brown
Director, Whitney Museum of American Art

"For anyone who cares for or is just curious about art, Doug Woodham is an astute, lively, and entertaining guide who tells you candidly how the art world works, how it's changing, and how to get engaged. *Art Collecting Today* presents his wealth of knowledge in a crisp, accessible, and fascinating form."

—MELISSA BERMAN, President and CEO,
Rockefeller Philanthropy Advisors

"Doug Woodham deftly explains how a sixty-billion-dollar marketplace works. It is beautifully written—clear, concise, and free of art-world jargon. A must-read at all levels of collecting."

—VIK MALHOTRA, Chairman of the Americas
and Senior Partner, McKinsey and Company

"This book is a gem. It is full of great stories and surprises for both specialists and general readers. It is brimming with practical advice for how collectors can best navigate the complex world of modern and contemporary art."

—LAURIE TISCH, Cochair of the Board of Trustees at the Whitney
Museum of American Art, President of the
Laurie M. Tisch Illumination Fund

ART
COLLECTING
TODAY

MARKET INSIGHTS FOR EVERYONE
PASSIONATE ABOUT ART

DOUG WOODHAM

ALLWORTH PRESS
NEW YORK

Allworth Press books may be purchased in bulk at special discounts for sales promotion, corporate gifts, fund-raising, or educational purposes. Special editions can also be created to specifications. For details, contact the Special Sales Department, Allworth Press, 307 West 36th Street, 11th Floor, New York, NY 10018 or info@skyhorsepublishing.com.

22 21 20 19 18 5 4 3 2 1

Published by Allworth Press, an imprint of Skyhorse Publishing, Inc.
307 West 36th Street, 11th Floor, New York, NY 10018.

Allworth Press® is a registered trademark of Skyhorse Publishing, Inc.®, a Delaware corporation.

www.allworth.com

Cover design by Mary Ann Smith

Library of Congress Cataloging-in-Publication Data is available on file.

Hardcover ISBN: 978-1-62153-573-7
Paperback ISBN: 978-1-62153-637-6
eBook ISBN: 978-1-62153-574-4

Printed in the United States of America

Table of Contents

To my wife, Dalya, and our daughters, Abby and Lizzy

Introduction

People are passionate about art. They like looking at it, thinking about it, and talking about it. Some also like collecting it.

This book provides invaluable market insights for everyone interested in the inscrutable and endlessly fascinating world of art. Whether a seasoned art world professional or an uninitiated newcomer, readers will learn how the art marketplace works in practice and how to smartly navigate it. The essential premise of this book is that by sharing the good, the bad, and the ugly about the market, collectors will be able to pursue their passion with more confidence. Those who may have been put off by art world practices will finally feel they have the knowledge needed to participate confidently.

In pursuit of this idea, I will take you to the night of October 18, 1973, when the actions of a collector heralded the beginning of a hyper-commercialized art market focused on contemporary art. In the years since, art collecting has come to require specialized knowledge. I will explain how the marketplace puts a price on an artwork and how different markets have formed for six well-known artists, including Christopher Wool, Yayoi Kusama, Rene Magritte, and Amedeo Modigliani.

Because buyers are sometimes blinded by passion, I will share practical wisdom for buying art effectively from galleries and at auction. A recurring question is which of these two channels offers buyers a better deal. While there is no single answer, I will explain how prices in these markets relate to each other so that buyers are more informed and can make smart purchase decisions.

Selling art is much harder than buying it. We will visit an evening auction where the ideas I explain in this book are used by siblings to sell their parents' valuable art collection. For those curious about deal-making practices at the very top end of the auction market where multimillion dollar works of art are sold, I will explain the mysterious world of enhanced hammer deals and guarantees.

Well-intentioned rules and tax laws can lead to unintended consequences, and the art world is no different. But there are many surprising twists and turns. I will explain how Andy Warhol is now considered cultural property by German and Italian authorities, subject to export rules and potential sale restrictions, and how tax laws in the United States reward art investors but penalize art collectors.

Where money goes, scoundrels follow. The marketplace is littered with incidents of duped buyers and sellers. As the price of art soars, the schemes and shenanigans of people who prey on those passionate about art grow bolder and more nefarious. I share throughout the book examples of bad behavior but, more importantly, actions collectors can take to protect themselves.

I wrote this book to help open the world of art to more people. It reflects my experiences as a collector, businessman, economist, and president of the Americas for Christie's. It also draws on interviews I did in 2015 and 2016 with close to one hundred collectors, lawyers, art advisors, gallerists, and auction specialists in the United States and Europe.

A little bit about me: I grew up in a middle-class family in Toledo, Ohio, that had little interest in art. When I was in high school, however, my girlfriend's father opened an art gallery in town for prints. He explained to me the different techniques artists use to create prints and showed me my first Picasso. The experience was fascinating and made me start questioning further. Why was a Picasso print so valuable? Why did the gallery source everything from New York? Who were the younger artists with a shot at being the Picasso of my generation? Since this was pre-Internet days, I soon found myself spending time in the Toledo Museum of Art looking at art and trying to make sense of it.

A lucky break occurred a short time later when I heard about a local group of collectors who met to talk about the goings-on in the world of

contemporary art. I joined the group and became their youngest member when I was fifteen years old. The most important collectors in Toledo at that time were Joseph and Mildred Gosman, who had an outstanding collection of Postwar and Contemporary art that included work by Robert Rauschenberg, Georgia O'Keeffe, Willem de Kooning, and Joseph Cornell. They taught me the importance of constantly looking at art to see what resonates, confuses, and pushes the envelope. Their advice has informed my approach to art ever since—to stand in front of as much art as possible to constantly challenge my eye. To critically assess what makes an artist important relative to his or her peers. For historical work, to understand the socioeconomic zeitgeist when the work was created because it shapes in some way what you are looking at. Because New York was the center of the art world, I had to find a way to be there. I used money from my summer jobs in high school to go to Manhattan and spend time in museums and galleries. When I was in my early teens, I went to the Whitney Biennial for the first time, kicking off a decades-long relationship with the museum. I have been fortunate to be able to contribute to the museum over the years, including as an advisor to the board of trustees on the museum's strategy and financial plan associated with moving from its Upper East Side location to the Meatpacking District.

In addition to art, I also love economics, specifically how markets function. I graduated from the University of Michigan with a PhD in Economics. I met my future wife there, who was also a PhD student in economics. Our first date was to the Detroit Institute of Arts, an institution I reconnected with decades later when I led the Christie's team helping the Institute extract itself from the City of Detroit bankruptcy. I talk about how the Detroit Institute narrowly escaped being liquidated at the end of Chapter 1.

Shortly after getting my PhD and a Brookings Institution fellowship, I joined McKinsey and Company. I worked my way up over the years to become a partner based in New York, working primarily with clients in the wealth management and asset management industries. During my time there, I learned an important lesson about collectors. Whenever I started working with a new client, I asked around to find out which members of the senior management team were collectors. Most were not, but the few who

were collectors were inevitably the business leaders most open to new ideas for growth and overcoming obstacles. Over time, I realized that collecting was a great predictor of business acumen.

After a long career at McKinsey and stints running businesses elsewhere, I wanted to pivot away from financial services and get more involved in the art world. I served as president of the Americas for Christie's, where I was responsible for all the company's activities and senior client relations in North and South America. I am now on the board of the arts venture Twyla, backed in part by Google Ventures, which is creating ways for new collectors to connect with artists and buy editioned work by them. I also advise clients on legacy planning associated with their art collections, including helping them to assess alternative disposition strategies.

A few final notes: all of the interviews I did for the book were off the record. These ground rules made it possible for interviewees to speak freely and honestly about their experiences with the art market. I honored their privacy, which is why you will see so many examples in the book identified by randomly assigned names. I also sometimes changed minor details to protect their identities. I want to thank all of the people I interviewed for their trust and confidence in me.

I hope you enjoy the stories and insights about the wonderful, exciting, and, at times, perplexing and confounding marketplace for art. If you have questions or comments about the book, then please contact me at dougwoodham.com.

—Doug Woodham
December 2016

<div style="text-align:right">

1

</div>

Experiencing Art Is (Almost) Free

Art is a noun, but what does it mean? Unlike a hammer, a chocolate bar, or other objects of daily living, art has no practical value. Its utter uselessness in performing a productive activity is key to its inherent charm and purpose. What makes an art object so interesting is less what it is as a noun and more the adjectives that people apply to it, such as: stunning, shocking, sublime, beautiful, boring, stupid, vapid, valuable, confounding, fun, derivative, meaningful, absurd, and insightful. The list is long of words used every day in museums, galleries, and on Facebook and Instagram to describe an art object. While the noun remains the same, the adjectives someone uses to describe an artwork can change over time. Rather than being fixed and immutable, emotional responses to an object can change as a person looks more, learns more, and lives his or her life. It is hard to think of another noun that can be ascribed with so many powerful and divergent adjectives, with the possible exception of humans.

People are passionate about art. But because of its inherent uselessness and multimillion-dollar headline prices at auction, art appreciation and access are often disparagingly described as a rarified world only available to the extraordinarily wealthy, of little interest or relevance to most people. However, the dramatic increase in the accessibility and popularity of art tells a different story. For very little money, it is now easy to experience it in person. Technology has also made it possible to appreciate art for free on our desktops and mobile devices. New forms of promotion and

collaboration across art, fashion, and music are also helping raise awareness of artists and their work. More people can now access and appreciate art than ever before.

The purpose of this chapter is to celebrate the institutions and drivers behind this easy and almost free access and highlight for those new to the art world some ideas for how to take advantage of what is on offer.

OUR NEW CATHEDRALS

Churches have been art museums for millennia, well before the nationalization of royal collections in the second half of the eighteenth century, which was the foundation for the modern concept of a public art museum. Mosaics in St. Mark's Basilica in Venice, sculptures by Gian Lorenzo Bernini in St. Peter's Basilica in Rome, and devotional paintings in medieval churches that dot the five-hundred-mile-long St. James pilgrimage path in Northern Spain were all installed to inspire and impress parishioners and visitors.

With a surge in attendance over the past decade, art museums have become our new cathedrals. The Metropolitan Museum in New York, one of the best encyclopedic art museums, welcomed a record six and a half million visitors in 2015, two million more than ten years ago. The top ten art museums in the world had fifty-five million visitors in 2015, the equivalent of running eight sold-out Billy Joel concerts every day for a year at Madison Square Garden.[1] While pop culture often glorifies the mundane, the salacious, and the trite, museums are cathedrals of the authentic where visitors can experience art and objects with deeper levels of potential meaning.

Great museums today are places of engagement that appeal to many different types of visitors, rather than just being a repository of precious objects, or (as some have derided them in the past) as places where objects go to die. Museums invest in a portfolio of exhibitions to entice people to their doors. While the notion of a "blockbuster show" may be a pejorative for some, the museum-going public is making wise choices when you look at actual attendance records. The highest-attended show in the United States in 2014 was Designing Modern Women: 1890–1990, a show exploring how twentieth-century design was shaped by the creativity of women, shown through design objects from more than sixty women creators. In Europe, the

most popular show was about new art from Africa and Latin America, while in Central and South America, shows about Salvador Dali, Yayoi Kusama, and Renaissance Virgins topped the list. (Exhibit 1.1)

Visiting a museum is an affordable experience, regardless of a visitor's financial circumstances.[2] About a third of art museums in the United States are free, while about 6 percent ask for a suggested donation. The rest charge an admission fee, but most offer evening or weekend events that are either free or allow visitors to pay what they want.[3] Membership packages make the cost of visiting a museum lower than that of seeing a movie.

Museums have taken steps to make their physical spaces more hospitable so that visitors will linger and return. Museum directors and boards of trustees often turn to the architect Renzo Piano when they want to expand or build a new facility. Piano frequently talks about using an Italian piazza as his design metaphor when imagining a new museum space: a place where people naturally want to gather for a cup of coffee or drink, to mingle, to gossip. Beginning with the audacious Pompidou Museum that opened in 1977 in Paris to the new Whitney Museum in New York that opened in 2015, Piano finds creative ways to reimagine the museum-viewer experience.

But with increased demand comes increased responsibilities. Art museums face unrelenting pressures to raise enough funds to support their programming. The average visitor in 2015 spent about $8 for tickets, food, and the occasional book or poster bought in the museum store. However, it cost the art museum $55 per visitor to deliver that experience, a substantial gap that must be filled every year with memberships, donations, endowment income, and government support.[4]

People passionate about art often become passionate about their local museums. A crisis can galvanize them to step up their support, demonstrated by the people and institutions who came together to preserve the Detroit Institute of Arts (DIA). The DIA risked being shut down and liquidated when the City of Detroit declared bankruptcy in July 2013. Over the next eighteen months, the museum's supporters raised $816 million to buy its freedom from the City. The story behind this generous outpouring of support, and the peculiar reasons why the DIA was embroiled in the bankruptcy in the first place, are shared in Exhibit 1.2.

THREE TECHNOLOGIES HELPING MAKE IT HAPPEN

Art is a visual experience. In the past, it could only be experienced in person or through printed materials. But three technologies have changed how we experience art: the JPEG standard, Google Images, and Instagram. The JPEG standard, first released in 1992, is an algorithm created by the Joint Photographic Experts Group (JPEG) to compress digital images into smaller, more manageable files. It is one of the most popular formats on the web for storing and transmitting digital images. The ubiquity of digital images in our email, text, and Instagram and Facebook feeds is due in no small part to a beautiful algorithm created twenty-five years ago by a group of mathematicians and computer scientists.

With easy storage of digital images, the next challenge became how to find them. Google solved the problem when it introduced Google Images in 2001. Using simple key words (for example "Picasso") Google Images returns all the pictures on the web related in some way to the search term "Picasso." It is an invaluable tool for everyone passionate about art. To see work by an artist, just put the artist's name into the Google Images search bar and enjoy the feast of images. Google Search and Google Images together make it possible to become an "instant expert" on virtually any living or deceased artist—art history for free on your mobile device and desktop.

Instagram, the newest of the three technologies, is an emerging platform for artists, galleries, and critics to share images and the latest news. Instagram will likely grow in importance over time as more artists and their supporters use it to build communities of followers and potential buyers. Young and mid-career artists are especially drawn to it, engendering at times "Instagram envy" of early adopters who built direct relationships with admirers and buyers.

CJ Hendry, a twenty-eight-year-old Australian now living in New York, is a fascinating example of an artist using Instagram to build a global audience for her work.[5] Her Instagram handle is cj_hendry. She grew up in Brisbane and thought she would become an architect. But she hated her first two years at university and loathed the design and engineering software tools she needed to master to be a practitioner. While software was not her thing, she had an almost savant-like ability to make large,

hyperrealistic drawings of consumer products using black-ink pens. She quit school in 2013, sold her belongings, and gave herself a year to make a go of things as an artist. She started making large drawings of crumpled up Chanel bags (she worked part time at the Chanel store in Brisbane), boxing gloves, and running shoes dipped in paint. Everything had to be drawn with the same type of black-ink pens: no pencils, pastels, or other mark-making implements that would leave any residue, no matter how microscopic. She believes her choice of medium is due in part to her being obsessive compulsive. She likes to work for long periods, sometimes drawing twelve to eighteen hours a day. It helps to quiet the mind. She is an intense, articulate, and charming person who likes working hard and is comfortable taking risk.

When she started drawing full time in 2013, she began posting regularly on Instagram. To stand out from the clutter, her posts have a consistent, clean look. Everything is in black and white. She shares both still images and videos of her making drawings. Once you see some posts, you quickly understand the design aesthetic. People started to find her. By early 2014, she had 100,000 followers and was selling work directly to people who contacted her via Instagram. There were enough inquiries that once she finished a drawing, it typically sold within a few days to someone on a growing waiting list. Sales were to people located all over the world, not just Aussie nationals.

Later that year, she partnered with a Sydney entrepreneur who owns a web business called The Cool Hunter to help evangelize her work. They organized two pop-up exhibitions, one in Sydney and the other in Melbourne, with more than fifty drawings in each show. Both sold out before they opened, with most of the work sent to international buyers. Drawings sold for between $5,000 and $50,000.

Early in 2015, CJ moved to New York. She now has 265,000 Instagram followers as of November 2016 and still sells all of her drawings within a few days of completing them to someone on her waiting list, which now numbers around six thousand people. Her prices have also risen. All of this is happening without her having traditional gallery representation. She is a powerful example of how Instagram enables people passionate about art to find and follow artists who inspire them and buy something directly from them.

Some of the most popular living artists based on their number of Instagram followers are shown in Exhibit 1.3. The artist known as KAWS, for example, has close to 553,000 followers (as of November 2016). Because he posts frequently, his followers get a steady diet of pictures showing his creative process, work being installed in museums and galleries, and the occasional picture of his young daughter. Instagram users also tagged more than 250,000 photographs with KAWS's name. It is a different measure of popularity. When someone tags a photograph with the artist's name, that person is taking a moment to announce an affinity with the artist.

Who are the most popular deceased artists based on the number of tagged photographs? Andy Warhol, with more than one million tagged images (Exhibit 1.4). If alive today, I am sure this would delight him. Pablo Picasso is a close second followed by Salvador Dali. Jean-Michel Basquiat, who died of a heroin overdose in 1988 at the age of twenty-seven, is eighth on the list with 277,000 tags.

Art galleries, art fairs, and art-world opinion makers are also experimenting with Instagram (Exhibit 1.5). Among galleries, Gagosian Gallery tops the list with 566,000 Instagram followers. For art fairs, Art Basel has 915,000 followers. Among critics, Artforum has 516,000 Instagram subscribers, which is multiples of its paid print subscription base. Jerry Saltz, the art critic for *New York* magazine, has built a large audience eager to see what he has to say about art and the world in which he lives. (Note: These numbers are correct as of November 2016 and may have increased.)

Figures from outside the "traditional" art world are also using Instagram to promote contemporary art. Kasseem Dean, otherwise known as Swizz Beatz, is a Grammy Award–winning hip hop recording star and record producer. Dean's 1.5 million Instagram followers get regular updates on the daily activities of Dean and his wife (Alicia Keys), along with occasional posts about visual artists and artwork that inspire him. Passionate about art, Dean's personal collection includes work by Warhol, Basquiat, Chagall, and Miró.[6] He is also a fan of KAWS, with a nineteen-foot sculpture by him in his home.

To help support living artists, Dean recently created an art and music extravaganza called No Commission Art Fair. The first event took place in Miami in December 2015 at the same time as Art Basel Miami Beach. While

Art Basel is sponsored by the Swiss bank UBS, Dean went down a different path and got Bacardi to support his fair. Artists received free exhibition space and kept 100 percent of sale proceeds, hence the name of the fair. In an interesting curatorial twist, Dean selected artists to participate in the fair using, in part, feedback from his Instagram followers.[7] Because of his reputation and marketing platform, large crowds attended the fair. It was a clever way to enlarge the audience for contemporary art and put more dollars in the wallets of artists. Building on the Miami event, Dean hosted the next iteration of No Commission Art Fair in August 2016 in a former piano factory in the South Bronx. This was followed by a No Commission art fair in London in December. Once again, artists kept all sale proceeds.

THE GREAT MASH UP—ART, FASHION, AND MUSIC

The fashion world looks to artists for inspiration. Before becoming an acclaimed designer, Christian Dior was a director of a small Paris art gallery in the late 1920s and early 1930s. Many of his popular fabrics and silhouettes were quotations from artworks that he loved.[8] But the fashion world has moved beyond mere quotations and now will incorporate artist-designed patterns into its merchandise. Among the most famous is a collaboration between Marc Jacobs, Takashi Murakami, and Louis Vuitton that began in 2003. The handbags and merchandise emblazed with Murakami designs generated hundreds of millions in sales. Louis Vuitton continues to use this type of collaboration, most recently with Yayoi Kusama in 2012. Kusama's colorful polka-dot designs were incorporated into a full product line that was launched with a global media and store rollout plan. The line generated millions in sales while simultaneously bringing the Kusama name to audiences well beyond the confines of the "traditional" art world. I talk more about Kusama's embrace of consumerism and the marketplace for her artwork in Chapter 4.

Reversing the flow of influence, the artistry of fashion is now recognized by museums. Alexander McQueen, who committed suicide in 2010, was a gifted and driven artist whose medium happened to be clothing. The distinctive shapes, colors, and patterns that sprang from his imagination were extraordinary. The world of fashion understood his brilliance; the museum

world embraced and showcased it in 2011 when the Costume Institute at the Metropolitan Museum organized a McQueen retrospective called *Savage Beauty*. It was a huge hit, with two-hour waits to get in. The Met extended the run of the show and created special viewing times when the museum was otherwise closed. It became one of the top ten most visited exhibitions in Met history. *Savage Beauty* traveled a few years later to the Victoria and Albert Museum in London where it became the most attended show in the history of that museum.

Art and music sometime merge. Drake, the global music phenomenon, released a video in 2015 that quoted the work of James Turrell, an artist in his early seventies. Turrell is known in the art world for his immersive light installations and a monumental earthwork in the cone of an extinct volcano that he has been working on for more than thirty years. His career was showcased in a 2013 retrospective that appeared at the Guggenheim Museum in New York, the Los Angeles County Museum of Art, and Houston's Museum of Fine Arts. Drake and his creative team reportedly saw the retrospective in LA and, like many who experience Turrell's work, were amazed at the beauty the artist conjures out of colored lights and translucent scrims. Inspired by the work, Drake and his team designed the video for his single titled "Hotline Bling" around Turrell-inspired installations. The video was a runaway success with more than one billion views on YouTube as of December 2016. When the video first came out, Turrell and Drake had a brief tussle about artist rights and compensation. Turrell considered taking legal action around copyright infringement but ultimately decided not to pursue it. "It's humbling that more people have probably heard about me through this [video] than anything else. They're happy to take without asking. But I am flattered."[9]

As the worlds of art, fashion, and music increasingly influence each another, they owe a debt of gratitude to the 1960s patron saint of multimedia platforms—Andy Warhol. The first shows of his now iconic pop paintings of Marilyn Monroe and Campbell's soup cans took place in 1962. But in addition to his work as a painter, sculptor, photographer, and printmaker, he also started managing the Velvet Underground in 1965, a band now deemed one of the most influential in rock-and-roll history. From 1963 to 1968, he produced close to 650 films, from full-length movies to hundreds

of short black-and-white films of people who visited him at his studio. He started *Interview* magazine in 1969, a compendium of conversations with artists, musicians, fashion designers, and celebrities. Warhol's influence on art and popular culture is now so strong that countries like Italy and Germany deem his work to be national cultural property—a funny thing for an artist born and raised in Pittsburgh. In Italy, for example, owners of work by Warhol created in 1967 or earlier, from a print to a painting, need permission from the Italian government to export it. More on this curious situation in Chapter 7.

ZERO, NADA, ZILCH

Where can you get free access to art worth billions? Art galleries and auction houses. Both are free and open to the public but are often underutilized by people passionate about art.

Art Galleries

With more than one thousand galleries in Manhattan and London, as well as large concentrations of them in Berlin, Miami, Los Angeles, and other cities, there are ample opportunities to see wonderful art for free.

What is on view? Art galleries host shows that display work by artists they either represent or artists they respect. The shows are generally of new work by a single artist or a group show built around a theme. Most galleries run an active exhibition program from September through June, with each show running for about six weeks. In the summer, they typically have a single group exhibition. Most of what they show is available for sale. But from time to time, a work may be unavailable. For example, a gallery may be showing new work complemented by an earlier piece borrowed from a museum or a private collection.

Is it really free? Art galleries around the world are free and open to the public, generally Tuesday through Saturday. In New York, there are two particularly fun times to go gallery hopping. Saturday is a great day because the crowds are out and there is a fun buzz in the air. Next are mid-week evening events that galleries organize for the openings of their shows. They tend to

synchronize these events with other galleries to maximize turnout. For those wanting to look at art in relative solitude, the ideal visiting times are midday/mid-week or early Saturday mornings before the crowds.

When I am there, what should I do? The first thing visitors encounter when entering a gallery is the front desk. The people manning it are generally young and beautiful, but many of them have an unfortunate tendency to glare and inspect all who enter. They can be safely ignored. After passing the front desk, feel free to wander around the gallery. Most of the time, there will be no labels next to the artworks. Many galleries feel the works should speak for themselves. If in a "no labels gallery," then the front desk will have a list of all the works in the show. The gallery may also have some materials about the artist at the front desk, such as a press release, copies of books on the artist, or an artist statement. Take a moment to review them.

If I want to know the price of a work, whom should I ask? From this simple question comes a complex answer. If you want to know the price of a work, then go back to the front desk and ask for the price list. Many galleries will be happy to share it with you. But some have a more complex ballet. Generally speaking, the more expensive the work, the more complex the dance. Instead of giving you the price list, the receptionist may ask you which piece(s) you are interested in. After letting the receptionist know, he or she will flip through the price list and share the asking price with you.

Galleries sometimes do not want the front desk staff to give out prices. Instead, the receptionist may say something like "I will be happy to see if one of the gallery directors is available to speak with you." Do not be surprised if, before calling a gallery director, the receptionist asks for your name and whether you have worked before with someone at the gallery. She is just trying to match you up with the right sales person. Sometimes no one may be available to speak with you at that specific moment, so the receptionist may ask you for your contact details so a director can follow up later.

How can I figure out which galleries to visit? There are five mobile apps you should consider using: Artforum Art Guide, Artsy, See Saw, Artcards, and Zingmagzine. The cities covered by each app differ, but across them you can get information on New York, Los Angeles, London, Berlin, Paris, Milan, San Francisco, Hong Kong, and Beijing. The *Time Out* franchise also publishes weekly guides, in print and online, on the best things to do in

major cities worldwide. They do a good job covering the local art scene with short reviews of current shows.

For galleries I like, what is the best way to stay in touch? Most galleries have a guest book on or near the reception desk. If you like a show, then take a moment and sign the guest book with your name and email address. The gallery will then most likely add your name to its email distribution list for upcoming shows. Most galleries also make it possible to sign up for these announcements on their website.

Auction Houses

Every time an auction house hosts a sale, the works are shown to the public in a free preview exhibition. Everyone is welcome to attend. Thousands of objects pass through auction house exhibition rooms every year, from paintings by Picasso and Jean-Michel Basquiat to prints by Rembrandt. More than two hundred exhibitions take place in New York City alone each year across the different auction houses, with art worth billions on view.

What is available to look at? The major auction houses sell things that fall into one of three broad groups: fine art (e.g., including categories like Postwar and Contemporary, Classical Chinese Painting and Calligraphy, and Old Masters), decorative arts (e.g., including English furniture, ceramics, American silver), and luxury goods (jewelry, watches, handbags, and wine). Regional and smaller auction houses tend to specialize in just a handful of categories. Everything for sale is "vintage," "previously owned," or "used." This is not a criticism, just a reminder that auction houses deal in what is called the secondary market for goods, not the primary market.

Items for sale are on display for several days before the actual auction, which is called the preview period. Potential buyers view and inspect the items at this time. Auction houses have an annual sales schedule for when different categories of goods are typically sold. For example, most auction houses in New York hold their important Postwar and Contemporary auctions twice a year in May and November, while in London, these sales are typically held in February and October. Information on auction dates and preview periods by sale category are available on auction house websites.

Is it really free to attend a preview? Every preview exhibition is free and open to the public. They are open during regular business hours, and some weekends.

When I am there, what should I do? Walk in the front door and do not be intimidated in the slightest by a uniformed doorman or people sitting behind the front desk. The doorman is there to welcome you, and the front desk staff are there to answer your questions. All the viewing galleries are open to the public. Feel free to wander around and move between floors. All of the items for sale are on public display. Nothing is hidden behind closed doors, contrary to popular belief. As you look around, it is unlikely that auction house employees will come over and ask if you have any questions. They typically only come up to people they already know. This is why you are likely to see auction specialists standing together, casually gazing at their cell phones. It is not necessarily a great experience for newcomers, but it tends to be the gestalt at many auction houses.

If I have a question about an object, whom do I ask? Before asking questions, review the sale catalogue to learn about the object. You will find copies of the catalogue discreetly placed throughout the exhibition galleries. You can also view sale catalogues for free on your mobile device. At the major auction houses, every object has a small wall label adjacent to it that provides important details (e.g., lot number in the sale, name of the artist, title of the work, dimensions, and presale auction estimates). Use the lot number to look up the object in the sale catalogue.

Three types of auction house employees are roaming the exhibition rooms: specialists, art handlers, and gallery assistants. Specialists are experts in the objects on display, often with advanced degrees. Their job is to get owners to consign objects to their sales and to then promote the sales to potential buyers. They can educate you about the work(s) that interest you, but just remember that because their job is to promote the works, it can influence what they say. Art handlers usually wear aprons or a uniform and are available to help a potential buyer inspect an object (e.g., take a painting off the wall so they can inspect the back of it). Gallery assistants can help you find a specific item in the viewing rooms, and connect you with a specialist and/or art handler if one is not immediately available.

Am I allowed to handle items for sale? Yes, but only with the assistance of a specialist and/or an art handler. Specialists love to talk about and handle the objects in their sales, so they are happy to assist potential buyers.

Can I attend an actual auction? Most auctions are open to the public. You can stay as long as you want or leave after just a few lots are sold. You also do not have to worry about inadvertently bidding on an item when you scratch your nose or cough. That is just not the practical reality of auctions. To be a bidder, you must register for the sale and receive a numbered paddle. A few auctions take place each year that are closed to the general public and require advance tickets. While you cannot see them in person, most auction houses webcast all of their auctions, so you can watch them from the comfort of your home or office.

EXHIBIT 1.1
TOP FIVE MUSEUM SHOWS[10]
2014

SHOW	MUSEUM
United States	
Designing Modern Women: 1890–1990	MoMA, NY
Applied Design	MoMA, NY
Jasper Johns: Regrets	MoMA, NY
American Modern: Hopper to O'Keeffe	MoMA, NY
Magritte: The Mystery of the Ordinary	MoMA, NY
Europe	
Pangaea: New Art from Africa and Latin America	Saatchi Gallery, London
Civic Art in Florence	Galleria dell'Accademia, Florence
Selections of the Guggenheim Collection	Guggenheim Museum, Bilbao
Van Gogh/Artaud	Musée d'Orsay
Yoko Ono	Guggenheim Museum, Bilbao
Central and South America	
Salvador Dali	Centro Cultural Banco do Brasil, Rio de Janeiro
Yayoi Kusama: Infinite Obsession	Centro Cultural Banco do Brasil, Rio de Janeiro
Renaissance Virgins	Museo Soumaya, Mexico City
Visions from the Ludwig Collection	Centro Cultural Banco do Brasil, Rio de Janeiro
Yayoi Kusama: Infinite Obsession	Instituto Tomie Ohtake, São Paulo

EXHIBIT 1.2
HOW THE DETROIT INSTITUTE OF ARTS NARROWLY ESCAPED THE 2013 CITY OF DETROIT BANKRUPTCY

How did an art museum get ensnared in a municipal bankruptcy? By the 1950s, the Detroit Institute of Arts (DIA) was a world-class encyclopedic art museum that reflected the status, power, and wealth of the Motor City. Masterworks by Rembrandt, Michelangelo, Van Gogh, Matisse, Degas, and Monet were in the collection. But unlike most other public art museums, the DIA collection and building were owned by the City of Detroit. This unusual financial arrangement came about in 1919 when the museum ran into financial difficulties. In exchange for providing the museum with funds for its operating budget plus money to acquire paintings and sculptures, the museum transferred its collection to the City of Detroit and became a department of city government.[11]

After decades of decline and financial mismanagement, the City of Detroit filed for bankruptcy protection on July 18, 2013. From being the fourth-largest city in the United States in 1950 with 1.8 million residents, Detroit was now half that size, with tens of thousands of abandoned buildings. At the time of the bankruptcy filing, the city was saddled with debt and pension obligations to teachers, first responders, and other city employees that totaled close to $18 billion. The museum collection immediately became one of the most valuable assets the city could potentially sell in whole or in part to make good on these obligations. The prospect of the DIA collection being sold became front-page news across the world and the source of heated debates about the role of art and museums in society and the claims of creditors.

Art versus Pensions for Cops and Firefighters

Art can be ethereal, beautiful, and deeply meaningful to many people, but how do you weigh the value of art against the monthly pension checks of retired cops and firefighters? At the time of the bankruptcy, financial analysts estimated that retired municipal workers would face substantial reductions in their monthly pension checks. "Pills over Picasso" was how an attorney for the city's retiree associations summarized his position.[12] Because the DIA collection was one of the three most valuable city assets, the museum

could not escape making some type of financial contribution to resolving the bankruptcy. The question of what to do with the DIA became the central issue in the creation of a bankruptcy plan for the city that would be acceptable to the bankruptcy judge.

Valuing the Art Collection

Art in the DIA collection fell into two categories: works purchased by the City of Detroit and art donated or acquired using private funds contributed to the museum. Lawyers working for the city believed the City of Detroit had clear legal title to the works paid for with taxpayer dollars; the title status of other objects was more nuanced. Early in the bankruptcy process, Christie's was hired to value just the art purchased with city funds. As president of the Americas for Christie's at the time, I led the team working on this assignment.

It took more than four months for teams of specialists with backgrounds in Old Master Paintings, Impressionism, Islamic Art, and other fields to inspect on site the 2,773 City of Detroit–purchased artworks. These objects represented around 5 percent of the 66,000 objects in the DIA collection. The appraisal report, which was released to the public, concluded that:

- The fair market value of the city-owned works ranged from a low of $454 million to a high of $867 million. The lower number represented a conservative price at which the property would change hands between a willing buyer and willing seller; the higher number represented the most advantageous price.
- About 75 percent of the value was tied up in just eleven paintings. The most valuable was a large, glorious painting by Pieter Bruegel the Elder from 1566 depicting a boisterous wedding dance. It was valued at between $100 and $200 million. The next most valuable was a small self-portrait by Vincent van Gogh, valued at between $80 and $150 million.

The $816 Million "Grand Bargain"

Once the Christie's appraisal was published, the different parties involved in the bankruptcy moved from speculation on what the DIA collection was

worth to discussions about a possible settlement. Ken Buckfire, the city's investment banker and principal architect of the restructuring, shared with me, "We realized early during our due diligence process that the city would need to generate value from the DIA to satisfy its obligations to creditors. So we turned the DIA into a bargaining chip and encouraged the community to pay the city for its fair value. The appraisal by Christie's was a key factor in saving Detroit and the DIA. Without it, we wouldn't have known how much money we had to raise."[13]

The governor of Michigan, the City of Detroit emergency manager, the DIA museum director, the head of the Ford Foundation, and others came together to create what became known as the Grand Bargain Settlement. In exchange for the city granting the DIA full independence from city ownership, $816 million of funds were committed to city pensions. The DIA agreed to pay the city $100 million over twenty years, national and local foundations contributed $366 million, and the State of Michigan contributed the remaining $350 million. These funds helped to reduce (but not eliminate) the haircut on current and future retiree benefit checks. The Grand Bargain also preserved $20 million of annual support the museum was already receiving from three outlying counties (Oakland, Wayne, and Macomb) in exchange for free DIA admission for its residents. The Grand Bargain, which was accepted by the federal judge on November 7, 2014, ensured that the DIA collection remained out of the reach of city creditors.

EXHIBIT 1.3
POPULAR LIVING ARTISTS BASED ON NUMBER OF INSTRAGRAM FOLLOWERS[14]
As of November 2016

ARTIST	NUMBER OF INSTAGRAM FOLLOWERS
Banksy	1,000,000
JR	950,000
Shepard Fairey	813,000
KAWS	553,000
CJ Hendry	265,000
Ai Weiwei	265,000
Takashi Murakami	261,000
Jeff Koons	180,000
Damien Hirst	141,000

EXHIBIT 1.4

POPULAR DECEASED ARTISTS BASED ON NUMBER OF HASHTAGS[15]

As of November 2016

ARTIST	NUMBER OF HASHTAGS
Andy Warhol	1,142,000
Pablo Picasso	1,092,000
Salvador Dali	982,000
Vincent Van Gogh	782,000
Leonardo DaVinci	480,000
Claude Monet	461,000
Michelangelo	398,000
Jean-Michel Basquiat	277,000
Keith Haring	247,000
Henri Matisse	237,000

EXHIBIT 1.5
TOP GALLERIES, ART FAIRS, AND CRITICS BASED ON INSTAGRAM FOLLOWERSHIP
As of November 2016

ART GALLERIES	NUMBER OF FOLLOWERS
Gagosian Gallery	566,000
Pace Gallery	483,000
David Zwirner Gallery	263,000
White Cube	235,000
Hauser & Wirth	196,000
ART FAIRS	
Art Basel	915,000
Frieze	364,000
CRITICS AND PUBLICATIONS	
Artforum	516,000
Frieze Magazine	282,000
Jerry Saltz	194,000
Hans Ulrich Obrist	152,000

The Marketplace for Fine Art

Rapid wealth accumulation, social media as a platform for self-promotion, and global demand for art collided in a spectacular way when an Amedeo Modigliani painting was offered for sale in November 2015. It depicted a full-length nude with brunette hair and luscious red lips reclining provocatively on a blanket. Modigliani certainly loved reclining nudes, with this painting from 1917 among the strongest of the twenty-two he made.

The painting was reportedly tucked away in a Swiss warehouse by Laura Mattioli Rossi, an art historian who was bequeathed the painting after her father, Gianni Mattioli, passed away in 1977. Gianni was a passionate collector who set out in the middle of the last decade to assemble a collection of important works by modern and contemporary Italian artists. Modigliani, born and raised in Livorno, Italy, was a prime candidate for the collection. Gianni had not only the desire to collect but also the means due to a successful career in Milan as a cotton merchant. He bought the Modigliani in 1949 as part of a larger purchase of eighty-seven works of art being sold by another Italian collector.[1]

From cotton wealth to wealth created from the reform of China's economy, the painting is now owned by one of the wealthiest people in China. Born in 1963, Liu Yiqian started from humble beginnings. He dropped out of middle school and was briefly a salesman in a family handbag business before becoming a taxi driver. In the 1990s, he made his first fortune speculating in the new Shanghai stock market. He is now the chairman of Sunline Group, a diversified holding company.[2]

Mr. Liu and his wife have been collectors for more than two decades, focused primarily on Chinese works of art. In April 2014, they bought an Imperial Ming dynasty porcelain cup for $36.3 million; Liu then became notorious in China for using his new purchase to have a cup of tea. Seven months later, he bought a fifteenth-century Tibetan tapestry for $45 million. They have two private museums in Shanghai to showcase their collections, with another one on the way. The couple decided recently to start collecting masterpieces of Western art. "We need to collect foreign art so that our museums can be on a par with their foreign peers. Foreign countries have really [sic] a lot of museums, big and small, public or private. But we think China is lacking something when it comes to art . . . Even if we have enough food, we will be empty inside if we don't have spiritual fulfillment," said Liu's wife.[3]

Within days of acquiring the Modigliani at auction for a record $170 million, they embarked on a global media campaign to announce their purchase and make it known that it would soon be on view in one of their museums. In those few days, the world learned about Mr. Liu's wealth and new collecting interests. The owners of Western masterpieces were also happy to discover another buyer potentially willing to pay extraordinary sums for work in their collections.

From collectors like Mr. Liu, to a millennial spending part of their first bonus on a print, the wonderful world of art is propelled forward by a marketplace that employs hundreds of thousands of people around the world. The purpose of this chapter is to describe the important services provided by the four key sectors of the art market: art galleries, art fairs, auction houses, and art advisors. To provide some context, I start by describing how bifurcated the art market is today between selling beautiful, lower-priced items to a large audience and headline-grabbing sales involving a small number of extraordinarily expensive objects. I also touch on why the demand for art has increased, especially for living artists. Appreciating these trends, and the risks associated with them, helps explain some nuances in how the art market works.

WINNER TAKE ALL

Approximately $64 billion of fine art and antiques were sold globally in 2015, as reported by The European Fine Art Foundation (TEFAF).[4] To put

that in perspective, this was about sixteen times the sales of Tiffany's and 60 percent of sales at Amazon.

Where do people buy art? Based on the value of the objects sold, the market is roughly evenly split between art galleries and auction houses.[5] This has been true for a number of years. But if we use the number of objects sold rather than value, sales through galleries would represent the lion's share of global sales activity. This is due to extraordinarily valuable masterpieces being sold more frequently at auction, inflating sales totals in that channel.

What type of art are people buying? Detailed numbers only exist for auction sales. Using them, TEFAF estimates the top category was Postwar and Contemporary, at 46 percent of the total value of sales. The runner up was Modern Art at 30 percent, followed by Impressionist and Post-Impressionism at 13 percent and Old Masters at 13 percent.[6]

What do people spend to buy a piece of fine art? Less than what you may think. TEFAF estimates that 90 percent of auction sales were for objects worth less than $50,000. But these objects represented only 12 percent of the value of auction sales. Most of the remaining balance was associated with the sale of extremely valuable objects. About 2,500 objects sold for more than $1 million in 2015, representing in total almost 60 percent of the value of auction sales.[7]

How many artists sell at auction? While it varies year to year, work by fifty-nine thousand living and deceased artists was sold at auction in 2015. While this number gives a sense for the breadth of the market, the much more interesting story is that a small number of names accounts for most of the value of sales: about six hundred artists made up 57 percent of total auction sales.[8] Like many talent markets, the art market is one of "winner take all," where the top names capture most of the rewards and the rest sell for far less.

MEANS AND DESIRE

Art is the ultimate discretionary purchase made by those who have the means and desire to own precious objects. The number of people with the means to acquire art has increased sharply, as has the subset that desires it.

Close to thirty-four million people around the world now have a net worth of at least $1 million, up from approximately fourteen million in 2000.[9] Further up the pyramid, 124,000 individuals globally are worth at least $50 million.[10] The number of billionaires has also increased. My favorite measure of extreme wealth is the price of entry to the Forbes list of the four hundred richest people in the United States. In 2015, one needed $1.7 billion to join the club, almost twice what it was ten years ago. It is also a club that excludes many: 145 billionaires in the United States missed the 2015 list because the bar was so high.[11]

But means alone does not make an art collector. Three factors are behind the increased desirability of art: education, exclusivity, and opportunity cost. The triumph of liberal arts education has led to greater awareness of art and higher demand for art and design in daily life. Almost sixty-nine million people in the United States now have four or more years of higher education, an increase of twenty-four million since 2000.[12] Cultural literacy in this large pool of individuals is an important social requirement to effectively navigate the worlds of business, finance, and professional services. Once culturally literate, it is a relatively short hop to getting involved with the worlds of art and design and experimenting with collecting.

Conventional and social media have also enhanced the sense of exclusivity associated with owning art. Museum curators share stories with me regularly about tours they lead where visitors are excited to see paintings they have only experienced digitally. Ironically, the easy availability of digital images has made the original artwork seem even more precious and valuable. Moreover, as high-quality clothing, restaurant meals, and vacation travel have become more readily available, many luxury goods and services are now viewed as far less exclusive and special. Unique objects created by artists, in contrast, have soared in perceived value. Owning them becomes a way to communicate social status and taste in ways no longer possible with many other luxury goods.

Finally, changes in financial markets have lowered the opportunity cost of owning art. Low interest rates make owning non-yielding assets like art more attractive. Since the financial crisis, the rate on one-year US Treasury Notes has been less than 1 percent, down from around 4 percent in the middle of the last decade. Banks and non-bank financial institutions are also

now willing to lend money against a portfolio of high-quality art, upending the historical norm of art being a highly illiquid asset.[13]

But as a discretionary purchase, collectors can easily elect to defer buying something. Likewise, discretionary sellers can decide to postpone selling work if they feel there may be a lull in buyer demand. Speculators eager to participate in the market when it is on an upswing can just as easily elect to sit out when there is market uncertainty. Taken together, this can lead to sharp changes in sale volume in the art market.

Consider, for example, what happened over the past few years in the market for especially valuable works of art. An important collector shared with me his notes from meetings with auction specialists in early 2015 when they were trying to entice him to sell valuable paintings in his collection by Pablo Picasso and Andy Warhol. They told him the auction market was at an all-time high, driven by new and seasoned collectors, and that many of the new buyers had no "price-point barriers." When quizzed about what that meant, the specialists told him stories of extraordinarily wealthy new buyers intent on quickly building collections of masterworks by twentieth-century artists. Their drive and ambition made them comfortable bidding far above prices paid earlier in the decade. The upward spiral of prices also led many seasoned collectors to believe that the value of art had structurally adjusted higher, which made them feel comfortable jumping in. The auction specialists felt confident they had the inside track on demand because of their relationships with the exceedingly small group of people willing to spend millions on art. They told him approximately 140 people worldwide had the means and desire to spend $50 million or more on a work of art. For objects worth around $20 million, there were maybe three hundred potential bidders, and at $5 million, the number was closer to one thousand.

To entice masterpiece owners to sell works in 2015, auction houses (sometimes in partnership with third-party speculative capital) took on enormous financial risks. Owners were given generous financial guarantees that their works would sell for at least a minimum price (e.g., $10 million), with a share of the upside going to them if the work sold for more than the guaranteed amount (e.g., 80 percent of the upside above $10 million).

Competitive pressures between auction houses led them to ante-up guarantee amounts and upside-sharing percentages as potential sellers

played them off each other. Specialists acquiesced to these demands to keep their auctions full of high-status artworks. Their actions were reminiscent of financial institutions in 2007 right before the financial meltdown, when Charles Prince, the CEO of Citigroup, famously said "As long as the music is playing, you've got to get up and dance." But many of these guarantees soured when buyers were unwilling to stretch as far as auction house specialists estimated. It turns out that 2014 was the market peak. The financial pain auction houses suffered caused them to be far more parsimonious when negotiating guarantee deals in 2016. With less of this protection available, many discretionary sellers elected to sit on the sidelines. The supply side effects of fewer masterworks from discretionary sellers and less work being sold because of the traditional 3Ds (death, divorce, and debt-related problems) contributed to a drop in auction sales. Christie's and Sotheby's reported that first-half sales in 2016 were off by almost 30 percent.

But when great work did come to market, some members of the extremely small group of buyers with the means and desire to spend millions on art still elected to show up. In June 2016, Sotheby's offered a Modigliani painting of his common-law wife, Jeanne Hebuterne. Unlike the reclining nude bought by Mr. Lui, Modigliani painted her fully clothed and sitting upright in an armchair. It sold for $56.5 million.

BEST TIME TO BE AN ARTIST

Collectors have been passionate about contemporary art for hundreds of years. In 1479, for example, the Doge of Venice sent a prominent artist to work in the court of Sultan Mehmed as part of a peace settlement. Gentile Bellini spent almost two years in Constantinople working for the sultan, who had a particular love for contemporary Italian art and decorative objects. Bellini painted portraits of court members and at least one of the sultan. When he returned to Venice, Bellini was able to return to paintings that he had previously started in the Doges Palace. His portrait of the sultan now hangs in the National Gallery in London.[14] While today we think of Bellini as an old master, he was at one time a contemporary art star.

Work by living artists is often easier for new collectors to appreciate, because it is an expression of the zeitgeist in which they live. They do not

need to learn about another historical period to gain full appreciation for the art. Interest in living artists is at an all-time high now, in large measure because there are simply so many new collectors. Many established collectors who understand the full sweep of art history also like trying to "see around the corner" and enjoy buying work by living artists who they believe have a chance of making it into the history books. Living artists have an additional advantage over their deceased forbearers: studio visits. A lot of art is sold every year by artists hosting buyers at their studios—so much so that some collectors refuse to go for fear they may be seduced into buying based on the charisma of the artist, rather than the merits of the work.

At the very top of the artist pyramid is a small group, no more than three hundred to five hundred artists, who today likely earn in excess of $1 million a year.[15] They tend to be represented by the best galleries, enjoy support from important museum curators and tastemakers, and make work that is generally easy to recognize. These artists are sometimes referred to as "branded artists." The top twenty-five based on recent auction sales are shown in Exhibit 2.1. Gerhard Richter is at the top of the list with $1.2 billion of sales; David Hockney is twenty-fifth with $73 million of auction sales.

Moving down the pyramid, thousands of artists are now able to sell enough of their work to earn at least the median household income of $56,500. A middle-class life, combined with the chance to become an art-market superstar, has led more people than ever before to pursue being a professional artist. The Yale School of Art and the Visual Arts Program at Columbia University are two of the top masters in fine arts programs in the United States. While an advanced degree is by no means required to be a successful artist, acceptance rates at these two programs were 5 percent and 2 percent in 2014, lower than the odds of getting into Harvard or MIT as an undergraduate.[16]

THE ART-MARKET ECOSYSTEM

Let's turn now to brief overviews of the services provided by each of the key sectors of the art market: art galleries, art fairs, auction houses, and art advisors.

Art Galleries Select and Promote Artists

Because there are thousands of living artists and artist estates, galleries play an important role filtering this universe to identify those who have commercial potential. Galleries then market the artist's work to collectors, museums, and art-world influencers. This is the so-called primary market, because it is the first time the work is offered for sale after leaving the artist's studio.

For many dealers, as for artists, the work is a calling, not a job. But like other businesses, galleries live and die based on sales and their ability to manage their infrastructure costs. As a general rule of thumb, artists and galleries split sale proceeds fifty/fifty, with the gallery responsible for the costs associated with showing and promoting the work. These can include the costs to stage shows, exhibition catalogues, and opening events. Galleries may also be called upon to help cover production costs and advance money to artists against future sales. Well-known artists in high demand can sometimes negotiate more advantageous selling agreements, perhaps receiving as much as 90 percent of sale proceeds.

The world of art galleries is one of the few industries that have been led for years by women. After World War II, for example, Denise René opened her eponymous gallery in Paris devoted to abstract art. She later opened additional galleries in New York and Germany. In honor of her career, the Pompidou Center held an exhibition in 2001 titled *The Intrepid Denise René, A Gallery in the Adventure of Abstraction*. Another important leader was Ileana Sonnabend, who opened her first gallery in Paris in 1962. She introduced European collectors to postwar American artists like Jasper Johns, Robert Rauschenberg, and Andy Warhol and reversed the flow of introductions when she showed European artists like Gilbert and George, Mario Merz, Piero Manzoni, and Jannis Kounellis in her New York gallery. A list of just some of the many women who run important galleries is in Exhibit 2.2.

Galleries operate in a hierarchical system from those selling expensive, blue-chip art to new galleries run by twentysomethings handling artists just out of school. A gallery's position in the hierarchy depends on the importance of the artists it handles, the location and quality of its physical exhibition space, the art fairs in which it participates, and its relationships with

collectors, curators, critics, and other art-world influencers. Because it can be hard to evaluate the importance of an artist, many buyers rely on the brand of the gallery (i.e., its position in the gallery hierarchy) to help them decide whether the artists represented by the gallery are important.

Given the costs and risks associated with representing an artist, scale is now more important than ever before to running a successful gallery. The largest galleries tend to represent many artists, so they always have something of interest to sell collectors. They have exhibition spaces in several of the major locations where collectors congregate, and they participate in numerous art fairs to stay in touch with as many top collectors as possible. They have talented staff to manage artist and client relationships and curate the numerous shows they put on each year. They have sophisticated back-of-house operations to handle all the valuable objects that flow through their gallery networks. Senior staff in these galleries also tend to have their finger on the pulse of what top collectors are looking to acquire and use this information to help source art in the secondary market for them to buy. Secondary market sales are now an especially important and lucrative part of running a large gallery network. Some of the scale galleries with global exhibition programs are shown in Exhibit 2.3.

A benefit of scale to the larger public is that these galleries can afford to put on museum-quality shows. The Gagosian Gallery, for example, organized in 2009 a retrospective of Piero Manzoni, a major figure in the Italian Arte Povera movement. The show reintroduced the deceased artist to an American audience and was a critical success:

Manzoni's work has, in general, been a mystery in the United States: familiar, sort of, from books, but fuzzily grasped and seldom seen. Sonnabend Gallery organized a survey in 1972. Then there was pretty much nothing until "Manzoni: A Retrospective," now at Gagosian Gallery in Chelsea. Maybe that's why the show feels like such an amazement.

The situation is different in Italy, where Manzoni (1933–1963) is a major presence, both as a pivotal player in the country's post–World War II avant-garde, and as a progenitor of the homegrown version of Conceptualism known as Arte Povera. The curator who gave that

movement its name, Germano Celant, is responsible for the Gagosian show.[17]

Everyone passionate about art benefits enormously from these types of shows, not only because they see wonderful art for free but also because of the scholarship that typically goes into the exhibition catalogues.

Art Fairs Provide Convenience

From essentially nothing twenty-five years ago, art fairs are now one of the most important venues where people buy art. Close to 40 percent of worldwide gallery sales are conducted at art fairs.[18]

Art fairs are important because they meet three collector needs:

- *Convenience.* Collectors are time-starved, like everyone. Art fairs enable them to see art from many different dealers in a concentrated period. Fairs are especially important for collectors who do not live in one of the major art hubs and want to keep up with market trends.
- *Comparison shopping.* Buyers can easily compare work by the same artist that is being shown by different galleries at the fair. Collectors can also see work by many other artists, enabling them to make price and value comparisons about what to acquire.
- *Social engagement.* Art fairs are an opportunity to see and be seen. Collecting is a specialized activity, so collectors do not have many opportunities to spend time with like-minded people. Art fairs are a moment in time when collectors, curators, art advisors, and others passionate about art come together.

One of the largest art fairs is Art Basel Miami Beach, held every year in early December at the Miami Beach convention center. The seventy-seven thousand people who attended it in 2016 walked through the equivalent of four football fields of art displayed in more than 250 individual booths, each one representing a gallery who paid substantial fees to be there. Tens of thousands of artworks were on display and available for sale. The show is open to the public and all are welcome.

While art fairs are sometimes derided as crass sales emporiums, they deliver a buying experience enjoyed by many collectors. For an up-to-date calendar of art fairs taking place around the world, consult the gallery apps mentioned at the end of Chapter 1. Most of them have information on upcoming art fairs.

Auction Houses Provide Price Transparency

Auction houses are trading platforms, similar in nature to the New York Stock Exchange and NASDAQ, where buyers and sellers meet to exchange art for cash, with a public record of whether the object sold and for what price.

Like stock exchanges, buyers and sellers migrate to the platform with the most liquidity. Participants, however, will resist a single auction platform from forming because it would wield monopoly power. But if there are too many platforms, liquidity is fragmented to the detriment of buyers and sellers. As a result, the fine art auction market in Europe and the Americas tends to be a duopoly with most auction sales occurring at Christie's and Sotheby's, followed by Phillips and Bonhams, and then a handful of regional players and some online specialists like Paddle8 and Artsy.

The downside of duopolies is that they invite collusion. This is what happened in the 1990s, when executives from Christie's and Sotheby's colluded to raise commission rates. Executives were prosecuted and jailed, and the auction houses paid $512 million in fines.[19] Since then, auction houses have competed ruthlessly to win selling mandates.

Due to their global scale and access to lines of credit, the major auction houses are especially useful to collectors looking to sell the following:

- *Large collections.* Death and divorce, or changes in a collector's financial circumstances, can trigger a collection sale. Celebrities (Jackie Onassis, Elizabeth Taylor, Joan Rivers), performers (David Bowie, Andy Williams), financial titans (John Whitehead, ex-CEO of Goldman, Sachs), fashion icons (Yves Saint Laurent), and entrepreneurs (Alfred Taubman, a shopping mall tycoon and past owner and Chairman of Sotheby's), among others, have sold collections at auction. The inside track to selling a collection is covered in detail in Chapter 6.

- *Masterpieces.* Auctions create a moment in time when the very small pool of buyers with the means and desire to acquire masterpieces must compete for them. Unlike private sales, where it is hard to create a sense of urgency, auctions force bidders to decide whether to participate. Public bidding can also validate for buyers that multiple parties are interested in the work, causing them to bid more.

- *Objects with a price guarantee.* Selling at auction entails risk to the consignor—risk that bidding will not reach the confidential reserve price (the minimum acceptable sale price set by the consignor). Sometimes consignors will only want to sell at auction if they know with certainty that the object will sell for at least a guaranteed minimum price. Auction houses will sometimes agree to offer a guarantee, either alone, or in partnership with a third party. More information on how guarantee deals work is covered in the appendix titled *A Peek Behind the Curtain.*

In the battle to win consignments, auction houses sometimes compete by offering ever higher guarantee amounts. In the fall of 2015, Sotheby's announced that it made a $515 million guarantee to land the Alfred Taubman estate, the largest guarantee in auction history. But the sale of the Taubman Collection performed poorly relative to the guarantee, causing Sotheby's to book a loss and its stock price to swoon. The story of how the largest guarantee in auction history went awry is covered in Exhibit 2.4.

Art Advisors Are a Solution to Art-World Complexity

With so many wonderful things to buy at so many different art galleries, art fairs, and auctions, it is easy to get overwhelmed. Even when a collector knows exactly what she wants—for example, an abstract work by Gerhard Richter—it is challenging sorting through available work and making quality and price comparisons. With choice comes complexity.

At different points in their collecting journey, many collectors elect to use advisors. To demystify the marketplace for art-related advice, let's start with different ways advisors can help collectors:

- *Collection strategy services.* Art advisors can help new collectors decide what to focus on given their interests, their resources, and the time they can devote to collecting. For established collectors, art advisors can help them figure out where to prune or restructure their collection in light of changes in their interests, the art market, or personal circumstances.
- *Buyer support services.* From strategy comes tactics. Art advisors can help collectors source works of art from the marketplace and negotiate price and terms. Chapter 5 is devoted to this topic.
- *Seller support services.* Most art advisors can help collectors buy, but fewer of them are skilled in helping collectors sell. The tricky topic of selling art is covered in detail in Chapter 6.
- *Collection management services.* These are services that help collectors manage and care for their physical art objects. Framing, conservation, installation, and lighting are services art advisors can arrange for clients.
- *Credit services.* Major private banks, plus a growing number of specialty lenders, will lend money based on some combination of the value of a collector's art and other assets. Properly trained art advisors can solicit proposals from credit-market providers so the collector gets the best possible deal.

When selecting an art advisor, collectors need to have a clear picture of the type of assistance they need. If they are primarily interested in someone escorting them through a few art fairs and galleries and helping them buy art for a new home, then they need someone who can deliver a terrific buying experience. But if they have been collecting for a number of years and now need to create an art legacy plan, they need an advisor who can help them think through their options and work closely with their tax, legal, and financial advisors. The sometimes-complicated relationship between art, taxes, and legacy planning is covered at the end of Chapter 7.

Collectors need to make sure the advisors they retain will put their interests first, a so-called fiduciary relationship. Clean and simple. They should always have a written agreement that formalizes this obligation and how the advisor will be paid.[20] By doing so, it will help them avoid the pitfalls I talk

about in "Avoiding the Scoundrel's Corner" sections, which appear at the end of Chapters 5 and 6 and in the appendix.

One final note about art advisors: auction house specialists and gallery employees are important resources for collectors to draw on for information and advice. But it is important to remember that they are sellers' agents, not buyers' agents. The auction house employee is working on behalf of the seller, not the buyer. Likewise, the gallery employee is working on behalf of the artist who consigned work, not the buyer. As a result, advice given by auction house and gallery employees is not fully independent and objective. It is similar to real estate. When you sell your home, the real estate agent you hire is working on your behalf, not the buyer. His or her role is to market the property to potential buyers and sell it for the highest price possible.

* * *

The sexy Modigliani painting of a reclining nude that sold for $170 million was first offered for sale in December 1917 at a Paris show organized by the artist's new dealer. Until then, Modigliani was painting portraits of fellow artists and the habitués of Montmartre, but few of them had the means to buy anything. His new dealer, Leopold Zborowski, a young upstart looking for artists he could mold and turn into selling machines, suggested that Modigliani paint nudes. Given the rakish charms of the artist and his insatiable sexual appetites, the female body was certainly something he knew a lot about. His nudes became painted sex: pubic hair, luscious ripe colors, and a female gaze of pleasure and satisfaction.

Zborowski was new to the art trade and had yet to open his own gallery. But like all good entrepreneurs, that did not stop him. He partnered with Galerie Berthe Weill to host a show of works by Modigliani that included his nudes. The gallery was located across the street from the local police station, which became a convenient way to manufacture some scandal. After putting a nude painting in the storefront windows and encouraging locals to visit the gallery, the police felt compelled to shut it down for acts of moral turpitude. While raising Modigliani's profile, it failed to translate into meaningful sales. Two drawings sold and the gallery bought

some paintings for inventory, but the now-record-breaking painting did not sell.[21]

Modigliani finally started to achieve some commercial success about six months before he died in January 1920. The setting was London, not his adopted hometown of Paris. A London department store still in operation today, Heal's, hosted a group show of works by contemporary artists. Modigliani had more works in it than any other artist, including Picasso and Matisse. Modigliani got the best reviews of his lifetime and sold many works.

But fame arrived too late. He died a few months later at the age of thirty-five. He was essentially a penniless, broken man brought down by his raging egomania, reckless behavior, and a communicable illness—tuberculosis—which he was diagnosed with at the age of sixteen and which he tried to hide from his friends and sexual partners. "People like us . . . have different rights, different values than do normal, ordinary people because we have different needs which put us—it has to be said and you must believe it—above their moral standards."[22] Modigliani was a lifelong abuser of alcohol and drugs, perhaps to help ameliorate some symptoms associated with tuberculosis. He had a temper and a tendency to act out, and he regularly discarded people, especially women. His common-law wife, with whom he already had one child who they left to others to raise, committed suicide the day after Modigliani died by jumping from a building, eight-months pregnant with their second child. It was Jeanne Hebuterne, the subject of the portrait sold at Sotheby's in June 2016.

Modigliani's artistic talents and personal behaviors helped him become one of the most recognized artists of the twentieth century, if not the past five hundred years. When he died, many of the people who were part of his circle sensed that he might be appreciated more after death. His dealer and others with access to his work quickly bought or took title to what they could put their hands on. His artist friends allegedly helped complete unfinished work and created fakes to meet growing demand for his work. Within five years of his death, Modigliani's work was being sold at auction and traded in the private market for multiples of his pre-death prices. His reputation and the prices collectors are willing to pay for

authenticated work have only grown with time, with the wonderful nude painting that was unsalable in 1917 being sold less than a hundred years later for $170 million.

EXHIBIT 2.1
TOP TWENTY-FIVE LIVING ARTISTS BASED ON AUCTION SALES[23]
2011–2015

Rank	Artist (Date of birth)	Value ($million)	Number objects sold
1	Gerhard Richter (1932)	$1,166	1,191
2	Jeff Koons (1955)	380	606
3	Christopher Wool (1955)	324	211
4	Zeng Fanzhi (1965)	268	258
5	Cui Ruzhuo (1944)	224	236
6	Fan Zeng (1938)	177	1,571
7	Peter Doig (1959)	155	227
8	Yayoi Kusama (1929)	153	2,234
9	Richard Prince (1949)	146	321
10	Ed Ruscha (1937)	129	693
11	Damien Hirst (1965)	127	1,435
12	Zhou Chunya (1955)	121	428
13	Zhang Xiaogang (1958)	111	235
14	Robert Ryman (1930)	110	66
15	Wayne Thiebaud (1920)	108	312
16	He Jiaying (1957)	99	432
17	Huang Yongyu (1924)	93	1,089
18	Fernando Botero (1932)	86	326
19	Pierre Soulages (1919)	80	542
20	Liu Wei (1965)	78	209
21	Jasper Johns (1930)	77	559
22	Georg Baselitz (1938)	77	477
23	Cindy Sherman (1954)	74	444
24	Ju Ming (1938)	73	456
25	David Hockney (1937)	73	1,779
		$4.5 billion	

EXHIBIT 2.2
ART GALLERY LEADERS WHO HAPPEN TO BE WOMEN

NAME	GALLERY
Claudia Altman-Siegel	Altman Siegel Gallery
Kristine Bell	David Zwirner Gallery
Mary Boone	Mary Boone Gallery
Marianne Boesky	Marianne Boesky Gallery
Sadie Coles	Sadie Coles Gallery
Paula Cooper	Paula Cooper Gallery
Virginia Dwan (retired)	Dwan Gallery
Barbara Gladstone	Barbara Gladstone Gallery
Marian Goodman	Marian Goodman Gallery
Jeanne Greenberg Rohatyn	Salon 94
Rhona Hoffman	Rhona Hoffman Gallery
Susan Inglett	Susan Inglett Gallery
Alison Jacques	Alison Jacques Gallery
Anke Kempkes	Broadway 1602
Pearl Lam	Pearl Lam Gallery
Margo Leavin	Margo Leavin Gallery
Dominique Lévy	Lévy Gorvy Gallery
Philomene Magers	Sprüth Magers Gallery
Lucy Mitchell-Innes	Mitchell-Innes & Nash Gallery
Victoria Miro	Victoria Miro Gallery
Wendy Olsoff	PPOW Gallery
Penny Pilkington	PPOW Gallery
Eva Presenhuber	Galerie Eva Presenhuber
Shaun Caley Regen	Regen Projects

Janelle Reiring	Metro Pictures Gallery
Andrea Rosen	Andrea Rosen Gallery
Monika Sprüth	Sprüth Magers Gallery
AnneMarie Verna	AnneMarie Verna Galerie
Meredith Ward	Meredith Ward Gallery
Angela Westwater	Sperone Westwater Gallery
Helene Winer	Metro Pictures

EXHIBIT 2.3

EXAMPLES OF GALLERIES WITH A GLOBAL EXHIBITION PROGRAM[24]

Gallery	Permanent Exhibition Spaces	Number of Artists on Website
Gagosian Gallery	New York (5 locations) London (3 locations) Paris (2 locations) Los Angeles San Francisco Rome Athens Geneva Hong Kong	121
Pace Gallery	New York (4 locations) London Paris Beijing Hong Kong Menlo Park Palo Alto	87
Hauser & Wirth	New York (2 locations) London Los Angeles Zurich Somerset	66
Sprüth Magers Gallery	Berlin Cologne London Los Angeles Hong Kong	62
David Zwirner Gallery	New York (2 locations) London Hong Kong (announced)	54

EXHIBIT 2.4
HOW THE LARGEST GUARANTEE IN AUCTION HISTORY WENT AWRY

Alfred Taubman, a real estate and shopping mall entrepreneur, was passionate about art and assembled a large collection of more than five hundred objects. He was also the chairman of the board of Sotheby's at the time of the price-fixing scandal and went to jail because of his role in it.[25] When he died in April 2015, his heirs moved quickly to sell the collection to raise funds for estate taxes and other obligations. Sotheby's proudly announced on September 3, 2015, that it would be selling the collection. But to win it, Sotheby's guaranteed the family would receive no less than $515 million from the sale, the largest guarantee in auction history.

When the first of four auctions of Taubman property failed to perform well, Sotheby's stock price dropped. Once all the sales were completed, total sales proceeds (hammer price plus buyer's premium) were not enough to cover the guarantee amount. Sotheby's had to dig into its own pockets to cover the guarantee amount, a disappointment for Sotheby's employees and its shareholders.

Why was Sotheby's willing to guarantee the collection for $515 million? The Taubman name has been intertwined with that of Sotheby's for more than thirty years, ever since Alfred Taubman bought the company in a leveraged buyout in 1983. Sotheby's felt the Taubman collection was "must win" business. For example, in his 2015 third-quarter-earnings call with securities analysts, the Sotheby's CEO stated that "only [Alfred Taubman's] collection had both the size and the unique importance to Sotheby's shareholders to make this consignment important to win."[26] But Sotheby's crosstown competitor, Christie's, also wanted the business. If successful, Christie's would land a decisive punch and harm the Sotheby's brand.

Specialists at both auction houses worked feverishly over the summer on their proposals. In addition to creating detailed sales and marketing plans, specialists at both firms estimated the likely hammer price for each object in the sale. This analysis, sometimes referred to as the "will make" process, is essential to setting an acceptable guarantee level.

Creating "will makes" for more than five hundred objects is time consuming. The end product is a spreadsheet with a low, midpoint, and high

hammer-price estimates for each object based on specialist input. Senior management then use the spreadsheet to make decisions on different guarantee levels—high enough to win the business but low enough to make money on the sale.

The Taubman family, being especially astute observers of how auction houses work, understood clearly the competitive needs of Sotheby's and Christie's and the process they were going through to determine acceptable guarantee levels. The family probably felt that if the two houses devolved to similar guarantee deals during the back-and-forth negotiating process, then Sotheby's would probably be willing to up its bid at the very end of the process to win it.

No one was surprised when Sotheby's announced in early September that it was selling the Taubman Collection, but the art world was shocked by the size of the guarantee. Rumors passed that Sotheby's guarantee was $50 million higher than Christie's "walk away" guarantee amount. The higher amount probably had less to do with Sotheby's specialists believing they could sell the collection for higher prices than Christie's, and more from a conviction they had to win the business at any cost.

How did Sotheby's market the collection to potential buyers? Sotheby's executed a thorough and exacting marketing plan so that every potential buyer, anywhere in the world, knew about the Taubman sale. From elaborate catalogues, to special pop-up exhibitions of property in different cities around the world, to videos highlighting works from the collection, Sotheby's pulled out all the stops to make the Taubman sale a success.

When did financial markets realize that Sotheby's had a problem? When Sotheby's announced on September 3 that it won the Taubman estate, it did not impact the company's stock price. Between the announcement date and the end of October, Sotheby's stock price remained largely unchanged, trailing somewhat the performance of the S&P 500 over the same period. But in early November, the combination of weak sale results from the first Taubman sale and Sotheby's announcement that it would at best only cover the guarantee amount led to significant downward pressure on the stock. By the end of November, the stock was down almost 17 percent relative to the beginning of September. Poor results from additional Taubman sales,

plus early signs of a weakening in the overall art market, continued to weigh heavily on the stock. By the end of the year, Sotheby's stock price had fallen 24.3 percent from September 1, while the S&P 500 was up 6.3 percent over the same period.

3

Passion and Emotions

Monumental change can begin with a single event—one catalyst that comes to define the start of a new era. Picasso's blue- and rose-period pictures were interesting, if somewhat sentimental, but no one thought of them at the time as radical departures from the past or a precursor of the potential for modernist painting. His breakthrough came in 1907 when he completed *Les Demoiselles d'Avignon* at the ripe old age of twenty-five. It was a large painting of five nude female prostitutes and was supposedly inspired by a Barcelona brothel he liked to visit on a street called Carrer d'Avinyo. Three of the life-size women have almond-shaped faces. The two women on the right have faces inspired by African masks, cut up into angular shapes and cubes. When Picasso showed this first cubist painting to his inner circle of fellow artists, dealers, and collectors, the shock of the new style quickly established him as the leader of Modern painting: an avant-garde wild beast, a mantle he proudly carried for the rest of his life. On the hundredth anniversary of the painting, *Newsweek* described it as the most influential work of art of the last one hundred years.[1]

It wasn't a painting, but instead the actions of a passionate collector in New York City on October 18, 1973, that heralded the beginning of a new era in the art world: a hyper-commercialized art market focused on promoting and selling contemporary art.[2]

The United States was gripped by political turmoil in 1973. The Watergate scandal was growing in importance every day. H. R. Haldeman and John Ehrlichman, two of Nixon's closest advisors, resigned in April. Spiro Agnew, the vice president, followed shortly after when he resigned on October 10,

1973. Nixon would hold on for another year before resigning on August 8, 1974. The stock market was swooning. In the first eight months of 1973, the Dow Jones Industrial Average fell almost 20 percent, followed by a "dead cat bounce" of 15 percent over the next two months, before returning to free fall. The economy officially entered a recession in November.

To make matters worse, Syria and Egypt, in coalition with other Arab states, launched a surprise attack on Israel on October 6. In what came to be called the Yom Kippur War, Nixon delivered within days of the attack weapons and supplies to Israel after the Soviet Union began sending arms to Syria and Egypt. The Organization of Petroleum Exporting Countries (OPEC) stepped into the battle on October 16 when it announced an increase in the posted price of oil and a cut in production in retaliation for US support of Israel. On October 19, Libya announced that it would embargo oil shipments to the United States. Saudi Arabia and other Arab oil-producing countries joined the embargo on October 20.

New York City, like much of the rest of the world, was in turmoil. At the time, the city was a gritty and dangerous place. Close to 1,700 people were murdered in 1973, almost five times that of 2015. Williamsburg was a desolate stretch of the Brooklyn shoreline, a far cry from the affluence and trendy crowds that rule the area today. There was no Chelsea gallery scene. The High Line was a decrepit and abandoned train line where you went to score drugs or find a prostitute—only if you didn't feel like going to Times Square, Thompkins Square Park, or Prospect Park to find similar diversions. The World Trade Center was dedicated in April of that year. But after years of cost overruns and few commercial tenants who wanted to move downtown, it was a white elephant bleeding cash. The city subways were filthy, covered with graffiti, and dangerous except during rush hour. None of them were air-conditioned, which added to their charm in the summer months.

As strange as it seems today, one of New York City's cottage industries in 1973 was the American contemporary art market. Because so few people were interested in buying contemporary art, not that many galleries were in operation. Those that existed tended to be clustered around 57th Street and the Upper East Side.[3] SoHo was just beginning to emerge as a gallery center. Because the buyer base nationwide was so small, it was difficult to run a gallery outside New York City. Christie's, one of the major auction houses

today, had yet to hold its first auction in the United States; that would have to wait until 1977. Art Basel, which we now think of as a global contemporary art fair juggernaut, hosted its first fair in Basel, Switzerland, in 1970. In 1973, it was a curiosity to the few American collectors who were aware of it.

Even museum shows devoted to contemporary art were downright homespun. The catalogue for the 1973 Whitney Museum Biennial Exhibition, for example, listed the addresses of the artists in the show so you could contact them directly. The list included John Baldessari, Lynda Benglis, Louise Bourgeois, Jasper Johns, Brice Marden, Joan Mitchell, Robert Smithson, Frank Stella, and others. You could also go up to the Information Desk in the lobby and ask for the prices of the works in the show. A Joan Mitchell painting titled *Bonjour Julie*, for example, had an asking price of $17,000 (or $92,000 in current dollars). It was a huge painting, almost nine feet by nineteen feet, that Mitchell painted in 1971 shortly after moving to a larger studio.[4]

For those with the means and desire to collect contemporary art, the art world before October 18, 1973, was a pleasure palace. You could spend a few hours on Saturday visiting galleries and museums and confidently stay on top of things. Maybe you read one art-related magazine a month. There were no art advisors to speak of, because the art world was just not that complex. Because not that many people were buying, galleries would immediately befriend you if you bought work from time to time. Art was far less expensive. Your friends may have snickered behind your back at what you were buying, but if you were serious about the work, then it was easy for you to meet and befriend artists. The inside world of artists, parties, galleries, and collectors was intoxicating. The only downside was that the artwork had an unknown value on the secondary market. In fact, there was not much of a secondary market for contemporary art. The gallery where you bought it may try and resell it for you, but it was focused on making ends meet by selling new work by the artists it represented. Moreover, the notion of flipping was not part of the collector mind-set: you bought it and held it. Auction houses were not particularly interested in selling contemporary art either, because they believed the buyer base was too small and the honeypot was in Old Master, Impressionist, and Modern paintings. Events on October 18, 1973, disproved all of that.

It was a collector, not a gallery or artist, who changed things. Born on the Lower East Side in 1916 to Russian immigrant parents, Robert Sokolnikoff, who shortened his name to Robert Scull, dropped out of high school during the Depression to help his family make ends meet.[5] In his spare time, he took art classes and over time helped put food on the table as a freelance illustrator and designer. Despite finding little success in those pursuits, he married well. His wife's family owned and operated a successful taxi fleet company called Super Operating Corporation. Lore has it that when the future Ethel Scull brought Robert home to meet her parents, her mom immediately started contacting old boyfriends to try and head off what looked to her like a terrible marriage prospect. They married anyway. He got involved in the business and ultimately ended up running it. The business was very lucrative and enabled the couple to live a large and glamorous life of parties and collecting, centered around their apartment located across the street from the Metropolitan Museum of Art at 1010 Fifth Avenue.

While Robert may have been an indifferent illustrator, he certainly understood how to use branding, PR, and the media to promote his fleet of 135 taxis and four hundred drivers. Using radio and TV commercials and a distinctive logo, New Yorkers came to know the renamed Super Operating Corporation as Scull's Angels. He was gifted in generating publicity, an early-days Kris Kardashian Jenner. He hired Amy Vanderbilt, an authority on etiquette, to teach manners to his cab drivers. Scull sent all his drivers an invitation to join him at the Waldorf Astoria for the lecture. One of his taxis was installed in the east foyer of the hotel to act as Vanderbilt's podium for the event. The press, of course, was invited, loved the stunt, and showered the event with publicity that helped advance the Scull brand.[6]

Tom Wolfe, the author of *Bonfire of the Vanities* and *The Right Stuff*, among other books, once described Robert and Ethel Scull as "the folk heroes of every social climber who ever hit New York."[7] Perhaps a harsh and unfair indictment, at least when applied to their art collection. By all accounts, Robert and Ethel loved looking at and buying contemporary art. They befriended artists and supported them when others were not buying their work. Their relationships with artists also provided them with access to the best work their artist friends produced and tips on other artists to follow. "But it was Bob who was the heart and soul of the operation, who

commissioned the works and could not live without them," said Judith Goldman, an expert on the Scull Collection.[8] Collecting was a competitive sport for Scull. He was interested in the best of what was new and relied on his own eye and taste. He fell in love first with Abstract Expressionism and counted Willem de Kooning, Franz Kline, and Barnett Newman as friends.

His next love affair was Pop Art. Through their friendship with Jasper Johns and his dealer, Leo Castelli, the Sculls acquired twenty-two works by the artist. Robert hunted down and bought major work by Warhol, Lichtenstein, Oldenburg, Rosenquist, and a list of other artists who are now in the history books. His third and final love affair was with a group of artists challenging notions of what could be deemed a work of art. He funded a series of massive earthworks that Michael Heizer created in a remote desert in Nevada. He also bought early work by Bruce Nauman and Walter de Maria, two other artists who are now recognized as some of the most important artists working in the second half of the twentieth century. By the early seventies, after about twenty years of collecting, everyone in the small art world knew the Sculls. Because they were publicity hounds and used art to burnish their public personas, everyone who read the social pages was also up to date on the comings and goings of the glamorous Sculls.

Sometime in 1973, Robert Scull decided to sell part of the collection. Many years later, when Ethel and Robert were adversaries in bitter divorce proceedings that went on for more than ten years, Ethel said that Robert told her he wanted to sell things "at the top of the market."[9] But given Robert's taste for publicity, this sale would be unlike anything before it. October 18, 1973, was to become the first blockbuster sale of contemporary art, fed by a PR and marketing campaign that brought the curious and the committed from around the globe.

Robert was the sale impresario. He selected fifty artworks by twenty-six artists and titled the sale *A Selection of Fifty Works from the Collection of Robert C. Scull.* All but two of the artists were alive at the time, the exceptions being Franz Kline and Barnett Newman. Six works by Jasper Johns were in the sale, along with three paintings each by Willem de Kooning and Andy Warhol. Scores of great works by other artists including Cy Twombly, Claes

Oldenburg, Frank Stella, Philip Guston, and Jim Rosenquist were on offer. The catalogue for the sale, which was a hardbound book with multiple fold-out pages illustrating the works, was lavish for the times.

We have become so accustomed to auction sales of work by living artists that it is hard to imagine how unprecedented and deeply threatening the sale was for artists and their galleries. Would the buyers show up? Would the work sell for prices below what the galleries were asking for comparable work?

Because Christie's had yet to cross the pond, Sotheby's was the only game in town to host the auction. Robert negotiated a sale agreement that involved Sotheby's providing a guarantee.[10] Because Sotheby's used guarantees selectively to win Old Master consignments, and the occasional Picasso, guaranteeing an auction full of work by living artists was new and risky. Once the deal was signed, Scull and Sotheby's then turned their talents to promoting the sale. Presale exhibitions were held in Switzerland and other locations followed by numerous parties when the works went on display at Sotheby's Madison Avenue location on October 12. Behind-the-scenes press tours were offered, which created great presale coverage. Documentary filmmakers were also there to record events. The resulting film, *America's Pop Collector: Robert C. Scull*, is a wonderful, quasi-exposé of a moment in time and a precursor of today's reality TV shows.[11]

The night of the auction was replete with artifice and drama. The Sculls arrived in a chauffeur-driven taxi with Ethel wearing a black dress by Halston emblazoned with the Scull's Angels logo. All great spectacles draw crowds. Because it was the seventies, it was also a platform for protest. Taxi drivers blocked the Sotheby's entrance with signs saying "Robbing cabbies is his living/buying artists is his game" or "Never trust a rich hippy." The Art Workers Coalition, a group formed in 1969 to pressure museums to change their exhibition practices, among other demands, staged a protest. A group of artists protested that work by only one woman, Lee Bontecou, was included in the sale.

It took about an hour for the lots to sell, with cheers and applause from the room as lot after lot sold for a record price. A Jasper Johns painting titled *Double White Map* that Scull bought for $10,500 went for $240,000. A Cy Twombly painting that he bought for $750 went for $40,000. A painting by

Willem de Kooning called *Police Gazette* sold for $180,000. Extraordinary prices for the time. In total, the works sold for $2.2 million.

Coverage of the sale quickly became an echo chamber of the personal themes of different market participants. Art critics tended to lambaste the Sculls for profiteering and putting notoriety and attention above cultivation of the art; artists protested that they were not getting any proceeds from the sale and agitated for artist royalties; galleries expressed disappointment that collectors who claimed to be in love with the art were selling it in such a crass and bombastic way (but perhaps more importantly, not trying to sell it through them). Whatever their complaints, the sale shouted to the world that is was now possible to sell great examples of American contemporary art for spectacular prices. As one critic described it at the time, ". . . nowhere are the profits so immense, or realizable in so short a time, as in the art market. As a matter of fact, Scull is a kind of genius. Not necessarily even a financial genius, but a genius of timing and promotion. The Sculls are in many ways pop creations, 'living sculpture' if you like."[12]

But what no one at the time could possibly have understood was that the auction was just the beginning of an almost uninterrupted forty-year "bull market" for American Postwar art. The $2.2 million spent that night, which in current dollars is about $12 million, is small change relative to the value of these works today. The 1955 de Kooning painting that sold that night for $180,000 sold again in 2006 for $63.5 million when Steve Cohen bought it from David Geffen.[13] The value of that work has continued to rise, due to a slightly larger painting by de Kooning from the same year with similar imagery being sold in 2015 for a staggering $300 million.[14] If the Scull auction could magically be held today, what would the fifty works in it be worth? Robert Manley, worldwide cohead of Twentieth-Century and Contemporary Art at Phillips, believes "if the storied Scull works were to come up for auction again, they could realize in the neighborhood of $1 billion." All at once, the art world had changed.

* * *

Robert and Ethel Scull were extraordinary collectors. Building on their story, the purpose of this chapter is to share insight and teachings about being an effective collector. I start by answering the primary question: Why

do people collect art? From there, I describe the different types of collectors active in the marketplace today and share the story of Frances and Michael Baylson, connoisseur collectors of art books and printed materials created by Matisse. Advice from seasoned collectors comes next, including the accumulated wit and wisdom from a major collector who wishes to remain anonymous. I then review how recent collecting trends are impacting the market, including the curious case of Taek Jho Low, otherwise known as Jho Low. The now-notorious Malaysian national was willing to spend extravagantly during the recent boom years, only to see the value of works in his collection fall precipitously. Given the important role of auction houses in the art market, I close with Dan Loeb, a collector and activist shareholder who invested close to $300 million in Sotheby's in a quest, as yet unmet, to transform it into a more profitable enterprise.

AN ITCH TO SCRATCH

Passionate collectors rarely start that way. They usually begin buying art because they have a home to decorate, perhaps some of their friends are collecting, or maybe they have come into some money. This phase of experimentation can be short or long. But at some point, collectors tend to choose something to major in ("I want to collect works by an artist associated with American Modernism") and perhaps something to minor in ("My wife and I also like photography, so we decided to collect contemporary fashion photography").

Based on my time with collectors, their motivations fall into three categories: material, emotional, and social.

Material

- *The need to possess.* The proliferation of digital images makes the act of viewership more mundane—appreciation alone is now within reach for all art lovers. Collectors want to own something, rather than just experience it digitally, in books, or at museums. Possession satisfies a need to control and experience a work of art on terms decided by the collector.
- *The need to accumulate and diversify wealth.* Great works of art can sometimes serve as a long-term store of value. The adage of "buy what

you love" ignores an important motivator, which is to purchase works with the potential to appreciate in value over time. No one buys art with the expectation that it will fall in value.

- *The need to compete.* Building a collection is a competitive activity requiring both means and desire. A collection also becomes yet another way for people to judge others (e.g., "Sally and John have an interesting collection, but no one would ever accuse them of being connoisseurs.") and vice versa.

Emotional

- *The need for sublime experiences.* Collecting is fun, a counterpoint to the demands of daily life. For dedicated collectors, owning work by artists they love can be a deeply meaningful experience.
- *The need to learn.* Collectors love to learn. Most can easily explain the rationale behind their love for the artists or genres they collect. Just as the history of art is about winnowing down the artists who were most influential, the history of the art of our time is still being written. Many contemporary art collectors are excited to be part of an unwritten and uncertain narrative.

Social

- *The need to connect and share.* Collectors generally enjoy spending time with other collectors and specialists in their fields of interest. Through discussion and socialization, they add to their body of knowledge and enjoy the company of like-minded individuals.
- *The need to express taste and wealth.* The world is full of ways to spend money: expensive clothing, homes, modes of transportation, jewelry, and so on. Art is unique in its ability to convey the wealth of an individual and his or her taste and knowledge.

Most collectors are driven by a handful of these needs. Collectors who are especially honest with themselves about the needs they are satisfying through collecting seem to have the most fun.

DIFFERENT COLLECTOR SPECIES

Before becoming a collector, most start as art enthusiasts. They want to be involved in some way with the art world and have some fun. More people than ever before fall into this category. The art world has benefited enormously over the past twenty-five years from a huge influx of interested parties. Many start buying because they have a home to decorate. They buy until the walls are filled, and then stop, perhaps never to buy again. Art galleries and auction houses sell a lot of works to art enthusiasts. From small to extravagant budgets, they represent a very large part of the art market.

While the journey from art enthusiast to passionate collector can be short or long, once there, collectors tend to fall into one of three categories:

Connoisseur Collectors

These are the collectors who are especially drawn to the emotional aspect of collecting. Because they enjoy learning, they tend to spend a lot of time studying everything possible about their collecting area(s) of interest. They seek out experts in their fields of interest, especially museum curators. The walls of their home(s) tend to be filled with art books and catalogues. Almost everything they buy is for a specific reason so, when asked, they can quickly and eloquently speak about the history behind every object in their collection. They tend to have strong points of view on what makes for an important work of art. Their independence of thought, borne from studying and looking, enables them to collect where others may have been heretofore reluctant to go. They enjoy spending time with other passionate collectors, but they can be dismissive of collectors they meet who may have valuable collections but who bought without passion or knowledge and relied extensively on art advisors or galleries to influence their tastes. The collecting themes of connoisseur collectors vary widely, from those who collect work primarily by one artist, to those who focus on a specific art movement or time period, to those who focus on a specific medium.

Masterpiece Collectors

These are collectors interested in the best work possible by an artist. The notion of owning the best is more important than allegiance to a particular collecting category. Their collections can be quite eclectic. For example, they may have a handful of masterworks by European modernists like Picasso and Leger hanging in their dining room with a few Renaissance bronze sculptures on the credenza, and a selection of drawings by Goya and Warhol in a hallway. What knits the collection together is a focus on having as close to A-level works as possible by all the artists in their collection. Being a masterpiece collector today in mainstream collecting categories like twentieth-century art requires great wealth. But there are more masterpiece collectors than ever before. Luckily, it is still possible to be a masterpiece collector without having extraordinary financial resources, but it requires exploring under-known or overlooked collecting themes.

Marketplace Collectors

These are collectors who love art and enjoy collecting it but tend to buy only work by established artists who have been validated by the marketplace. They devote less time to collecting than connoisseur and masterpiece collectors and tend to rely more on advisors for research and input on what to do. They particularly enjoy the social aspect of the art world and the experiences they have with artists and gallerists. Most of what they collect is by the artists of well-known galleries who exhibit at the major art fairs. Marketplace collectors may have the capacity to buy at the same level as masterpiece collectors but generally elect not to because the sometimes-subtle differences between an A-level and a B-level work is not meaningful enough to them relative to the incremental cost.

While masterpiece collectors are driving the very top end of the market, connoisseur collectors are the "heart and soul" of the art world. Frances and Michael Baylson illustrate the passion and diligence of connoisseur collectors.

Frances and Michael Baylson: Connoisseur Collectors of Matisse Art Books and Printed Materials

Henri Matisse, born in 1869, is a giant of twentieth-century art. His uses of color, pattern, and fluid line has captivated viewers since he started showing his work in 1904. By the time he was diagnosed with abdominal cancer in 1941, his paintings, sculptures, drawings, and prints were in private collections and museums around the world. While surgery immobilized him that year and kept him chair- or bed-bound for the rest of his life, his spirit was undiminished. He embarked on what he referred to as his second career as an artist, inventing his celebrated paper cutouts. These works, which he started when he was in his early seventies, were the subject of a recent retrospective at the Museum of Modern Art in New York and the Tate Modern in London. Less well known, Matisse also spent countless hours during his "second career" creating wonderful illustrated books that combined poems and text from authors he admired with his special brand of visual imagery. Assembling a complete collection of these books and related materials became the forty-year obsession of the Baylsons.

Frances and Michael Baylson independently found their way to Matisse when they were in college.[15] For Michael, it was a 1960 visit to the Barnes Foundation when he was a college student at Wharton. "My visit to the Barnes was an eye-opener, a life-changing experience. . . . I was overwhelmed by the literally overarching beauty of the huge *Dance* by Matisse in the most prominent spot, framing the upper-story windows."[16] For Frances, her senior thesis was on Matisse's sculpture. He went to law school, and she became an MD.

By the 1960s, Matisse was expensive. How in the world could the salaries of a young lawyer and a new doctor enable them to collect Matisse? Michael came up with a clever idea:

> I thought Matisse the greatest artist of the 20th century, and I wanted to focus on building a Matisse collection that would be unique and limited to a relatively unknown area of his work. As I quickly discovered, his paintings and drawings were way beyond our means, and his graphics, although attractive, were also widely known and frequently available

to the highest bidder at auctions of modern prints. Matisse's illustrated books were the undiscovered nuggets – elegant but not yet costly.[17]

Like many connoisseur collectors, the Baylsons read everything they could find on Matisse and his career, hunted high and low for items to add to their collection, and pursued their passion in a quiet and private way.

After Frances and I were married in 1969, I began the pursuit of books by and about Matisse with the limited (but growing) funds of a young Philadelphia lawyer. Over the course of 40 years, after scouring dusty shelves in many old bookstores as well as catalogues from auction houses and many book dealers in many countries, I built a unique and complete collection of all the books designed and illustrated by Matisse, plus almost all of his original illustrations for other books, in addition to hundreds of monographs, dozens of catalogues, and a quantity of ephemera. In this way I have assembled the material to trace the artistic development of this consummate artist of the book. As proud as I have been of our collection, I have revealed to very few my interest in these books. It has been a reclusive pursuit. I discovered that the pursuit of old books was not very common, and that the overall supply was plentiful enough that catalogues and monographs, the two principal types of books a collector could find about artists, were not unduly expensive. Those items acquired by mail were delivered to my office and transported to our home without Frances's knowledge. My acquisitions—quiet, selective and somewhat secretive—were accumulated and stored in a locked metal cabinet in a seldom visited third-floor closet in our home. Periodically these were gradually given, as surprise birthday or anniversary presents, to Frances, to become part of our collection.[18]

Like collectors before them, the Baylsons had to make legacy decisions. In 2010, they elected to donate their entire collection to the Morgan Library and Museum in New York. They were drawn to the museum, founded in 1924 by the son of another bibliophile, J. P. Morgan, because of its long history of collecting, preserving, and displaying historical manuscripts, early printed books, and Old Master drawings and prints. In 2015, the museum celebrated

the donation of the Baylson collection and the scholarship it stimulated by organizing a show titled *Graphic Passion: Matisse and the Book Arts* and publishing a catalogue documenting this previously under-known aspect of Matisse's career. No doubt a proud moment for the Baylsons and a wonderful illustration of how a single idea can drive an entire collection.

WISDOM FROM SEASONED COLLECTORS

Collectors are sometimes willing to share their hard-won wisdom and advice on how to be an effective collector. When I step back from all the conversations I have had over the years with collectors on this topic, a handful of important themes emerge:

Find an area of focus. Pick at least one focus area. Because looking and learning is so important, collectors risk being taken advantage of by the marketplace if they flit from one area to another. The art market is truly a buyer-beware marketplace; focus helps level the playing field for collectors.

Develop visual acuity. Spend as much time as possible looking at art in museums, art fairs, galleries, and auction-preview exhibitions. Time spent flipping through books and looking at images online counts too. The art version of the old joke "How do you get to Carnegie Hall? Practice, Practice, Practice" is "Look, Look, Look." By acquiring visual acuity, collectors will understand the artists that really tickle their brain, enable them to distinguish between a good and great work by an artist, and gain an appreciation for the relative importance of an artist to the movement or time period in which he or she was active.

Buy with your eyes and *ears.* The old chestnut of "buy what you love" is generally terrible advice for new collectors. They do not know enough yet to know what they really love, so they can waste a lot of money on infatuation. If the amount of money a collector is thinking about spending on a work of art is not meaningful to him, and if it fell dramatically in value, he would not be fussed, then he should go ahead and buy based on presumptive love. But before buying something that is financially meaningful, he should seek input from those with more knowledge and experience. Input can come from many different places: a local museum curator, other collectors he has gotten to know, an art advisor. He needs to listen carefully to what is both

said and implied, because most people are reluctant to "call a baby ugly." Ears are sometimes more important than eyes when buying art.

Stretch for A works. This does not mean you have to join the super-rich club to be a collector. But if a collector is priced out of buying a great painting by a certain artist, she should avoid buying something mediocre just to have a painting by that artist. Consider instead buying a great drawing. If great drawings are too expensive, then consider buying a great print or buying work by a related artist.

Upgrade over time. No matter how astute and devoted they are to collecting, collectors make mistakes. Everyone does. Use these experiences to learn but also to upgrade a collection. Selling work is not a sin but rather an important way to help finance additions to a collection. A very small, but inordinately vocal, group of collectors pride themselves on never selling anything. There is nothing wrong with that, but it is just not what most collectors can do.

Support a museum. This is an essential part of being a collector. Museums are repositories of knowledge and objects and deserve and require the support of collectors.

Wit and Wisdom about Art Collecting

Harry, who asked to remain anonymous, is an extraordinary collector. He started out almost thirty years ago as an art enthusiast looking to decorate a new home that he and his wife had bought. But the pursuit of art and objects quickly became for him the pursuit of perfection. For example, when buying a mirror, it became an opportunity to learn about the history of mirrors and how to distinguish the good from the great. This involved not only reading about the history of mirrors in his free time but also finding the best private dealers in the world and studying auction records to understand how the public market priced mirrors from different periods. Only when he understood what "the best" meant, and what it would likely cost, could he then commit to buying the best when it became available.

He applied this sense for learning and exploration to many collecting categories, including twentieth-century paintings by European modernists, Chinese ceramics, and Old Master paintings. Relative to buyers

today who hunger for things quickly, Harry has been patient and slow in his buying. But when you walk through his home now, it is a cornucopia of paintings, sculptures, and decorative art of the highest order linked by perfection.

While collecting art and objects, Harry also collected wit and wisdom about the marketplace. Whenever something occurs to him, or he hears a new pearl of wisdom, he adds it to a document he calls *Art Wisdom*. With his permission, I share below some of my favorite witticisms from his manuscript:

- There is plenty of information but not enough knowledge in the art market.
- Buyers are over-informed but undereducated.
- Collecting art is more an investment of time than of money.
- Rarity is common; quality is rare.
- What you buy is more important than what you pay.
- Only art that makes money finds its way into textbooks.
- Your taste grows with knowledge.
- The most expensive is not always the best, but the best is always expensive.
- Success breeds imitation, and imitation breeds mediocrity.
- Some people acquire reputations much greater than their achievements.
- One price is a record; two is a trend; three equals a market.
- Things move from being uncrowded to being crowded and from unconventional to conventional.
- Look more than a few seconds at a work of art—and half of that at the label.
- It is not difficult to have new ideas; it is more difficult to get rid of old ones.
- People with happy private lives and backgrounds rarely become obsessive collectors.

Harry tries to spend some time every day looking at art for inspiration, for ideas, for a sense of history. He is constantly training his eye, ten minutes one day, two hours the next, and maybe a weekend visit to a museum. Having a highly informed and educated eye is extremely important to him. Because he remains an active collector, he is also constantly challenging himself about

whether to buy a specific painting or object. The punch list of questions he uses to help him make that decision include the following:

- What makes this object special?
- Is it good enough for you?
- How does it compare to other pieces?
- Would you actually prefer another piece?
- It is beautiful or only important or rare?
- Is this the piece you have been dreaming about?
- Do you want to impress somebody else with this piece?
- Are you pressured to buy it by a dealer, friend, or advisor?
- Why do you want to buy it?
- What exactly do you like about it?
- What are the arguments for and against buying it?
- Does it add something to the collection?
- Does it fit into the collection?
- How and where would you display it?
- What is its condition?
- Is it of the right period?
- What is the provenance?
- Is the piece hyped or overexposed, and what are the reasons for that?
- Why did it not sell at auction or by the dealer?
- Is the estimate or the price justifiable?
- If you were to steal one, which one would it be?

For many collectors, this type of questioning and scrutiny over every purchase would be exhausting and take all of the pleasure out of collecting. But for Harry, a connoisseur collector of masterpieces in multiple categories, it brings peace of mind and happiness.

THE PRICE OF PERFECTION

I shared in the last chapter why the demand for art has increased and why now is the best time in history to be an artist. Building on those sections, I

want to touch on four recent collecting trends that are having an especially important impact on the art market.

Homogenization of Collector Tastes

With so many people interested in collecting art, and with so many choices on what to buy, more collectors than ever before rely on art advisors. But instead of creating great diversity in what people buy, it seems to have promoted a homogenized view of what to collect. Because new collectors often feel uncertain about what to buy, many have a natural predisposition to focus on well-known artists. Their art advisors are often only too willing to reinforce this by recommending their clients buy recognizable work by known artists.

Collectors Quickly Going from Zero to One Hundred Miles per Hour

It used to take time for new collectors to become comfortable increasing their spending to acquire important works of art. But with information and art advisors now so readily available, the cycle has shortened for those with a predisposition to collect. Many new collectors will transition quickly from buying a few mid-priced works to spending much larger sums of money. With ease of access and advice comes the ability to feed a passion more quickly and emotionally.

Collectors Acutely Focused on the Value of Their Collection

Collectors are acutely interested in the value of what they own and love to talk and speculate about which artists or sectors of the art market may see appreciation and those poised for a correction. Many of them are looking for analytic tools that will help them understand the health of the overall art market and that of individual artists so they can try to more effectively time their consignments and purchases.

Collectors Willing to Pay Extraordinary Sums for Exceptional Works

The well-known collector Ronald Lauder uses a three-level scoring system to evaluate works of art. When seeing something, does he say "Oh," "Oh my,"

or "Oh my god"? Even great artists have very few "Oh my god" works, but as more collectors aspire for the best, the spread between an "Oh my" and an "Oh my god" work of art has grown enormously. Perfection comes with a huge price premium, as illustrated by the recent sale of a work by Kurt Schwitters.

Born in Germany in 1887, Schwitters was a key member of an early twentieth-century avant-garde art movement called Dada. He is known for collages that incorporate found objects like newspapers, wire, nails, and pieces of wood. His work was ridiculed by the Nazis and included in the notorious Degenerate Art exhibition held in Munich in 1937. Schwitter's work influenced many artists, including Robert Rauschenberg. His work now graces the walls of the Museum of Modern Art (MoMA) and many other museums around the world. A prolific artist, work by Schwitters is frequently for sale at auction and at art fairs. But art-historically important works rarely come to market, because most of them are already in museum collections. Approximately five hundred works were offered for sale at auction over the past twenty years; six sold for between $1 million and $2 million with everything else selling for far less. But a large, colorful work from 1920 titled *Ja - Was? - Bild* was offered for sale in June 2014 with a presale estimate of $6.6 to $10 million. The work embodied everything a masterpiece collector could possibly want in a great Schwitters. It sold at auction for a new world record of $23.7 million.

While artwork perfection is extraordinarily expensive, it can be extremely risky to buy masterworks if the new owner is forced to resell them quickly, as revealed by the actions of the now notorious Jho Low.

Jho Low: The Curious Case of Nightclubs, Real Estate, and Art

Club promoters in New York and Las Vegas competed intensely for the attentions of Taek Jho Low in 2009, otherwise known as Jho Low. The baby-faced, twenty-eight-year-old Malaysian national was spending up a storm on table service and parties. Stories passed of his spending $160,000 one night at Avenue, a Manhattan night club and, on another night, sending Lindsay Lohan twenty-three bottles of Cristal when she was celebrating her twenty-third birthday at 1 Oak, a different celebrity-fueled club.[19]

Soon the Malaysian financier moved from clubs to real estate, spending serious money on super-luxury real estate: $24 million in 2010 for an

apartment at the Park Laurel in Manhattan with sweeping views of Central Park; $30.6 million in 2011 for a seventy-sixth-floor penthouse in the Time Warner building that was once home to Jay Z and Beyonce; and $17.5 million for a Beverly Hills mansion.[20]

Around the same time, he became the catnip of the art world, a buyer with the means and desire to acquire extraordinarily expensive works of art by Modern and Contemporary artists. In 2013 and 2014, he spent an estimated $200 million to buy works by Pablo Picasso, Lucio Fontana, Mark Rothko, Jean-Michel Basquiat, and Claude Monet.[21] For example, in May 2013, he bought at auction a 1982 painting by Jean-Michel Basquiat titled *Dustheads*, paying a world-record price of $48.8 million. Six months later, he bought a 1982 drawing also by Basquiat titled *Head of Madman* for $12 million and a 1935 painting by Picasso titled *Tete De Femme* for $39.9 million. He liked brand-name artists and seemed to have no price-point barriers. But his desire for art was apparently born more from a need to own trophies than from any real appreciation or interest in art. He bought primarily at auction or through a very short list of private dealers and squirreled away his treasures in warehouses in Geneva, Switzerland.

Where did the wealth come from that enabled someone so young to spend such extravagant sums on clubs, real estate, and art? Jho Low grew up in George Town, the capital city of the Malaysian state of Penang, attended a boys' boarding school in London, and then entered university at the Wharton School in Philadelphia. While at school, he appeared to have a knack for developing relationships with Malaysian and Middle Eastern business and political figures, especially the stepson of the Malaysian prime minister. After school, Low got involved in different Malaysian real estate transactions before setting up Jynwel Capital in 2010, a Hong Kong–based investment advisory company. Low's profile changed dramatically in 2015 when the *Wall Street Journal* reported on Low's potential involvement in an evolving Malaysian corruption scandal involving the Malaysian prime minister (Najib Razak), his stepson (Riza Aziz), and 1MDB, a multibillion-dollar Malaysian sovereign wealth fund run by the prime minister.[22] Government investigators in Malaysia, Switzerland, Singapore, Hong Kong, and the United Arab Emirates were all soon looking into allegations of misappropriation of funds and money laundering.[23]

Some of these investigations came to a head in July 2016 when US prosecutors filed a lawsuit seeking the return of more than $1 billion in assets they believe were fraudulently diverted from the 1MDB fund in a scheme orchestrated by Jho Lo and Riza Aziz, among others. Prosecutors believe "The funds diverted from 1MDB were used for the personal benefit of the co-conspirators and their relatives and associates, including to purchase luxury real estate in the United States, pay gambling expenses at Las Vegas casinos, acquire more than $200 million in artwork, invest in a major New York real estate development project, and fund the production of major Hollywood films."[24] In a bizarre twist, some of the purloined funds allegedly went to finance the production of *Wolf of Wall Street*, the 2013 movie starring Leonardo DiCaprio about a crooked stockbroker. Jho Lo was apparently the intermediary who connected DiCaprio, an art-collecting buddy with whom he partied, with the Malaysian prime minister's stepson who ran the Hollywood production company that financed the movie.[25] Low has denied involvement in any of the allegations.

Masterworks can sometimes be a good long-term store of value, but not if flipped quickly. Early in 2016, Jho Low sold the three artworks mentioned earlier—the Basquiat painting and drawing and the Picasso painting—that he acquired for a total of $100.7 million.[26] Buyers are generally quite suspicious of record-setting works coming back quickly to the market. Was the record simply a function of two bidders going crazy one night, with the seller now having buyer's remorse and the underbidder nowhere to be found? In the case of the three Jho Low works, the exceptionally small pool of people with the means and desire to acquire work by Basquiat and Picasso were not biting. None were willing to stretch to acquire the works, resulting in Jho Low selling them for $71.5 million, almost $30 million less than what he paid for them two years before.

* * *

You can always rely on Oscar Wilde to be clever and pithy: "When bankers get together for dinner, they discuss art. When artists get together for dinner, they discuss money." It is as true today as it was in the second half of the nineteenth century when Wilde penned it. Every year, *ARTnews* publishes its list of the top two hundred art collectors in the world. When you parse the

lists for US-based collectors, it is uncanny how many are leaders in the world of finance: hedge funds, private equity, venture capital, insurance, investment banking, asset management, and wealth management.

One name that stands out is Dan Loeb. He is the CEO of Third Point, an asset management firm he founded in 1995. Loeb and his wife collect contemporary art. But he is best known as an activist shareholder investing in what he deems to be underperforming companies and then mounting public campaigns to replace management, implement new strategies, and improve operating performance. In one recent example, Third Point accumulated a stake in Yahoo in the fall of 2011. Loeb then mounted a campaign to shake up the company, which led to Loeb and two of his colleagues joining the board and the CEO being replaced by Marissa Mayer. In July 2013, Third Point sold two-thirds of its Yahoo stake back to the company for a tidy profit. As part of the deal, Loeb and his colleagues left the board. Other companies he has targeted include Dow Chemical, Sony Corporation, and the biotech giant Amgen.

Improving underperforming companies requires someone like Loeb to be constantly on the prowl for new prey. In August 2013, he leveraged his experiences as an art collector and activist shareholder to launch a campaign for change at Sotheby's, the only art-related public company. Combining business with pleasure can sometimes be a recipe for happiness, but the campaign he launched that August has so far resulted only in disappointment for his investors.

Third Point announced its intention to agitate for change at Sotheby's when it filed Schedule 13D with the SEC on August 26, 2013—such a benign-sounding name for a form that can move markets. Because Sotheby's is a publicly traded company, the SEC requires those who own 5 percent or more of the common stock to inform the market that they have accumulated a position of that size. On August 26, Third Point let the market know it spent $157 million to acquire a 5.7 percent stake in Sotheby's at an average price per share of approximately $40. Moreover, it said it intended to engage in a dialogue with Sotheby's and other shareholders about potential changes in strategy and leadership.

Because it was Third Point doing the filing, the market knew fireworks were coming. Sotheby's took immediate steps to respond. It announced

on September 23 that a new CFO was joining the company following an announcement earlier in the month that the board would conduct a thorough review of the company's financial and investment policies. The actions of prey and predator positively impacted the stock price. By the end of September, the stock closed at $49.13, up 7.2 percent from $45.84 on August 23, the last trading day before the Loeb announcement. Compared to about a 1 percent rise in the S&P 500 over the same time period, investors in Sotheby's stock and Third Point funds had smiles on their faces.

Open warfare broke out between the parties on October 2. Loeb released a letter he sent to Bill Ruprecht, Sotheby's CEO, saying the board was derelict in its duties and that Ruprecht should step down immediately and be replaced with a more capable leader. Loeb backed up his demands by also releasing an updated Schedule 13D showing that Third Point was now the largest shareholder owning 9.3 percent of the company.

The Ruprecht letter became front-page news in the financial, business, and art presses. Loeb is known for his beautifully written CEO challenge letters. His Sotheby's letter did not disappoint.

> . . . we have concluded that Sotheby's malaise is a result of a lack of leadership and strategic vision at its highest levels.
>
> . . . you have not led the business forward in today's art market. It is apparent to us from our meeting that you do not fully grasp the central importance of Contemporary and Modern art to the Company's growth strategy, which is highly problematic since these are the categories expanding most rapidly among new collectors.
>
> Emblematic of the Company's misalignment with shareholder interests are both your own generous pay package and scant stock holdings by virtually all Board members.
>
> In sharp contrast to your limited stock holdings is a generous package of cash pay, perquisites, and other compensation. We see little evidence justifying your 2012 total compensation of $6,300,399.
>
> We acknowledge that Sotheby's is a luxury brand, but there appears to be some confusion—this does not entitle senior management to live a life of luxury at the expense of shareholders.

Sotheby's is like an Old Master painting in desperate need of restoration.

As with any important restoration, Sotheby's must first bring in the right technicians.

I am willing to join the board immediately and help recruit several new directors who have experience increasing shareholder value, share a passion for art, understand technology and luxury brands, or have operated top-performing sales organizations.

It is also time, Mr. Ruprecht, for you to step down from your positions as Chairman, President and Chief Executive Officer and for the role of Chairman to be separated for your successor.

We have already begun informal discussions with outside candidates . . .

Two days later, Sotheby's board passed a resolution putting a "poison pill" in place. It essentially blocked Loeb from acquiring more than 10 percent of the company. Game on. For the next seven months, the combatants fought a ground game trying to convince major shareholders they had the best plan for the company while simultaneously waging a public-relations battle to win in the court of public opinion. On January 29, 2014, for example, Sotheby's announced that it would return $300 million to shareholders via a special dividend. Third Point announced on February 27, 2014, that it was launching a proxy fight to install three new directors to the board, followed shortly thereafter by a lawsuit against the company and all members of the Board of Directors to overturn the poison pill.

In a surprise move, both parties announced on May 5, 2014, right before the Sotheby's annual shareholders meeting, that they had reached an agreement. Sotheby's would expand the board and include the three directors proposed by Third Point, permit Third Point to acquire up to 15 percent of the company, and reimburse Third Point up to $10 million in out-of-pocket expenses incurred as part of its activist campaign. It was a moment of amazing capitulation, especially the provision to reimburse Third Point for its expenses. It was likely a result of a majority of shareholders lining up to vote in favor of Third Point at the annual meeting. Loeb had been successful before. Investors were banking that his magic would continue to rub off on

their Sotheby's investment. Sotheby's stock price closed that day at $44.80, still above the average cost Third Point paid for its position but down from the high after launching its battle.

From turbulence to quiescence, at least for a few months. At the end of November 2014, Sotheby's announced that Bill Ruprecht would step down as chairman, president, and CEO but remain in place until his successor was named. In March 2015, Sotheby's announced that Tad Smith would join as the new president and CEO. It was a surprise hire since Smith had no operating experience related to the art world or luxury brands.

New CEOs, especially those who come to the role via an activist shareholder campaign, need to work quickly with their board to put in place a new strategy, operating plan, and management team that will hopefully increase shareholder value. Since joining Sotheby's, Smith has been very active, including overseeing the $515 million Taubman guarantee covered in Chapter 2. In an effort to lower staff costs, he announced a buyout program in November 2015. The next month, the CFO who joined Sotheby's shortly after Loeb launched his campaign surprised the market when he announced that he was leaving the company. A new head of HR, a new CFO, and a new head of marketing are now in place. Similar to Smith, they are new to the world of art and luxury brands. In an effort to bolster its position in the Postwar and Contemporary art market, Sotheby's announced in January 2016 that it was paying up to $85 million, a truly extraordinary price, to acquire Art Agency Partners, a fifteen-person art advisory boutique that had been in business for just two years. While cause and effect are hard to pin down, the influx of very expensive talent with the acquisition was correlated with an acceleration in the number of senior specialists and client-facing staff electing to leave the firm.

Since Smith joined Sotheby's, the art market has softened considerably, especially at the top end. Investors started to doubt whether the company would ever be able to generate higher and more predictable earnings. The stock fell to a new low of $19.13 on February 11, 2016—a very painful development for Third Point that no doubt led to many tough conversations inside the firm about what to do with its troubled investment.

The clouds parted a bit on July 27, 2016, when a Chinese life insurance company released its own 13D filing informing the market it had accumulated

a 13.5 percent stake in Sotheby's. But Taikang Life Insurance is no ordinary company. The chairman and CEO is Chen Dongsheng, the grandson-in-law of Chairman Mao Zedong. Mr. Chen is also the founder and part owner of China Guardian, the second largest auction house in China. Because Sotheby's and China Guardian are fierce competitors in China, many viewed this as an opening gambit by Guardian to acquire Sotheby's.

When Dan Loeb launched his campaign for change at Sotheby's more than three years ago, his demands included: replace the CEO; separate the chairman and CEO roles; add Loeb and two other colleagues to the board so they could drive change; undertake a board-driven, top-to-bottom strategic and operational review; reduce costs; and explore tax-efficient ways to return capital to shareholders. These demands are part of the standard activist shareholder playbook that firms like Third Point use to improve the financial performance of a company. Because all of his demands were met, along with a potential take-out partner emerging in the form of Taikang and Guardian, you may think that investors in Third Point funds would now be celebrating a financial home run. But it has yet to come to pass. On December 1, 2016, Sotheby's stock closed at $38.23 a share, down 10.4 percent relative to the $42.67 average price Third Point spent to acquire its Sotheby's position.[27] Moreover, since Third Point's first 13D filing on August 26, 2013, the S&P 500 increased 32.3 percent. For Third Point investors, this 42.7 percentage point negative spread is a painful reminder that the "Sotheby's Project" remains a problematic investment with an uncertain future.

Case Studies— How the Marketplace Works

There is joy and excitement associated with buying a work of art, bringing it home, and sharing it with friends and family. Because buyers can sometimes be blinded by passion, it is important to understand how the marketplace evaluates different artists and puts a price on their artwork. Later in this chapter, I share a framework for doing this, including highlighting differences in how the marketplace treats deceased versus living artists. But I start this chapter with case studies of how the marketplace works for some well-known artists to highlight the subtlety and nuance that goes into evaluating an artist's career. Each story illustrates an important aspect of how the art marketplace functions:

- *Christopher Wool*: Becoming Trophy Art
- *Amedeo Modigliani*: Fakes and Catalogue Raisonnés
- *Yayoi Kusama*: Embracing Consumerism
- *Rene Magritte*: Condition Issues and Pricing
- *Ruth Asawa*: A Well-Timed Museum Retrospective
- *Elizabeth Murray*: Right Place at the Right Time, Until Tastes Changed

As you read the case studies, please use Google Images to look at examples of each artist's work. Just type their names in the Google search box, and then click Images. A little bit of art history for free.

CHRISTOPHER WOOL: BECOMING TROPHY ART

Born in 1955, Christopher Wool arrived in New York City in 1973, the same year as the Robert Scull auction. New York was a tough, rough place where determined young artists congregated. Wool attended art school for a while, got involved in the experimental film and music scene, and was a studio art assistant.

Success did not come quickly. It took almost fifteen years to land on a distinctive style. Every living artist confronts the challenge of coming up with something new. Because they stand on the shoulders of all the artists who came before them, it is difficult to create something fresh and relevant for collectors, critics, and curators. In 1988, when the artist was thirty-three, he showed his word paintings for the first time. Painted on large sheets of metal with black enamel paint on a white ground, the artist used generic stencils to paint short, elliptical phrases. He would sometimes push the letters in the words together making it hard to decode the phrase he was painting. This helped create a sense of disquiet and doubt about the meaning of the work. While other artists had used text before, like Rene Magritte and Jasper Johns, Wool created a visual style that felt raw and transgressive. Critics loved the work, and it started to sell.[1] In addition to his word paintings, he created work with abstract imagery that also appealed to the market.

Over the next ten years, Wool was represented by a well-regarded gallery (Luhring Augustine) that helped place the work with influential collectors and museums. The artist was included in many group shows, which helped to expand his audience. Museums also supported his work. In 1998, he had a mid-career retrospective at the Museum of Contemporary Art in Los Angeles, which traveled to the Carnegie Museum of Art in Pittsburgh and the Kunsthalle Basel in Basel, Switzerland. After the retrospective, Wool continued to make work that many collectors, critics, and curators thought was important and relevant. He was not a "flash in the pan" artist who debuted well but was unable to sustain critical attention and interest. Because he was not prolific, it was also hard to buy something by him. By 2010, Wool was a well-known artist, coveted by collectors, with a history

of sold-out shows. He was also an inspiration to younger artists, many of whom did explicit or inadvertent riffs on images and techniques Wool used in his abstract paintings.[2] As explained in a review by Peter Schjeldahl in the *New Yorker*,

> Like it or not, Christopher Wool, now fifty-eight, is probably the most important American painter of his generation . . . Once you stop resisting the gloomy mien of Wool's work, it feels authentic, bracing, and even, on occasion, blissful . . . His works ace the crude test that passes for critical judgment in the art market: they look impeccable on walls today and are almost certain to look impeccable on walls tomorrow. Lately, fetching millions at auction, Wool's art leaves critics to sift through the hows and whys of a singular convergence of price and value. Would that the expensive were always so good.[3]

From a market perspective, Wool's breakout moment came in May 2010 when a large word painting titled *Blue Fool* sold at auction for $5 million. It was a very big price, selling way above the presale estimate of $1.5 to $2.0 million. Very few living artists, let alone artists of his generation, sold for that amount. Since he only made about seventy-five word paintings, it signaled a pent-up demand for large, iconic word paintings.[4] It also started to validate for some extremely wealthy collectors that Wool was an "important artist." Unlike other markets where an increase in price tends to decrease demand, in the art world, a big price increase at auction can do the opposite. Wool's word paintings were becoming trophy art, similar to what a Rothko painting represents to many collectors.

The sale of *Blue Fool* created a frenzy among middlemen (sometimes called "runners") to find the owners of other word paintings and entice them to sell. Speculators came into the market, willing to buy what middlemen sourced to either flip immediately or to hold for sale at a later date. The $5 million price on *Blue Fool* was confirmed a few years later when another large word painting sold at auction for $7.7 million. These big prices had three knock-on effects. First, the price of word-related

works on paper jumped as demand increased from collectors and speculators who were priced out of the paintings market. Second, prices for his abstract works rose, because more collectors wanted to have something by the artist in their collection. Lastly, collectors and speculators started to look more seriously at other less expensive artists who did work that was similar or relatable in some way to work by Wool. For example, more collectors started to consider work by Joe Bradley and Lucian Smith.

The frenzy around Wool accelerated in November 2013, when a word painting that many critics felt was his most important came up for sale. Titled *Apocalypse Now*, it sold at auction for an astonishing $26.5 million. The sale occurred just as a Christopher Wool retrospective was kicking off at the Guggenheim Museum. Six months later, a word painting titled *If You* sold at auction for $23.7 million, confirming that a plus–$20 million painting by Wool was not a one-off aberration. On May 12, 2015, another word painting titled *Untitled (Riot)* sold at auction for a new world record of $29.9 million. But the very next night, the market paused. A slightly smaller word painting was offered for sale with a presale estimate of $15 to $20 million. It failed to sell, or in auction parlance, it was bought-in. A surprising and confusing signal from the market: Were large word paintings worth more than $20 million or something far less?

Over the next year, buyers and sellers interested in Wool shadowboxed. Potential sellers referenced the high auction prices to put a price on works they owned, while potential buyers were reticent to step into the market for fear of overpaying. In May 2016, the market rendered its opinion: great word paintings are worth far less, perhaps 40 percent below the record-breaking prices. Because artworks are unique, the price someone is willing to pay for one object versus another can swing easily based on size, color, date, and other factors. But in May 2016, Christie's offered for sale *And If You*, an almost perfect substitute for *If You*, the painting that sold in May 2014 for $23.7 million. Both paintings were the same size (108 by 72 inches), painted in the same year (1992), and used the same medium (enamel on aluminum). The two paintings also had virtually identical text:

If You	And If You
IFYOU	ANDIFYOU
CANTTAKE	CANTTAKE
AJOKEYOU	AJOKEYOU
CANGET	CANGETTH
THEFUCK	EFUCKOUT
OUTOFMY	OFMYHOUSE
HOUSE	E

But *And If You* sold for $13.6 million, approximately 40 percent less than what its twin sister sold for two years earlier—a painful realignment for those who splurged on a word painting during the run-up in prices. The next day, this pricing level was confirmed when another word painting sold at Sotheby's for $13.9 million. Perhaps a tarnished trophy, yet still extraordinarily expensive by most measures.

AMEDEO MODIGLIANI: FAKES AND CATALOGUE RAISONNÉS

Marketplaces work best when there is a widely recognized standard that buyers and sellers agree is the authoritative voice on whether an object is authentic. For diamonds, it is a GIA certificate. For Patek Philippe watches, it is the reference number and the authentication certificate issued with a new watch. For artists, a catalogue raisonné can serve this purpose: a comprehensive annotated listing of known works by an artist.

For Modigliani, the market has coalesced on a catalogue raisonné compiled by Ambrogio Ceroni. First published in 1958, it was last updated in the early 1970s. Ceroni was an art critic and appraiser for auction houses. He elected to include in his catalogue only works he inspected in person: 337 paintings and 25 sculptures. The marketplace deems all of these works to be authentic. While there do not appear to be errors of commission by Ceroni, there may be errors of omission given that he only included works he inspected in person. Since the publication of Ceroni, other scholars have researched and published their own catalogue

raisonnés. But they do not always agree on which works are authentic, and some authors have filed lawsuits to prevent or challenge attributions. Too much drama.[5] The marketplace wants consensus, not lawsuits. As a result, Ceroni remains the standard and the bulwark helping prevent fakes from entering the market.

For authentic Modigliani paintings, the marketplace sharply differentiates between iconic works and then everything else. Iconic masterpieces, in order of desirability, fall into three categories: reclining nudes; fully finished female portraits, especially with some nudity; and fully finished male portraits. Over the past few years, roughly speaking, a reclining nude cost in excess of $100 million, a fully finished female portrait between $40 to $60 million, and a fully finished male portrait between $15 and $25 million. Everything else costs far less, because while they may be beautiful paintings, they do not encapsulate the essence of what collectors crave in a Modigliani painting. Experts in his work shared with me that perhaps 50 percent of the Ceroni paintings are in private hands, so it is still possible for collectors with sufficient means and desire to acquire one.

Because the Ceroni catalogue raisonné most likely suffers from errors of omission, does the market ever come to accept as authentic a painting not included in it? The bar is extremely high. Before he died, Modigliani was not widely known or collected. So the general belief is that no one made fake Modiglianis before his death. If people painted fakes and wanted to pass them off in the marketplace, their time was better spent creating fake Picassos or Matisses.

To convince the market that a Modigliani not listed in Ceroni is authentic, the owner will need hard evidence establishing that the painting existed during the artist's lifetime, perhaps a photo of the artist standing in front of it or a picture of one of his dealers with the painting. Bills of sale and correspondence that specifically mention the painting can help build the fact base. Original documents are needed, not facsimiles or duplicates, because it is so easy now to digitally manipulate images and create fake photos and documents.[6] Given the sketchy records kept by the artist and his dealer, creating a compelling fact base is very challenging. Even with that evidence, the painting will still likely trade at a discount to the "authentic Modigliani" market.

Many beautiful paintings are in this unauthenticated limbo, including one in the collection of the Detroit Institute of Arts (DIA). The DIA painting, titled *A Woman*, is of a beautiful young woman with brown hair against a green background. It entered the DIA collection in 1926. Reproductions of it are for sale in the museum gift shop and online. Because the City of Detroit paid for it with city funds, *A Woman* was ensnared in the Detroit bankruptcy proceedings that were covered in Chapter 1. Christie's rendered an opinion on the fair market value of this Modigliani painting. In its collection appraisal document, Christie's reported:

> Christie's did not provide a fair market value range for this painting because the work is not included in the principle catalogue on Modigliani's oeuvre by the late Ambrogio Ceroni who is currently the sole universally accepted authority on the artist. If a work attributed to Modigliani does not appear in Ceroni, it is not readily accepted in the marketplace.

YAYOI KUSAMA: EMBRACING CONSUMERISM

When Yayoi Kusama moved to the United States in 1957 at the age of twenty-eight, she was an ambitious young artist tired of the conservatism and discrimination she faced in her native Japan. She settled in New York and quickly became part of the avant-garde art scene. She had a number of signature motifs. She loved brightly colored polka dots, sometimes covering an entire painting, wall, or room with them so that the polka dots obliterated the underlying support. She created mirrored rooms with suspended colored lights so that when the door was closed, visitors felt part of an ethereal infinity. She also created large, monochromatic paintings called infinity net paintings filled from edge to edge with painted loops. The simple act of painting loop after loop created surprisingly complex paintings that seemed to have different points of tension as you scanned their surfaces.

In 1959, she showed five large infinity net paintings in her first New York exhibition. Each was composed of thousands of individual white loops painted on top of a black ground. Donald Judd, who at the time worked

as an art critic for *ARTnews*, wrote in his review that "Yayoi Kusama is an original painter. The five white, very large paintings in this show are strong, advanced in concept and realized." He went on to say, "The expression [in the paintings] transcends the question of whether it is Oriental or American. Although it is something of both, certainly of such Americans as Rothko, Still and Newman, it is not at all a synthesis and is thoroughly independent."[7] High praise from a curmudgeon.

Kusama was a workaholic. Moreover, she was obsessed with being noticed and recognized; she hungered to be famous. She found her way to the center of the action, be it people, parties, or performances. Because she created provocative work for the time, it was easier for her to be noticed. She covered tables, chairs, and shoes with phallus-like objects she made out of stuffed canvas and then painted them with silver paint. She also organized anti-war naked happenings, including one on the Brooklyn Bridge, where participants stripped down and Kusama painted them with polka dots.

After fifteen years in the United States, Kusama moved back to Japan in 1973. She had a history of recurring psychiatric problems. When her issues became particularly acute in 1977, she elected to admit herself to the Seiwa Hospital for the Mentally Ill in Tokyo. She continued as an active artist, going to a nearby studio to work and returning to the institution for meals and treatments. But the art world is a tough place: out of sight, out of mind. She fell off the radar and became more of an interesting footnote in the history of the 1950s/1960s New York art scene. She started to be noticed again in the early 1990s when she represented Japan at the 1993 Venice Biennale. Her work slowly started to appear again in gallery shows in New York, London, and Los Angeles. By the middle of the last decade, her career had accelerated, with important galleries in Europe and the United States representing her. It also coincided with a surge in Asian collectors buying her work. Important museum shows followed, including a major retrospective in 2011 and 2012 that traveled to the Whitney Museum in New York, the Tate Modern in London, the Centre Georges Pompidou in Paris, and the Reina Sofia Museum in Madrid.

Personal narratives are sometimes an important factor behind collectors buying an artist's work. This is especially true for Kusama. I remember one

conversation with a young collector couple about the artist. When I asked them "Why Kusama?" the couple's quick response was "She is bad ass. She does her own thing. She has stayed true to herself and makes no apologies for it. She thumbed her nose at the world and waited for the world to come to her. While potentially crazy, she is crazy like a fox." The visual and the emotional merged for this couple. Stories about Kusama's mental health issues and her fierce determination and longevity help some collectors understand her work and explain it to their friends. The artist still craves attention and for years has dressed so that she remains unforgettable. Bright red wigs, outfits covered with polka dots, including a polka-dot encrusted wheel chair, is how the eighty-seven-year-old artist presents herself to the world.

As her popularity increased, so did her production. She started using studio assistants and repeating older themes, especially infinity nets. She created work in different sizes, colors, and media, including new infinity rooms. An infinity room at the Broad Museum in Los Angeles is now a major tourist attraction and a destination of choice for selfies. Her work is perfect for Facebook and Instagram. She also embraced consumer culture to expand her market, licensing images for key chains, mouse pads, paperweights, and pillows. Her partnership with Louis Vuitton, which I talked about in Chapter 1, dramatically increased the number of people aware of her work and her personal narrative.

Her partnership with consumerism is an important factor behind her career renaissance. The ready availability of her work at different price points helps stimulates demand for it. It is an odd case of an increase in supply helping to increase demand. Buyers do not have to search high and low to find something by her. If unable to get something from one of the galleries that represent her, they can buy something at auction, or at an upcoming art fair, or call around to the numerous galleries that offer her work on the secondary market. People can also buy mass-produced objects emblazoned with one of her signature motifs on eBay or in museum gift shops. Familiarity has not bred contempt but instead greater interest and demand for her work. Collectors are now willing to pay extraordinary sums for her important early paintings. In November 2014, a white infinity net painting from 1960 sold for a new world record of $7.1 million; ten years ago it would have sold for a fraction of this amount. For most artists, scarcity rules. But for

Kusama, like Andy Warhol, embracing consumerism helped propel awareness and sales of her work.

RENE MAGRITTE: CONDITION ISSUES AND PRICING

Everyone knows and loves Rene Magritte, the master of the surrealist image. Maybe the first time you saw something by him was when you noticed a poster of a train engine with a full head of steam inexplicably barreling out from the center of a fireplace in an ordinary living room. Or maybe it was the image of a gigantic green apple filling an otherwise empty room. Magritte is the master of the double take. You sense that something is afoot, something is amiss, something is not quite right, but there is nothing hysterical or terrifying about it. His deadpan delivery adds to the sense of disquiet, which draws viewers in yet again to try and make some sense of the image. The power and popularity of his work helps explain why there are over 1,300 results when searching for books about the artist on Amazon.

Born in 1898, Magritte spent most of his life in Belgium. Art-making was an early passion. He started drawing classes when he was about twelve and attended art school when he turned eighteen. He hit on his distinctive style in 1926 when he was twenty-eight years old and continued to paint in this vein until the late 1930s. Paintings from this period are generally referred to as his early works. During this time, Magritte also started a small advertising agency with his brother. Given the visual punch of his paintings, it makes sense he would at times earn a living designing posters and other advertising materials.

Magritte pivoted away from surrealism in the early 1940s and produced what many critics deem mediocre work. But by 1948, he returned to his surrealist tropes and continued to paint in that style for the next twenty years until he died in 1967. Generally speaking, work from his later period is more popular than the earlier work because the images are more "iconic." Magritte had an interesting take on his work:

> I despise my own past and that of others. I despise resignation, patience,
> professional heroism, and all the obligatory sentiments. I also despise

the decorative arts, folklore, advertising, radio announcers' voices, aerodynamics, the Boy Scouts, the smell of naphtha, the news, and drunks.

I like subversive humor, freckles, women's knees and long hair, the laughter of playing children, and a girl running down the street. I hope for vibrant love, the impossible, the chimerical.

I dread knowing precisely my own limitations.[8]

Magritte was world famous when he died. But like Modigliani, success breeds fakes. In 1970, the Menil Museum and Foundation in Houston provided funding for a catalogue raisonné. The respected scholar David Sylvester was hired to oversee the project. Twenty-two years later, the first volume came out. By 1997, Sylvester declared victory when Volume 5 of the catalogue raisonné was published. It is an extraordinary piece of scholarship that the marketplace accepts as the authoritative voice on what constitutes a real Magritte. To keep the catalogue alive, the Magritte Foundation was founded in 1998 to safeguard the work and reputation of the artist. The Foundation subsequently created an authentication committee that now meets regularly to review and render opinions on whether newly discovered work is authentic.[9] A sixth volume of the catalogue raisonné was published in 2012 to document the committee's decisions.

How much work did the artist produce? The catalogue raisonné includes approximately 1,700 works: around one thousand paintings and seven hundred sculptures, objects (like painted bottles), and selected works on paper (generally works done in gouache, which is opaque watercolor). Smart collectors and their advisors know to acquire only work that is already in the catalogue raisonné or for which there is firm documentation showing that the work has been vetted and approved by the Foundation's authentication committee. Major auction houses and top galleries will only offer work that satisfies these authentication requirements.

Two types of collectors buy work by Magritte. One group is a narrow band of collectors who are very interested in the artist and collect his work in depth. There are probably ten or so people worldwide who fall into this category, with Wilbur Ross being the most public about his Magritte obsession.[10] Collectors in this group understand the art historical importance of the artist's early work,

and they appreciate the linguistic jokes that Magritte often incorporated into his paintings (e.g., a painting of a pipe that someone would use to smoke tobacco with the words "this is not a pipe" in French below it). The second group of buyers is a much broader audience of primarily Western collectors who are interested in owning something with subject matter that clearly identifies it as a Magritte. Works that are beautiful, perhaps something with a naked woman, are particularly valued by this audience. They want something that is instantly recognizable as being by the artist, because they are likely to only buy one work by him.

Given the number of paintings the artist produced that are still in private hands, collectors have a choice about what to buy. Over the ten-year period ending December 2015, paintings by Magritte were offered for sale at auction approximately 150 times.[11] While it is impossible to know how many works were offered privately during this period, it is probably safe to assume another fifty to one hundred paintings. On average then, maybe twenty to thirty paintings a year were on the market. Collectors, as a result, could be somewhat choosy and comparison shop.[12]

While the desirability of the image is the primary determinant of value, the physical condition of a Magritte painting can also be an important swing factor. By condition, I mean whether the surface of the painting has ever been repaired. First, a short digression on condition as it applies to all artists. Paintings can be damaged because of how they have been handled (e.g., the painting fell and was scratched), what they have been exposed to (e.g., smoke or water damage), or how they were painted (e.g., thick paint surfaces that crack). For example, Chaim Soutine, an artist compatriot of Modigliani, is known for highly expressive paintings using very thick layers of oil paint. Because of this technique, many of his paintings have cracks in them. So if collectors want to own a Soutine painting, they need to be comfortable with that type of condition issue. Generally speaking, restorers can now return most damaged works to their original appearance. Only when the painting is examined with special lights or magnifying lenses is it possible to detect the restoration.

Returning to Magritte, because his painted surfaces are so flat and deadpan, there is nothing inherent in how they were painted that would naturally lead to condition issues. Damage is only likely if the work was

mishandled in some way or exposed to environmental factors like smoke or moisture. An example of damage is a very fine network of cracks in the paint surface that distorts the faux brickwork or wood grain that he painstakingly painted. Because Magritte paintings come to market frequently, many of his core collectors prefer work that is in pristine condition, untouched by restorers. As a result, works with meaningful condition issues tend to trade at a discount, everything else being equal. Well-informed and well-advised collectors know this about the Magritte market, but novice buyers may not be in on the game. They may be excited to be shown privately a painting by the artist but be duped into overpaying for something with restorations. Buyer beware.

RUTH ASAWA: A WELL-TIMED MUSEUM RETROSPECTIVE

For Ruth Asawa, commercial success came very late in life. Born in 1926 in California, she faced rampant discrimination of Japanese Americans during World War II. During her high school days, she was forced to live in an internment camp. After graduating in 1943, she went to the Milwaukee State Teachers College to become an art teacher. She completed all of her graduation requirements except for a teaching internship, which she was unable to complete because no one would hire a Japanese American at that time. She left in 1946 and headed to North Carolina. For the next three years, she was a student at Black Mountain College, a center of avant-garde art, architecture, music, and dance. Josef Albers, the German-born American artist and educator who was instrumental in the forming of Black Mountain, was one of her teachers and mentors.

In 1948, she hit upon a distinctive way of weaving wire into hanging sculptures that played with transparency and shadows. She also created drawings that complemented perfectly her three-dimensional work. In 1949, she moved to San Francisco where she lived and worked for the rest of her life. Despite her talent, daily devotion to her artwork (in addition to raising six children), and some early critical success, she was an "artist's artist" working in relative obscurity. John Yau, who studied and wrote about the artist, said:

In every account of Ruth Asawa's life, one thing stands out. With remarkable economy, she was able to transform the many obstacles that lay in her path—from her impoverished childhood on a small truck farm, to the racial and sexual politics she encountered at different points in her life—into lessons learned. Her creative genius endowed her with the ability to repurpose whatever she has experienced. In her original synthesis of form, process, and transparency, Asawa has created a diverse body of work that challenges the historical definition of sculpture. Whatever threatened to block her progress instead helped her to become an artist without peer.[13]

From time to time, Asawa's work sold—including a six-foot hanging sculpture to Blanchette Rockefeller, wife of John D. Rockefeller III. But when portions of Blanchette's collection were sold at auction in 1994, the Asawa sculpture sold for only $2,300. At the time, Ruth was sixty-eight years old. While a committed artist, she was the antithesis of a breakout art star.

Things began to change in 2007 when the de Young Museum in San Francisco organized a retrospective of Asawa's work that also traveled to museums in Los Angeles and New York. The catalogue accompanying the retrospective was a first-class piece of scholarship with essays that made the case for the importance of Asawa's work in the history of twentieth-century art.[14] Catalogues like this are an invaluable tool to help broaden the appeal of an artist to collectors and art advisors. At the age of eighty-one, the artist was finally getting the recognition she deserved. The show also occurred at a time when museums and collectors were paying more attention to older female and/or minority artists who may have been overlooked. Following this institutional support, Asawa's work started to show up in more museum and gallery group shows. When a very large hanging sculpture by Asawa was offered at auction in 2010, bidders drove the price up to $578,500, an order of magnitude change in the market value of her work.

Interest in Asawa continues to grow. The Whitney Museum included her work in the reinstallation of the permanent collection when the museum moved to its new building. The de Young Museum in San Francisco has a large group of works on permanent display. Christie's organized two private

selling exhibitions of her work in 2013 and 2015. The artist was able to experience some of this burst of interest before passing away in 2013 when she was eighty-seven years old. She is a wonderful example of a great artist with a long career who was ignored by the marketplace—until all of a sudden, things changed.

ELIZABETH MURRAY: RIGHT PLACE AT THE RIGHT TIME, UNTIL TASTES CHANGED

In 2005, the Museum of Modern Art hosted a retrospective of paintings, drawings, and prints by Elizabeth Murray. It was a celebration of her career, an honor MoMA bestows on few living artists. When announcing the show, the museum described her inventive work:

> Over the course of more than four decades, she has transformed painting's conventions to forge an original artistic idiom through the use of vivid colors, boldly inventive forms, and shaped, constructed, multi-paneled canvases. Murray's paintings are animated by recurring biomorphic shapes and vibrant images of domestic objects—cups, glasses, spoons, chairs, tables, and shoes—by which the artist subverts the viewer's notion of the familiar.[15]

From an early age, Murray wanted to be an artist. She graduated from the School of the Art Institute of Chicago in 1962 and then got an MFA from Mills College outside San Francisco. She settled in New York City in 1967. By the mid-1970s, she landed on her distinctive style and was represented by Paula Cooper Gallery, a gallery with a reputation for spotting young talent. In 1996, Pace Gallery started to represent her. Over her career, Murray had more than seventy one-person shows at galleries across the United States and Europe.[16] Museums were early buyers. More than forty public collections in the United States have her work, including the Art Institute of Chicago, MoMA, the Whitney Museum, the Guggenheim Museum, and the Walker Art Center in Minneapolis. She was the recipient of a MacArthur Foundation "Genius Grant" in 1999. The artist passed away in 2007 from complications associated with lung cancer.

Since her retrospective, tastes in contemporary art have changed. The marketplace is now more interested in artists exploring identity politics (e.g., David Hammons, Glenn Ligon, Felix Gonzalez-Torres, Kara Walker) or abstraction with a street art sensibility (e.g., Christopher Wool, Jean-Michel Basquiat). Murray, by comparison, is almost too joyful and colorful. She is no longer a name on the lips of collectors and curators. You rarely see her work anymore in gallery shows or at art fairs. When her work does come up at auction, it tends not to sell well. What is fascinating about her market is that nothing about her work has changed, except the context. For contemporary artists, the context in which they are shown, compared, and talked about is an important factor in how the marketplace prices their work. Because she is deemed less relevant now, demand for her work has shrunk. Collectors who bought her work ten to fifteen years ago are likely to be disappointed if they try to sell it today. Maybe her market will return. Perhaps there will come a time when her vibrant, idiosyncratic work will seem fresh and exciting once again to new collectors. I hope so; she deserves another look. The fickle world of contemporary art.

PUTTING A PRICE ON AN ARTWORK

Pricing in the art market is confusing. Paintings by one artist sell for more than $500,000 while another never breaks the $25,000 mark. While it may seem random or inexplicable, there is a logic to how the marketplace puts a price on an artwork. No market with $60 billion in turnover can work if pricing is random or unhinged to drivers of fair market value.[17] While there is a tremendous amount of subjectivity in how works of art are priced, there are also some common themes and ideas that inform what a willing buyer will pay a willing seller for a work of art. The framework provided in this section builds on insights I hope you detected in the case studies. It also draws on what I have learned over the years from auction specialists, gallery directors, appraisers, and collectors.

What causes an artwork to be expensive? Let's start with deceased artists. There are seven factors that influence the price at which a willing buyer and a willing seller will agree to transact. Some of the factors are subjective,

leaving room for interpretation, while others are more objective and measurable.

1. **Is the artist a major innovator in an important style or time period?** History is written. As in business, politics, and warfare, innovators tend to be the people who make it into the history books and remain there. Art is no different. Examples of important innovators in the art world include Wassily Kandinsky for pioneering Modern abstract art, Andy Warhol for Pop Art, and Edward Hopper for twentieth-century American Modernism.

 The more an artist is deemed an innovator by museum curators, critics, and other opinion makers, the more valuable his or her artwork, all else being equal. Because art historical movements tend to encompass many artists, there is also an artist hierarchy associated with each movement. For example, there were many impressionist artists, but the history books unequivocally deem Claude Monet and Edgar Degas to be more important than Camille Pissaro and Alfred Sisley. Hierarchy exists in every art movement. The more important the artist, the more expensive the artist's work tends to be relative to work by the lesser lights.

 For deceased artists, their relative positions in an art movement tend to become more secure and less subject to change with the passage of time. The history books, for example, are pretty set now on the relative importance of the artists associated with seventeeth-century Dutch golden-age painting, nineteenth-century landscape painting, Impressionism, American Modernism, and Abstract Expressionism, among many other categories.

2. **Is the artist relevant to current collectors?** This is the important question about taste and context: Is the work relevant to buyers today? Jean-Baptiste-Camille Corot is an important artist in the history books, but nineteenth-century landscape painting is now out of favor. His work tends to be small and delicately painted and it does not fit well in modernist homes. His status in the history books will not change, but not many people are interested today in acquiring his work. While it is relatively easy to describe current tastes and their impact on pricing, it is difficult to predict if and when tastes may change. As a result,

the long-term value of many works of art is much more uncertain than many people realize.

3. **Is the work authentic with a good provenance?** The stronger the authentication standard, the stronger the market for the artist. Collectors have choices about which artists to collect. Taking authentication off the table as an issue reassures collectors that they can buy without fear, as the Modigliani and Magritte case studies illustrated. Provenance is the record of who owned the work from the time it left the artist's studio to the current owner and is used to help establish its authenticity. Sales receipts, exhibition catalogues, and gallery stickers on the back of a painting are some of the documents experts utilize to establish whether a work is authentic.

4. **Is the work iconic relative to the artist's other work?** Artists tend to have a signature style. For Magritte, his later work is considered more iconic; for Warhol, many critics consider his early silk-screen paintings to be his most important. Some artists have more than one signature style. Gerhard Richter, for example, makes both colorful abstract paintings and blurred photorealist paintings. But he is more the exception than the rule. Just as there is a hierarchy of artists associated with an art movement, there is also a hierarchy that helps to define the relative importance of work produced by an artist. Iconic work is premium priced. The further you get from it, the sharper the fall off in price. This tends to be true for every medium in which the artist worked.[18]

The degree to which a work is iconic depends on answers to some very practical questions of ascetics, such as: Is it beautiful? Is it a large work? Is it the best in the series? Does it use the right colors? Answers to these questions impact value, especially the question about color. Look no further than the marketplace for abstract work by Gerhard Richter to understand the relationship between color and price. When his abstract paintings come up for sale at auction, collectors are willing to pay more for red and blue over green and orange.

John Baldessari, a well-known artist based in LA, made a painting in the late 1960s about ascetics and subject matter titled *Tips for Artists Who Want to Sell*. Baldessari hired sign painters to paint in black capital

letters on a life-size yellow canvas the following passage that he found in an art trade magazine:

TIPS FOR ARTISTS
WHO WANT TO SELL

• GENERALLY SPEAKING, PAINTINGS WITH LIGHT COLORS SELL MORE QUICKLY THAN PAINTINGS WITH DARK COLORS.

• SUBJECTS THAT SELL WELL: MADONNA AND CHILD, LANDSCAPES, FLOWER PAINTINGS, STILL LIFES (FREE OF MORBID PROPS . . . DEAD BIRDS, ETC.). NUDES, MARINE PICTURES, ABSTRACTS AND SURREALISM.

• SUBJECT MATTER IS IMPORTANT: IT HAS BEEN SAID THAT PAINTINGS WITH COWS AND HENS IN THEM COLLECT DUST . . . WHILE THE SAME PAINTINGS WITH BULLS AND ROOSTERS SELL.

The painting, now in the collection of the Broad Museum in Los Angeles, is considered by many critics to be one of his most important works. An ironic twist for a very wry painting.

5. **Is the work in good condition?** Collectors tend to prefer work that is in excellent condition relative to the norms of other work by the artist. The more significant the condition issues, the higher the discount the dealer will need to provide to sell it.

6. **Is the estate represented by a good gallery focused on burnishing the artist's reputation and managing scarcity value?** A gallery can help build the artist's reputation via shows, publications, and sales to important collectors and institutions. For prolific artists, the gallery also plays an important role in managing the release of work from the estate in ways that promote the reputation of the artist (e.g., donations to museums) and scarcity value (e.g., limiting the amount of work on the market at any point in time).

The brand and reputation of the gallery, separate from the brand and identity of the artist, can also impact the market value of an artist's work. As discussed in Chapter 2, because it is difficult for many buyers to evaluate an artist's career, some rely on gallery brand names to determine whether an artist is important and valuable. As a result, galleries at the top of the hierarchy can sometimes sell work for higher prices than would otherwise be the case if a lower-tier gallery handled the estate.

7. **Is there a liquid market for the artist?** Collectors want to acquire things. If they rarely see work by the artist at galleries, art fairs, or auctions, they are less likely to develop an appreciation for it. When a work does become available, the artist's lack of regular market exposure can limit the pool of potential buyers and their willingness to pay. Generally speaking, the more liquid an artist's market, the greater the willingness of collectors to buy it. This helps support higher prices, which in turn can create a virtuous cycle of sales and prices. For most collectors, when they think of liquidity, they think in terms of how easy it would be to sell something at auction. But as I noted in Chapter 2, very few artists trade regularly at auction. As a result, there is very little real liquidity in the art market except for the "winner take all" stars.

How do answers to these questions inform what a willing buyer will pay a willing seller for a work of art? The more questions answered with a yes, the more expensive the artwork. For example, if the answer is yes to all of them, then it is a masterwork by a very important artist, in a sector of the market especially popular today with active collectors, in great condition, and trading in a liquid market. This work will be extremely expensive. But suppose every question gets a yes except for question three: the painting is a middling work from an unimportant part of the artist's career. Then the price will likely be a fraction of the masterwork.

For living artists, the same framework applies, but there is much more risk and opportunity around what the work may be worth in the future. There is more risk, because for most living artists, the jury is out on the first question: *"Is the artist a major innovator in an important style or time period?"* The position of artists like Jasper Johns and Gerhard Richter are secure. But

for most living artists, even successful ones, their positions are up for grabs over the long haul. Because artistic innovation is rare, the marketplace tends to be very harsh over time in its assessment of the relative importance of artists. For example, many artists today are consciously or unconsciously doing riffs on work by Christopher Wool. But with the passage of time, few will likely be remembered or collected, despite being commercially successful today.

The answer to question two for living artists—*Is the artist interesting and relevant to current collectors?*—is also very important. Positive changes can include a well-timed museum retrospective that brings greater recognition (like Ruth Asawa) or word passing in the marketplace that an important museum is buying work by a mid-career artist. But the attentions of contemporary art buyers are prone to change quickly, causing prices to spike for some, while others may experience a sharp drop-off in demand for their work.

A few final thoughts on pricing. Collectors are passionate, but this is especially true for those pursuing work by emerging artists. They buy a work for love but also for the excitement and potential associated with that artist. They are buying a piece of living history. Similar to fans following an athlete's career, collectors look forward to upcoming shows, reading reviews on the artist's "performance," and hoping the artist makes it into the Summer Olympics, otherwise known as a mid-career retrospective at MoMA, the Whitney, or another top-ranked museum. Because of this passion and potential, many collectors are willing to pay up to own something they feel may prove to be important. But things have gotten out of control recently with buyers overly enamored with the financial potential associated with emerging artists. One collector shared with me that he views his contemporary art collection the same way he thinks about his venture capital portfolio. When he invests in early-stage companies, he expects only one or two out of ten investments to be home runs, with the other investments being write-offs. But with so many people buying art with this mind-set, the price of young talent has gone way up. With so much money going to either emerging talent or established "branded artists," many talented mid-career artists are in a slump. As with most markets, things will likely adjust at some point.

<div align="right">

5

</div>

Buying Art Wisely

The art world is a wonderful, exciting place with many delightful things to look at and buy, from a $2,000 print to a $20 million painting by Picasso. The purpose of this chapter is to share practical wisdom about buying art effectively from galleries and at auction. This is followed by a section on the relationship between gallery and auction prices, an incendiary topic inside the commercial art world. Where money goes, scoundrels follow. The history of collecting is littered with incidents of buyers being duped. As the price of art soars, the schemes and shenanigans of those who prey on collectors have grown bolder and more nefarious. I share recent cases of bad behavior in the last section, titled "Avoiding the Scoundrel's Corner (Part 1)."

BUYING FROM GALLERIES

Buying from galleries can be a fun and rewarding experience, but one that has become more complicated over time. With so many galleries now in business, often with opaque practices, many people need a road map to building relationships with galleries. I spent time with fifteen seasoned collectors to learn about their gallery-buying experiences and combined them with my own experiences. I interviewed five marketplace collectors, four masterpiece collectors, and six connoisseur collectors (using the definitions introduced in Chapter 3). All the collectors were active buyers over the past five years in a wide range of categories including prints by Jasper Johns, Contemporary art by emerging artists, art from Latin America, paintings and sculpture by artists associated with American Modernism,

and blue-chip Postwar and Contemporary art. Even though their collecting interests and financial resources for collecting varied widely, there were more similarities in their approaches than differences. Here are some key takeaways.

Focus on a Small Number of Galleries

Choose galleries based on the quality of their exhibition programs and whether you like and trust the gallery directors. One collector couple, for example, focused on four galleries that handled work in their particular collecting category. The couple also wanted to have relationships with a few galleries known for spotting younger talent, so they spent time cultivating relationships with three additional galleries.

Building relationships is not complicated, if you are a regular customer. Visit the galleries frequently and pay promptly when you buy something. Because galleries are passionate about the artists they represent, they prefer engaging with collectors who want to learn and talk about the art in addition to making purchases. For infrequent buyers, getting gallery attention is easier if you have real passion for and interest in the gallery artists and avoid talking about the investment potential associated with buying work.

Good Relationships Pay Dividends

Like any business, important clients get special treatment. By focusing their attentions on a handful of galleries, buyers are more likely to get on waiting lists for artwork, be invited to special gallery dinners and events, have the gallery source things for them in the secondary market, and receive extended payment terms and "store credits."[1]

Waiting lists are a constant source of intrigue and derision in the art world. When galleries have a "hot artist," they have to ration supply in some way, because there is a limit to the amount of work the artist can create. But where a buyer shows up on a waiting list is fluid. Generally speaking, the list hierarchy goes something as follows: museums; clients willing to buy the work and make it a promised museum gift; clients who are already spending a lot at the gallery who are unlikely to flip things at auction; important

collectors new to the gallery but with the potential to buy a lot of work from gallery artists; everyone else. Museums are at the top of the list because being in a museum collection helps validate the importance of the artist. For the gallery, sharing news of a museum acquisition can stimulate more collector demand and higher prices. Because of this, galleries routinely offer museums substantial discounts. Collectors who are willing to make a promised museum gift of the work may enjoy similar benefits. One collector shared how he was able to buy a piece by a thirtysomething artist who was in very high demand. Earlier work by the artist was already being flipped at auction for around $150,000. The artist and his gallery wanted to reduce the supply of work in the secondary market and get it placed in important museums. After the collector committed to make a promised gift, the gallery sold him a large painting for $50,000. But a promised gift is a declaration of intent, not a formal museum gift. The collector plans to hang the painting in his home for many years to come.

Vet Potential Purchases with Those in the Know, But Keep the Feedback Confidential

Before purchasing something, get into the discipline of asking curators and other knowledgeable parties for feedback. Most of the people interviewed for this road map support museums, but they are not necessarily big check-writing trustees. Many have joined groups that donate at a lower contribution level. These groups meet three to five times a year for events the museum organizes around a lecture, an artist studio tour, or collection visits. Through these interactions, these collectors have built relationships with museum curators to whom they can turn from time to time for input. Museum curators are usually willing to provide feedback about a potential purchase. Curators typically have keen insight into the relative importance of artists and, for a specific artist, how to distinguish between good, great, and outstanding work. Listen to what they have to say, but also be sure to let them know you will keep their views confidential. They do not want to get on the bad side of a gallery looking to make a sale.

Specialists at auction houses may also be willing to share their perspective on a potential purchase, if they already know the collector. Because they

see so much work, they are likely to have an interesting point of view on the quality of the work and its current fair market value. Just because they work at an auction house does not mean they will try to talk the collector out of buying the work. Similarly, when a collector is thinking about buying at auction, she should consider getting input and feedback from art gallery staff she has gotten to know. Because the art market is so opaque, it is essential to get as much information as possible from different sources before making a purchase.

Be Mindful of Condition, Authenticity, and Title Issues

Galleries, like auction houses, sell work "as is," so ask questions about condition. They are not obligated to unwind a sale because a buyer claims after the fact that there were condition issues. For especially valuable work, consider retaining a third party to inspect it and prepare a condition report.

Talk with the gallery about how the artist's work is authenticated. For living artists, the control point is generally the artist's studio and inventory numbers associated with each work. For deceased artists, there may be an authentication committee and/or a catalogue raisonné the collector can look to for verification. Ask a lot of questions, because standards vary considerably by artist. For example, the Keith Haring Foundation decided in September 2012 to stop authenticating his work. This complicates matters, because sellers now use their own standards to decide whether a Haring is authentic. Haring was a prolific artist, even making hundreds of drawings on blank poster boards in New York subway stations in the early 1980s. Now referred to as his Subway Drawings, they frequently come up for sale but are very difficult to authenticate. Some selling venues have very lax standards and ask few questions about the work they are selling, while others will only sell Subway drawings with a photograph of the artist standing next to it. Buyer beware.

Title issues rarely arise when buying art, but there are some important special situations, including Nazi-looted art and artworks deemed cultural property. For Nazi-looted art, the original owner and his or her heirs still have some rights to the work, even if it has changed hands multiple times since being looted. Current owners may have to settle restitution claims before they can sell or donate the work.

The definition of cultural property has expanded greatly in many countries over the past few years and can now include work by Andy Warhol. Cultural property is generally subject to export restrictions that, if violated, can create title issues for unsuspecting buyers. I talk about cultural property in more detail in Chapter 7.

Negotiate in Good Faith, Leveraging Public and Private Information

Galleries are generally willing to discuss how they set the price for an artwork and how it compares to auction pricing, where relevant. (See Exhibit 5.1 to learn about online services collectors can use to obtain detailed auction sale records.) It is important for buyers to learn the technique of pricing conversations, so they can ask for discounts and buy with more confidence. For primary market work, galleries may be willing to extend a discount. It is not uncommon for buyers, even those who are new to a gallery, to be able to negotiate a 10 percent discount off the asking price. The more frequently a collector buys from the gallery, the higher the likelihood she may be able to obtain larger discounts over time.

A collector's ability to get a discount is also influenced by whether he is buying at the gallery or at an art fair. Art fairs are a convenient way for collectors to see a lot of work and to comparison shop. But at the same time, they have less negotiating leverage because so many people are on the prowl. Many of the collectors I spoke with enjoy going to art fairs but prefer buying during gallery visits, so they can avoid art fair buying pressures.

If Using an Art Advisor, Remain the Primary Point of Contact with the Gallery

For time-starved collectors, it is easy to "outsource" building and developing relationships with galleries to an advisor. But this practice should be avoided because a collection should reflect the taste of the collector. An advisor can be an invaluable partner when helping collectors build a collection, but galleries need to have a direct relationship with collectors to really support them.

AUCTION HOUSES—MORE SIMILARITIES THAN DIFFERENCES

Buying at auction is easy, because anyone who passes a basic credit check can bid. If a buyer wants an object, then she can have it as long as she is willing to be the highest bidder. No lists, no relationships to build and foster, no feelings or egos to manage. For some buyers, it is their preferred way to collect.

The buying experience at the large auction houses (e.g., Sotheby's, Christie's, Phillips, Bonhams) and important regional firms (e.g., Leslie Hindman and Freemans) share many similarities but few differences. All of them charge the successful bidder a buyer's premium on the hammer price of each lot the buyer purchases.[2] Most firms charge similar buyer's premiums, so the all-in cost of buying is similar across the companies. Specialists at all these firms write up condition reports for most items included in their sales and make them available for free to potential buyers before the sale. Specialists also vet these works for authenticity and title. Additionally, all of these companies provide buyers with some form of limited warranties against buying fakes or objects with title issues.[3] The major difference between the auction houses is the number of specialists on staff and their areas of specialization. Because the buying experience is so similar, buyers generally have little preference for one auction house over another. Buyers are drawn to objects, not the selling platform.

Auction houses provide five ways to bid, each one involving different levels of convenience and disclosure.

1. **Bidding in the Auction Room.** Once registered for an auction, bidders get a numbered paddle upon checking in. No one from the auction house will know ahead of time which lot(s) bidders intend to bid on, unless they have elected to disclose it to a specialist.

2. **Bidding on the Phone.** Bidding in the room is inconvenient for most people, so auction houses offer a service where an employee will call the bidder approximately five minutes before a lot the bidder registered for comes up for sale. The client tells the employee when to bid, which is then communicated to the auctioneer. Like bidding in the auction room, clients are under no obligation to bid when they are on the phone.

Because it is so easy and convenient, many collectors use phone bidding as a way to be in the game but only act if they can land something for a good price. Because clients have to register for phone bids, the auction house has prior knowledge of each bidder's potential interest in a specific lot.

3. **Bidding Online.** Online platforms enable bidders to register online, watch the auction-room action from their computer, and jump in when they want. Unlike phone bidding, bidders do not disclose ahead of time the specific lots on which they intend to bid. Additionally, because they are not in the auction room, no one knows who is bidding. It is the ultimate form of bidding anonymity.

4. **Bidding by Absentee Bid.** Sometimes clients are not available at the time of the auction, or they do not want to live bid because they may get carried away by emotion and overpay. To encourage people to participate, auction houses accept absentee bids. This gives the auction house permission to bid on behalf of a client up to a specific hammer price limit. Placing an absentee bid is convenient, but it discloses to the auction house the most information about the bidder's willingness to pay.

5. **Bidding via an Agent.** A variant of absentee bidding is for clients to appoint someone to bid on their behalf with an agreement on the maximum hammer price to which the agent is permitted to go. The agent can execute the client's bid via phone, online, or live bidding in the auction room.

With all these ways to bid, do bidders pay the same buyer's premium? Yes. Whether a first-time bidder or a seasoned auction buyer, regardless of the method by which the bids are placed, the buyer's premium calculation is the same. It is a level playing field.[4]

With auction mechanics behind us, any advice from the seasoned collectors I interviewed?

Seek Input from Auction Specialists

While auction house specialists are agents for the seller, most are happy to discuss in detail what they know about the condition of the object, its

importance and rarity, and the depth of potential buyer interest in the lot. Take advantage of their willingness to share information. Remember too that over the course of the preview period, as they interact with more prospective bidders and learn more about market demand, what the specialists have to say about an object and the market interest in it can change. Some seasoned bidders stay in phone contact with specialists right up until the sale begins.

But Minimize Disclosure

As agents for the seller, specialists help sellers set the confidential reserve price based on all available information the specialists have learned during the preview period. So if specialists know that interest is strong, perhaps because there are multiple phone bidders and some absentee bidders, they are more likely to recommend the seller set a higher reserve price for the object than would be the case if there was little buyer interest. Because of this, some seasoned bidders have a strict policy of waiting until the very last moment before letting an auction house know they intend to bid. In one case, a collector who bids regularly in evening auctions only registers to phone bid a few hours before the auction. By doing so, he feels he is preventing the auction house from setting a higher reserve price based on his potential bidding activity than would otherwise be the case. He wants the reserve price as low as possible so that it increases the odds he may get the object for a lower price. He will also register for multiple lots, even if he is only interested in one specific lot, to make it difficult for the auction house to predict what he may do.

Use Technology to Get Sale Alerts

With so many auctions taking place, it is difficult for collectors interested in specific artists to know when work is coming up for sale. Luckily, most of the auction-pricing services discussed in Exhibit 5.1 provide alert services. Subscribers specify the names of the artists and the type of work (e.g., paintings, drawings, prints) they are interested in following. They will get emails whenever a work satisfying these criteria is offered in an upcoming auction. Many

collectors find these alert systems an invaluable way to remain informed about artists on their wish lists.

Consider Buying Lots That Did Not Sell

All the lots in an auction rarely sell. While it varies from category to category, a good rule of thumb is that 75 to 85 percent of the lots will find buyers. The objects that do not sell, or in auction parlance, objects that are "bought in," can sometimes be an interesting post-sale buying opportunity. Because of the small number of bidders in most auctions, there is a bit of serendipity in whether something sells. Maybe the bidders interested in a lot were unable to participate because something as mundane as traffic or sickness prevented them from getting there. Or they bought a lot earlier in the sale and decided to pass on something later in the auction. For these and other reasons, many perfectly legitimate artworks in good condition just do not sell. After the auction, all of the bought-in lots are still available for purchase. Specialists are happy to get post-sale phone calls from potential buyers with offers that are at or below the low estimate. Serendipitous events sometimes create opportunities for the educated buyer.

Auction Houses Sell Things Privately Too

In addition to running auctions, many of the large auction houses have an active secondary-market business selling artwork privately. For example, the owner of a major Picasso painting may not want to risk selling it at auction but instead have the auction house offer it privately to a handful of potential buyers. Most of what auction houses have for private sale is very expensive "blue chip" art. For collectors with the means and desire to swim in that pond, it is worth exploring with auction specialists what may be available for sale.

THE CURIOUS RELATIONSHIP BETWEEN GALLERY AND AUCTION PRICES

A recurring question is whether galleries or auction houses offer buyers a better deal. For those in the art trade, this is an incendiary question.

Unfortunately, there is no authoritative database combining auction and private sale prices that can be used to arrive at a definitive answer. Based on my own experiences and those of other collectors, there is no single, monolithic answer. It depends on context and the type of work being sold.

To provide buyers with some guidance, I share the following general guidelines about the relationship between the sale prices of works at galleries and at auction.

When an artist's career is in a slump, gallery prices are likely to be significantly higher than auction prices. As an artist's career develops, galleries raise prices to reflect not only higher demand but also to signal to buyers that the artist is on an upswing. The latter occurs because many buyers find it hard to evaluate an artist's importance and sometimes use price increases as confirmation the artist is doing well. But if demand slumps for their work, galleries hate lowering prices. Many feel that if they do so, it will not stimulate enough new collectors to consider the work and will simply publicize to existing collectors that the artist's career has paused, or worse. But when work by the artist comes up at auction, it sells for its fair market value, which is far below the artificially high price galleries continue to ask for it.

If an artist trades infrequently at auction, then his auction prices are likely to be lower than gallery prices. Galleries spend considerable time and money building and cultivating a buyer base for their artists. Because artists create unique objects and collector tastes for the same artist can vary widely, finding a buyer for each work takes time. Ask three people at a gallery opening to point out their favorite artwork, and you will likely get three different answers. Because most artists have a small buyer base, it is hard to know whether a buyer who is both aware of the artist and interested in the specific work for sale will emerge on the day of the auction. If it sells, then it will most likely go for less than what the gallery gets for similar work.

Galleries rationing work by "hot artists" tend to price it too low, leading to price spikes in the auction market. Galleries experience both pleasure and pain managing the sales of work by "hot artists." To get it placed with the "right" collectors, they may offer discounts relative to what other "less desirable" collectors may be willing to pay for it. Galleries may also be reluctant to jack up prices too quickly because they are concerned about problems down the road if the artist's career pauses. But when work by the artist leaks into

the auction channel, those who could not get access to it through the gallery drive up the price. Speculators may also jump into the game, helping to push auction prices above gallery prices.

Masterpiece collectors are often willing to pay more for something at auction than privately. Masterpiece collectors know that the pool of potential buyers with the means and desire to spend millions for a work of art is very small. So it is difficult for them to know with confidence the likely fair market value of an object. Think back to the Kurt Schwitters case from Chapter 3. Nothing like it had been on the market for years. What was it really worth? If offered privately, collectors may balk at paying a big price for it because the price has not been validated in the marketplace. But this resistance can drop away during an auction when they see other bidders going after the work. Auction house specialists are full of stories of fruitlessly trying to sell a masterwork privately for a big price. But when the work is then offered for sale at auction, the same clients bid against each other, sometimes paying more for it than the private sale price.

Only in very liquid markets are auction and gallery prices largely the same, but even then there can be short-term differences that reward the diligent, informed buyer. A very liquid market creates a lot of visibility about the fair market value for work by an artist. This makes it hard for pricing differentials to persist between the two sales channels. But because the number of participants in the market at any point in time is small, and they have different levels of knowledge about current pricing, there can be meaningful short-term pricing differences between galleries and auction houses. The Kusama market, for example, is fairly liquid. But even that market goes through periods where it makes more sense to buy from galleries than auction and vice versa.

AVOIDING THE SCOUNDREL'S CORNER (PART 1)

Where money goes, scoundrels follow. The history of collecting is littered with smart collectors being duped. As the price of art has soared, the schemes and shenanigans of those who prey on collectors have grown bolder and more nefarious. The three situations below are examples of the need for collectors to be cautious about whom they trust and to verify claims made by people offering them work.

The Secret World of Introductory Commissions

Art galleries, just like wealth managers, rely on referrals for new clients. But when a wealth manager compensates someone for introducing a client to him, he is required to disclose it. For example, suppose an accountant introduces a client to a wealth manager. Under current securities law, the wealth manager is required to inform his new client in writing that the accountant is receiving an introductory commission and to get the client's approval before the payment can be made. Everything is aboveboard, with all three parties to the transaction fully aware of the existence and size of the introductory commission.

In the art world, unfortunately, there are no disclosure requirements around introductory commissions. For example, let's say an art advisor has an agreement with a client that allows her to bill a 10 percent fee on top of the sale price of any work the client buys based on her recommendations. The advisor may also have an arrangement with a gallery in which she gets a 10 percent commission from the gallery on all sales made to clients of the advisor. The payment from the gallery no doubt influences what the art advisor recommends to her clients. But unlike the wealth management industry, it is up to the gallery and the advisor to decide whether to inform the client of this payment.

Because disclosure is not required, it is hard to pin down the frequency of undisclosed introductory commissions. Based on my interviews, however, they seem to occur with enough frequency that collectors should take steps to protect themselves. For example, they should consider adding language to a purchase agreement that says something like "no payments have or will be made by the gallery to any third party related to my purchase of the artwork." The collector should also add language to the advisor agreement that says something like "the advisor will not accept any fee from a gallery or other third party, in cash or in kind, related to works of art that I purchase based on their advice."

How Does a Long-Trusted Art Advisor Try to Defraud a Client?

Hannelore and Rudolph Schulhof were important collectors of American and European Postwar and Contemporary art. Portions of their storied collection are now in the Guggenheim Museum.

In October 2011, the Schulhof family wanted to raise approximately $6 million by selling art from the collection. Based upon court documents, Michael Schulhof, on behalf of his mother Hannelore, turned to Lisa Jacobs for advice.[5] Jacobs was an art advisor the family had used for thirteen years to help manage the collection. Jacobs presented a proposal with different selling options involving paintings by Agnes Martin and Jean-Michel Basquiat. Schulhof and Jacobs signed an agreement on October 25, 2011, permitting her to sell one Basquiat painting, titled *Future Science versus the Man*, for no less than $6 million. She would receive a $50,000 fee upon a final, binding sale of the work. As part of the written agreement, Jacobs agreed not to accept any fee from the purchaser, in cash or in kind. It was a simple and clear document: Jacobs was acting on behalf of the owner and would only be paid by Schulhof for her role in the sale.

On November 7, 2011, Jacobs informed Michael Schulhof that she had a firm deal with a buyer for $5.5 million and that the buyer would pay immediately. In addition:

> [Jacobs] informed me in her November 7, 2011, email that the Buyer wished to remain anonymous (which is not uncommon for private collectors of art), and therefore proposed that we structure the contemplated transaction as a two-step process—first, a sale of the Work to [Jacobs], as intermediary, for $5,450,000 (i.e., the $5.5 million purchase price, less [Jacob's] agreed $50,000 fee), and second, an immediate resale by [Jacobs] to the buyer for $5.5 million.[6]

Schulhof agreed to these terms, and on November 16, 2011, Hannelore Schulhof received a wire transfer from Jacobs for $5,450,000.

The story would stop there, but for an odd twist of fate involving a housepainter, stolen artworks, and subpoenaed bank records. Early in 2011, before there was any discussion about raising $6 million, the Schulhof home on Long Island suffered flood damage. The family hired painters in March 2011 to get the house back in order. In 2012, an inventory of the Long Island residence revealed that three small works of art worth about $100,000 were missing. The family informed the police, who launched an investigation that included subpoenaing the bank records of people with access to the house.

The investigators soon determined that one of the stolen artworks was sold at auction and tracked a check for sale proceeds to a private mailbox in Bay Ridge, Brooklyn. The mailbox belonged to Joselito Vega, a housepainter who had been in the Long Island home back in March 2011. The check was in the name of Mr. Vega's sister-in-law. With Vega their prime suspect, the police set up a sting operation. He was hired once again to paint two rooms at the Schulhof house. He was caught on videotape in April 2013 stealing three additional works and was arrested and jailed.[7] He subsequently pleaded guilty in November 2014 to a time-served deal.[8]

How does all this tie back to Lisa Jacobs, who had no role in the theft? In an August 2013 lawsuit, Michael Schulhof details how the bank records that were subpoenaed as part of the theft investigation established that Lisa had actually found a buyer willing to pay $6.5 million for the Basquiat.

> Defendant [Jacobs] got away with her chicanery—i.e., her secret pocketing of $1 million of the purchase price paid by the Buyer—for more than a year. And, she probably would have gotten away with it for even longer (possibly forever), were it not for the fact that a theft of certain pieces of art from my mother's collection resulted in the issuance by the district attorney's office of a subpoena for defendant's [Jacobs] bank records . . . It was then discovered that two days *before* she paid Mrs. Schulhof the $5,450,000 for the Work, [the] defendant received $6.5 million (not $5.5 million) from the Buyer.[9]

The Schulhofs are seeking the $1 million, punitive damages of $2 million, repayment of the $50,000 fee, plus legal fees and expenses. After filing their lawsuit, Jacobs filed various motions of her own to dismiss it along with lawsuits against the family for various unrelated claims. Over the past two years, the judge assigned to the case rejected all of Jacobs' motions to dismiss the case and her counterclaims against the family. In the latest twist to the case, Jacobs' lawyer resigned in May 2016 because of unpaid legal fees. The Schulhof family filed a motion in August 2016 for the judge to rule in their favor on all claims. As the son of the now-deceased Hannelore said in the most recent filing: ". . . it is hard to imagine a more egregious case of fraud and

breach of fiduciary duty than cheating an 89-year-old woman—for whom the defendant [Jacobs] had worked for 13 years—out of $1 million by making blatantly false and fraudulent misrepresentations of fact, and ignoring the express provisions of the contract defendant [Jacobs] had knowingly and voluntarily signed."[10] The judge has yet to rule on the motion.

This is an especially troubling case for two reasons. First, while I am not a lawyer, based on my reading of hundreds of pages of court documents, the Schulhof family seems to have a strong and compelling case. What is disturbing is the extraordinary amount of time, money, and effort they have expended trying to get their money back. Justice is neither swift nor cheap. Second, if found liable, Jacobs will have to return the $1 million and pay some punitive damages. However, this is a civil suit filed by the Schulhofs, not a criminal complaint filed by the State of New York. As such, if convicted, Jacobs will not serve any jail time for defrauding the Schulhofs. But Joselito Vega, the forty-two-year old painter who stole $100,000 of art, served a year and a half in jail for his crime. Justice and proportionality do not seem aligned.

What can collectors take from this case? Aside from the obvious "be careful who you trust," be dubious of claims that buyers demand confidentiality for a deal to get done. This sort of claim is tossed around indiscriminately in the art world but is rarely a firm requirement. If pressed on the topic, the collector should put an intermediary, like a trust bank, in the middle of the transaction. By doing so, both sides of the transaction can be verified, while protecting the identities of each party.

Can a Collector Get His or Her Money Back When a Painting Is a Fake?

Since being elected the chairman of the Board of Directors of Sotheby's in March 2015, Domenico De Sole has been busy with the Sotheby's turnaround. He has also been occupied with a lawsuit to get his money back from the gallery where he bought a Mark Rothko painting that proved to be fake. Based upon court documents, De Sole and his wife bought the "Rothko" painting in 2004 from Knoedler Gallery in New York, paying $8.3 million for it. At the time of the purchase, Knoedler Gallery had an excellent reputation for sourcing works of art on the secondary market. In

connection with the sale of the Rothko, the De Soles received a letter from the gallery summarizing research on the painting's provenance, the names of experts who had reportedly inspected it, and an important written statement that concluded, "Knoedler warrants the authenticity and good title of the painting."[11]

Seven years later, the gallery suddenly closed amid rumors that it was selling fakes by Mark Rothko, Jackson Pollock, Robert Motherwell, and other artists. Two years after that, Glafira Rosales, a Long Island art dealer, admitted in federal court to participating in a scheme to sell more than sixty fake works of art to two New York galleries, one of which was Knoedler Gallery. She received approximately $33.2 million from the galleries for the fakes, which the galleries in turn sold to collectors for more than $80 million.[12] She created false backstories that the trove of paintings came from a private collector who acquired the never-before-exhibited-or-known works directly from the artists. Rosales' co-conspirators included Pei-Shen Qian, a seventy-three-year-old Chinese immigrant who came to the United States in 1981 and attended classes at the Art Students League. Investigators believe all the fakes were painted in Pei-Shen's home and garage in Woodhaven, Queens. Pei-Shen fled the country and is back in China. Knoedler Gallery claimed it had been duped by Rosales.

The De Soles filed suit against Knoedler Gallery to get their money back plus damages. In court documents, the De Sole lawyers presented evidence that Knoedler paid Rosales $950,000 in 2003 for the "Rothko" and then sold it to De Sole the following year for $8.3 million, a truly spectacular markup. The suit claimed the gallery should have realized that someone cannot buy an undiscovered authentic masterpiece at the price Knoedler paid for it. The gallery repeatedly said it was unaware the work was fake and that it had consulted numerous experts about its authenticity. As part of its defense, the gallery argued that sophisticated collectors like De Sole are responsible for their own due diligence and cannot rely just on statements from the gallery to make their purchase decision.

Expectations were high that *De Sole v. Knoedler Gallery* would create a court opinion on the responsibilities of collectors to do their own homework when buying a work of art and the responsibilities of galleries to investigate thoroughly the authenticity of works they sell. The jury trial began on

January 25, 2016. After two weeks of damaging testimony about the actions of the gallery, the parties settled out of court. The details of the settlement are unknown, but given the vehemence with which the De Soles pursued the case, they probably received not only the $8.3 million purchase price but also some compensation for damages.

What can collectors take from this case?

Beware of newly discovered works of art. It is hard for art forgers to make a living creating duplicates of known work. Instead, forgers tend to create work in the predominant style of the artist and pass it off as newly discovered work. Rather than "masterworks," they tend to make "solid" examples by the artist. Masterworks draw too much attention, which can undermine the scam. If presented with the opportunity to buy a newly discovered work without a reliable provenance, walk away. Run if it is being presented as an opportunity to buy something for a very good price.

Distinguish between different types of expert opinions. Three bodies of evidence can help determine whether an object is authentic: provenance, scientific evidence, and connoisseurship. Provenance is a record of who owned the work from the time it left the artist's studio to the current owner. The second is an assessment of the pigment, canvas, and stretchers to see if the materials were commercially available at the time the work was supposedly created. Both of these are largely objective opinions. Connoisseurship, however, is a judgment call that an expert makes based on a visual inspection of how the artist painted the work compared to other work the expert has seen over the years. But experts who render opinions based on connoisseurship are not all created equally. Some have dubious credentials, perhaps as an expert in one artist but not in the work of the artist in question. Moreover, the expert's judgment may be compromised because he will earn a success fee if the sale goes through. Even if he is a true expert, acting honestly, there is an asymmetry in how many experts express their views. Those who "believe" in the object speak up, while those who do not will either be unwilling to say anything or will only raise doubts in highly elliptical language to avoid risk of being sued by the object's owner. Because of this, potential buyers tend to only see evidence supporting the attribution.

As a preventative tool, wise buyers seek to embed in purchase agreements a requirement for galleries to represent that they do not know of any

information or evidence that would call into question the authenticity of the work. This is a great way to "flush the birds out of the tree." One case in the public domain relates to a "Jackson Pollack" painting the Knoedler Gallery tried to sell to Nicholas Taubman, the former US ambassador to Romania. As reported by the *Art Newspaper*, ". . . Taubman negotiated with Knoedler to purchase a 'Pollack' that had been evaluated by the International Foundation for Art Research (IFAR) that could not support the painting's addition to the artists' oeuvre. [Knoedler] never showed IFAR's report to the Taubmans. The deal fell through when Knoedler refused to sign a contract saying that it didn't know of any facts that called the authenticity of the painting into question."[13] Bravo to Taubman and his lawyer for adding this term into the proposed purchase agreement.

Beware of counterparty risk. Someone can provide a buyer with representations and warranties about authenticity, but will he or she stand behind them? The greater the time lapse between the date of purchase and the date the fraud is detected, the bigger a problem this becomes. For example, a collector who buys something from a sole proprietor takes on the risk that the dealer may not have sufficient resources in the future if the deal goes sour.

One collector I spoke with is working through this problem. This collector bought a very expensive nineteenth-century landscape painting from a small private dealer. A number of years later, he wanted to sell the work, but he was shocked to be told by auction house specialists they could not sell the work because it was not authentic. It took time and effort for the collector to track down the dealer, who retired in the intervening years. The dealer steadfastly denied the work was a fake and refused to return his money. The joy of owning the painting turned into a financial mess the collector is still trying to resolve.

EXHIBIT 5.1

EASY ACCESS TO INFORMATION ON HOW AN ARTIST'S WORK PERFORMS AT AUCTION

There are both subscription and free services to historical sale results from hundreds of auction houses around the world.

Subscription Services

These services enable a subscriber to:

- Determine whether a specific work of art was ever offered for sale at auction and the details around the sale (e.g., presale estimates, whether it sold and for how much, and at which auction house).
- Find similar works by the artist that have sold at auction so the collector can create a comparables database.
- Receive email alerts when work by the artist is included in upcoming auctions.

At least four companies provide subscription packages, from one-day passes that cost around $30 to annual subscriptions that cost around $400 a year, including:

- Artnet
- Artprice
- Askart
- Artvalue

Because these providers rely on the same underlying data, it is probably best for users to select one based on how much they like the user interface.

One note of caution: these services do not include information on the condition of the artworks. So if something did not sell or it sold for a low price, it may have been due to condition issues. But there is no way to determine that from the information provided.

Free Services

All the subscription services rely on data feeds from auction houses to populate their databases. Most auction houses provide free access to their specific data on their website.

Buying Is Easy, Selling Is Hard

The three Ds of death, divorce, and debt can turn collectors into sellers. But there is a fourth motivator that helps keep the art market going: discretionary sales. Examples include collectors selling to use the proceeds to collect in a different area or to support other needs, like funding college educations for grandchildren. Sometimes collectors sell because what they bought years ago is now too valuable to remain in their home—"an owner at $25,000, a seller at $250,000."

The purpose of this chapter is to help collectors understand different strategies and techniques they can use to sell artwork. The first section covers selling work by artists primarily sold through galleries who have not crossed over into the auction market. This is the largest part of the art-market-based sales volume. Next is a section focused on artists whose work regularly appears at auction. This applies to a smaller group of artists, but it represents most of the value of transactions in the art market. Advice on how to sell a collection comes next. I include a detailed account of how one family marshaled the ideas and tools described in this chapter and the appendix to achieve great sale results in 2015. If you only have time to skim this chapter, then be sure to take a moment and read "The Story of Jason and Lily." I wrap up the chapter with "Avoiding the Scoundrel's Corner (Part 2)," a reminder of how perilous it can be to navigate the art market.

For those curious about deal-making practices at the very top end of the auction market, there is an appendix with additional information. Consult

it if you want to learn about the mysterious world of enhanced hammer deals, how an auction house guarantee works, the difference between third-party guarantees and a house guarantee, and the third part of "Avoiding the Scoundrel's Corner."

WILL THEY OR WON'T THEY

It can be very tricky to resell work by artists who rarely, if ever, come up at auction. Hopefully the gallery where the work was purchased still represents the artist. But even so, it may not be interested in reselling it. More on that in a moment. For now, let's assume the gallery is interested in reselling the work. The collector has to rely on the gallery's judgment on what the object is now worth because there is no public market for the artist. The collector and gallery also need to select one of the three ways in which the gallery will be compensated for its important services:

1. **Flat Sales Commission.** Suppose the gallery believes it can sell the work for $20,000, but it wants to start with an initial asking price of $25,000. This spread gives the gallery some negotiating room with prospective buyers. With a flat sales commission, the collector and gallery simply agree on the percent of the final sales price the gallery will retain, perhaps 20 percent. Simple and easy, but the incentives of the collector and gallery are not necessarily fully aligned.

2. **Tiered Sales Commission.** Perhaps the gallery can push a buyer to pay $22,000 for the work. But if successful, the gallery would only earn an incremental $400 in commissions for selling the work for an additional $2,000. To better align incentives, a tiered sales commission is sometimes used. For example, the collector may agree to pay a 20 percent commission on a $20,000 sale but to then split sale proceeds above this amount.

3. **Net-to-Seller Deal.** The parties agree on the price (the so-called net price) the collector will receive from the gallery for selling the work. The gallery can then charge a buyer whatever it wants for it and keep all sale proceeds above the net price.

Let's return to the important question: How interested are galleries in reselling something they previously sold? Most of the time, they are not very interested, because the economics of a resale deal are inferior to selling new work by the artist. If the gallery sells a new painting for $20,000, the artist and gallery will most likely split sale proceeds, so each party receives $10,000. But if the gallery sells a $20,000 painting on resale using the compensation arrangements above, it makes less money, and the artist gets nothing. Many galleries will turn down reselling something unless it is owned by a very important client, or they will reluctantly accept the consignment but then put little energy into selling it. Only if earlier work by the artist has gone up considerably in value is there a path out of the woods for the owner. The gallery may then be interested because the sales commission on a higher-value older work may be greater than selling new work.

If the gallery passes on reselling the work, what can the owner do? Keep it and hope that it goes up in value over time. This is the harsh, yet often unspoken, economic reality of reselling art.

AUCTION HOUSE DEAL-MAKING

Collectors have more options for reselling work by artists who regularly trade at auction, because more galleries and auction houses are likely to be interested in the consignment. Competition among providers serves the interests of the seller. In addition to the gallery or auction house where the work was purchased, collectors should also ask people they trust for recommendations on other potential selling venues. Because galleries and auction houses create sale proposals all the time, collectors should know fairly quickly how many firms are interested in the work.

Getting proposals is easy, but picking the right provider is more nuanced. Evaluate the proposals along four dimensions:

- *Track record*. How good is the firm at selling work by this artist? For auction houses, the variables to look at include the number and value of lots they have recently offered by the artist and the sell-through rate, which is the percent of lots offered that actually sold. For galleries, the key is to understand their track record selling work by the artist in question,

not just whether they have relationships with collectors. For example, a gallery may have a great track record selling Contemporary art, but it is unlikely to be the right venue to sell a work by Magritte.

- *Marketing plan.* How will the object be promoted to potential buyers? For galleries, will it be included in an upcoming show? Will they take it to Art Basel or another art fair? For an auction house, how will it be promoted in the auction catalogue, online, and during the presale preview?
- *Personality and fit.* Who do you feel most comfortable working with? Who will keep you informed about how things are going with the sale process? Who will tell you the truth?
- *Financial deal.* The different ways a gallery can be compensated remain the same as in the previous section. But the compensation models used by auction houses are different, with their own peculiar nomenclature. More on that below.

A basic auction deal is anchored on the hammer price. The consignor agrees to pay a seller's commission expressed as a percent of the hammer price. For example, the seller's commission on a print may be 10 percent. If the print sells for a hammer price of $10,000, then the consignor will pay the auction house a $1,000 seller's commission and net $9,000. The seller may also be charged supplementary fees, such as marketing fees, insurance fees, and shipping and handling fees. The successful bidder on the object will pay the auction house a buyer's premium, also expressed as a percent of the hammer price. But in a basic auction deal, the consignor does not receive any of the buyer's premium; all that revenue stays with the auction house. The seller's commission rate and supplementary fees are negotiable and correlate to the value of the work being consigned (i.e., the higher the value of the work, the lower the seller's commission rate and supplementary fees). It is important to comparison shop across auction houses and ask for a discount. In auction house lingo, a "zero percent" deal is one where the consignor pays no seller's commission. A "zero percent, all-in deal" is where the auction house also absorbs all the supplementary fees.

For especially valuable property, say items worth a minimum of $1 million, auction houses may offer a consignor what is called an enhanced hammer deal or a guarantee deal. To learn more about these types of transactions, see "A Peek behind the Curtain" at the end of the book.

In addition to the financial deal, the auction consignment contract will specify the presale auction estimate that will be used to market the work. For example, suppose a collector consigns a Jasper Johns print. Based on how similar prints by the artist have sold, the print specialist may recommend a presale estimate of $10,000 to $15,000. This estimate will then be included in the formal consignment contract. As the date of the auction approaches, the print specialist will contact the consignor to agree on the confidential reserve price. This is the minimum price at which the consignor agrees the work can be sold. The reserve price can be no higher than the low end of the auction estimate. Auction houses often encourage consignors to set the reserve price at 80 percent of the low estimate.

As a general practice, auction houses try to get consignors to agree to the lowest possible presale estimate. The lower the estimate, the higher the likelihood the object will sell, which means the auction house will generate revenue from the consignment. A low estimate also helps to attract bidders, which is in the interests of the consignor. All it takes is two people who want the same object for auction magic to occur. But consignors need to be comfortable with the tension between attracting bidders via a low presale estimate and the possibility of the object selling at a low reserve price.

To win consignments, auction houses sometimes compete based on their auction estimates. It is similar to what real estate agents do to win business by suggesting the owner go with a higher initial listing price. Many real estate deals and auction consignments have been won this way, but it is not always in the interests of the seller. As in real estate, a high presale estimate may prevent potential art buyers from looking seriously at the work during the preview period and imagining what it would look like in their home. The risk to the consignor is that fewer bidders will be interested in the work, and the object may not sell because the reserve is too high.

FINDING THE NARRATIVE

Selling a collection is different from selling a single object, because the collector, executor, or family member overseeing the sale can get better selling terms than would be the case if the collection were sold piecemeal. In addition, they may benefit from a narrative being created around the

collection that helps attract buyers and lifts sale proceeds. A narrative is important not only for collections sold by celebrities but also for many other collection-sale situations.

Celebrity collection sales include the estate sales of Jackie Onassis in 1996 and Elizabeth Taylor in 2011 when jewelry, furniture, clothing, paintings, and bric-a-brac were offered for sale. Because of their fame, thousands of people wanted something owned by them and were willing to pay far in excess of fair market value for it. A piece of furniture that would normally go for $10,000 sells for $50,000; a piece of jewelry sells for twenty times what the equivalent object would go for at a resale jewelry shop. The imprimatur of the celebrity attracts bidders, lifting prices on both the great and the mundane.

Joan Rivers passed away in September 2014 after going into cardiac arrest during a routine outpatient procedure. In the summer of 2016, her estate sold some of her furniture, clothing, and jewelry at auction with a portion of sale proceeds going to two of her favorite charities: God's Love We Deliver and Guide Dogs for the Blind. One of the top lots was a silver bowl from Tiffany's engraved with SPIKE, the name of one of her favorite dogs. Used as a dog bowl, it sold for $13,750.

Fine art collection sales by celebrities also occur from time to time. Andy Williams, the singer known for his rendition of *Moon River*, his decade-long TV show that debuted in 1962, and his Branson, Missouri, theater, was a lifelong collector:

> Throughout my life, I have always been collecting. Every picture I ever sold I still regret. But I never gave up buying . . . I could not imagine a life without paintings. I look at my paintings every day. At night I will go into the living room and look at the Dubuffet because I love it so much. Then to the drawing room, to look at the Picasso, the de Kooning, the Diebenkorn. I could not imagine a room without art.[1]

His collection included great works by Postwar and Contemporary artists such as Ed Ruscha, Jean-Michel Basquiat, Willem de Kooning, Kenneth Noland, and Hans Hoffman; Impressionist and Modern Art masters like Paul Klee, Henry Moore, and Pablo Picasso; Latin American artists like

Wifredo Lam; American Modernists such as Milton Avery; and a choice collection of African and Oceanic art.

His collection was marketed via a dedicated catalogue and media campaign that described his passion and vision, along with separate catalogue entries in each of the auction catalogues where his property was offered for sale. Some objects traveled to Los Angeles, so they could be seen by prospective buyers from the entertainment industry who knew about Williams as an entertainer but perhaps not as a collector. There was a special exhibition of his collection in New York before the sales. The multipronged sales and marketing campaign worked: the collection had one of the highest sell-through rates of any collection sale and sold for more than $60 million when offered in 2013.

Finding the narrative in noncelebrity collections is just as important, because it helps the seller compete for the attentions of buyers. It forms the basis for an outreach program to potential buyers about why they should be interested in the work. When successful, narratives increase the percent of objects sold and lift the sale price of lower-value objects.

A Storied Name, But a Mediocre Collection

For more than thirty years, Simon collected contemporary art. By the time he passed away, his collection comprised more than 250 works of art. While a handful were very valuable, most of his collection was unfortunately comprised of mediocre works by well-known artists or works by artists currently out of favor. Selling the high-value objects would be easy, but creating a platform in which to sell all the other works was a problem that needed a solution. The key was using a narrative around the collector's considerable success as a businessman, supporter of political causes, and contributions he made during his lifetime to art-related nonprofits. His personal story became the way to draw an audience to look at the collection and consider buying something as a reminder of him.

A Tale of Two Collections

Sylvia and Robert's collection crossed two categories: Impressionist and Modern paintings the couple inherited from Sylvia's parents and a collection

of drawings they assembled by American and European postwar artists. The drawings collection was a capsule summary of the art during that time. To sell it, the best approach was an exhibition of the drawings at a gallery with a catalogue essay by an important scholar that was designed to attract connoisseur collectors. The primary selling narrative was about the quality and importance of the objects, with a secondary theme touching on the determination of the couple to find great works. The Impressionist and Modern paintings were different. There were only five of them, but none had any distinction (all of them being only solid examples by B-level artists). It was difficult to find a narrative that could credibly tie them together and make a difference to buyers. The couple decided to sell the paintings over time at auction.

THE STORY OF JASON AND LILY

Selling a collection is an important responsibility that can push collectors outside their comfort zones. So many decisions to make, so much money on the line, and so many questions about who to trust and how to proceed. Jason and Lily, siblings who want to remain anonymous, sold their mother's collection in 2015 after she passed away. Their story illustrates how to take advantage of the ideas and tools described in this chapter and the appendix.

Jason and Lily arrived at 6:30 p.m., exhilarated yet anxious about the events slated to start in thirty minutes. They grew up surrounded by art, a passion their parents shared together. But after their father died, and now their mother, it was time to let it go. Tonight was the first time that either of them attended an art auction, let alone an evening auction with more than $400 million of art for sale. They had one lot in the sale, a painting that used to hang in their parents' living room. The rest of the collection was scheduled to be sold over the next few weeks. Lot 12 would hopefully sell for at least $7 million, the rest of the collection for maybe $3 million. A great deal was riding on tonight, because the siblings were counting on using sale proceeds to help pay estate taxes that were due in four months.

The lobby was packed with people waiting to get their tickets and seat assignments. While a few people were blowing air kisses to each other, most were focused on getting through the line and into the auction room. Once

there, there would be plenty of time for preening. While being escorted to their seats, the siblings passed a pop-up bar near the main event—a bar without alcohol, just light refreshments and a few snacks. Auction houses want to avoid the risk of a bidder saying after a sale that they had been plied with alcohol and overbid as a result.

While settling into their seats, they scanned the audience. Older men with younger women, twenty- and thirtysomethings in jeans, couples in business attire. Given fashion today, it is hard to tell the billionaire from the gallery employee sent to bid on behalf of a client. Most of the fashion on display was of the dog-whistle variety, only recognizable to those in the know. It seemed as if recognizable brands, except for Prada, were too gauche for this crowd of approximately seven hundred.

The press was cordoned off to one side, maybe fifty people in total. Another side of the room was taken up with a phone bank filled with dozens of auction house staff primed to call people around the world who had registered to bid on one or more lots. An elevated podium at the front of the room was also filled with auction staff, each person standing alert, waiting for the action to begin. Looking up, Lily noticed skyboxes with what appeared to be one-way mirrored glass: private rooms for important clients who want to be incognito yet still in the center of the action. They would soon be communicating their bids by phone to the staff on the podium. Each skybox is catered according to the preferences of the client. From wings and beer to cheese and fine wine, it is hard to predict what those with the means and desire to spend $20 million on a work of art will want to eat and drink.

The light chatter in the room quickly ended with the sound of the auctioneer's gavel pounding on the rostrum. There was a brief welcome and then some unintelligible announcements about new third-party guarantees, lots being withdrawn, and people with a financial interest in certain lots potentially bidding that night. A confusing and inauspicious way to begin the night. And suddenly, lot number one was announced. Two people in the room bid on it, but most of the follow-up bids came from the phone bank. Sold. Lots 2, 3, and 4 also had many bidders and sold above their high estimates. For evening auction regulars, nothing surprising here. Auction house specialists spend a lot of time fretting over lot order to make sure the first lots have low auction estimates relative to their fair market value. This

helps create bidding activity so the show kicks off with a bang. It seemed to be working as planned tonight.

Lot 12 was really all that mattered to Jason and Lily. While it took maybe three minutes to sell a lot, it seemed like an eternity before Lot 12 was up for sale. Many collectors had supposedly expressed interest in the painting during the preview period. While Jason and Lily had no reason to believe this was not true, they wondered if auction house staff repeated this calming phrase to all their consignors. They had been told two prospective buyers sent independent conservators to inspect the painting and that three people had registered to phone bid on it. Estimated at $6 to $8 million, the specialists were confident Lot 12 would sell well that night. The last time the family had thought about the value of the painting was five years ago when it was appraised for $2.5 million. It would be a great night if it sold within the auction estimate.

Bidding opened at $5 million. Via a succession of quick hand motions from two bidders in the front of the room, bidding now stood at $6 million. But the phone bidders the specialists talked about had yet to materialize. Where were they? Would the bidders in the room continue to battle for the painting, or had the culling come to a quick end? Lily thought she saw some motion from the phone bank. Was it a bid?

Almost nine weeks before the evening auction, Jason and Lily wrapped up their negotiations to sell their mother's art collection. It had been two months of hard work to get to the point where they could confidently select the right firm. Because most of the value was tied up in one painting, they focused on picking the right sales agent for it. Maybe one firm should be retained to sell it, with a different provider hired to sell the remaining lower-value items? Maybe they should bundle all of the property together to get the best financial deal? Using input from an art advisor, Jason and Lily created a short list of firms to contact: three auction houses and one gallery.

After a few phone calls, they got to the right people. Once the auction houses understood the property that was in play, all of them were eager to meet Jason and Lily, inspect the property, and prepare sale proposals. The gallery, however, expressed little enthusiasm about selling the painting, per-haps because they were focused on selling other work from the artist's estate. They were also not interested in selling the lower-value objects.

Within three weeks of their phone calls, the auction houses inspected the property, prepared their proposals, and were ready to meet. The formal proposal review meetings were held back to back to make it easier to compare and contrast the firms. Proposals from two of the firms were elaborate documents with pictures, prose, and charts describing each firm's capabilities, approach to marketing and selling the collection, and auction estimates. The third proposal was shorter and lighter on content. All of the firms were reluctant to share ahead of time their proposed deal terms. But Jason felt it was important to get this information before the meeting so they could begin to process it. The proposals arrived early in the week, the deal terms on Friday. Over the weekend, their art advisor helped them assess the proposals and deal terms. They also started to strategize about how to get the best possible deal given all the apparent interest in the collection. Jason and Lily were ready with their questions when the first team arrived on Monday afternoon.

Each meeting lasted about ninety minutes. After the meetings, it was a two-horse race. The regional auction house that submitted its proposal was taken off the list because its auction estimates were too low. But when Jason and Lily dispassionately compared the marketing and selling plans from the two remaining firms, it was hard to identify any meaningful differences between them. Both firms recommended splitting the collection up and selling pieces in different auctions. How they proposed to market the collection in their catalogues was the same. They also had similar approaches for doing one-to-one marketing to top buyers with the capacity to spend $7 million on an object. Based on the marketing and selling plans alone, it was a draw between the two firms. It was only when they added in their personal reactions to the teams and who they would prefer to work with did one firm emerge with a slight advantage.

Unlike the marketing plans, there were substantial differences in the deal terms proposed by the two companies. For the valuable painting, both firms offered a choice of an enhanced hammer deal, where the auction house would rebate to Jason and Lily some of the buyer's premium paid by the successful bidder, or a guarantee deal, where the auction house guaranteed the painting would sell for at least a pre-set minimum (see the appendix for more on how these types of deals work). But for the guarantee deal, one firm was willing to guarantee it at a price that was substantially higher than the

other firm. If the family preferred an enhanced hammer deal, then that firm was also willing to rebate much more of the buyer's premium. This superior enhanced hammer deal would also apply to the entire collection. Things just got complicated. The firm who was at a slight disadvantage was offering superior financial terms.

With these opening gambits, the focus now turned to getting the best financial deal and incorporating the best elements of each firm's marketing proposals into the final contract. When one house was told about the superior deal from the other firm, it was quickly matched. The house with the stronger initial deal then elected to sweeten their deal by increasing the guarantee amount. A few days later, this was matched by the other house. This played out for a few more rounds. Their art advisor not only helped guide these conversations but also was at times the better person to ask the auction house for sweeteners. At the end of the process, the financial deals from both firms were now not only higher but also essentially the same. After some reflection, the family decided to go with the firm with the slight advantage coming out of the initial meetings. They also decided to go with the guarantee deal on the valuable painting for the assurance of knowing the painting would sell and that funds would be available for estate taxes. Their advisor made sure all the agreements and promises were properly reflected in the final consignment agreement.

Where were the phone bidders? After an uncomfortably long pause, someone sitting in the phone bank shouted "bidding." A phone bidder was finally in the game at $6.2 million. One of the bidders in the room then upped their bid to $6.4 million. But no counter response from the phone bidder. Despite coaxing from the auctioneer, no additional bids from the room either. And with that, the auctioneer brought his hammer down. Sold for a hammer price of $6.4 million, which was less than the guarantee amount. The auction house would have to dig into their pockets to make good on the guarantee. While the auction house probably had a frown on its face, the siblings were beaming. They were going to receive $7 million for a painting they believed not too long ago was worth $2.5 million.

Stepping back from Jason and Lily's experience, creating a plan to maximize proceeds from selling a collection involves thinking through four

topics: goals and constraints, collection value, sale options, and implementation plan.

Goals and Constraints

The first task is to make sure the collection is safe from potential damage or theft. Valuable collections sitting in an empty home of a recently deceased collector are exposed to pilfering and other risks. Likewise, messy divorces or sibling rivalries can sometimes lead to suspicious movements of valuable property. Next is to figure out the preferred timing for the sale. Do funds need to be generated quickly to pay estate taxes? Is the collection available for sale only after the residence where it is hanging has been sold? What about privacy? Some owners do not want their name attached to a sale, because they want to minimize publicity about how much money was raised. While a personal decision, the more privacy constraints placed on a sale, the more it may impede a sales agent's ability to create a narrative.

Collection Value

It is important to get a dispassionate view of the quality and value of the collection. Third-party appraisers and auction houses provide these services. Because valuing fine art is an imprecise science, get multiple views on fair market value. This is especially true for sculpture, which is harder to value than "flat art" because it has a narrower buyer base. In addition to understanding fair market value, shrewd collectors and their advisors also try to segment objects into four buckets: works with the potential for breakout prices; solid material with broad commercial appeal; work with the potential to increase in value over the next few years; and lower-value work or works with limited commercial appeal. This type of information can be useful in figuring out which objects to sell and the timing of sales.

Sale Options

Collectors have choices, such as sell the entire collection in one fell swoop, cherry-pick a few high-value objects and sell them privately, or use a credit

facility to bridge a short-term need for funds. To stimulate ideas, invite different selling agents to propose on how they can be of assistance. From this marketplace of ideas will emerge solutions. The best path forward will then depend on the financial deals that can be negotiated and who the collector or executor feels most comfortable working with.

Implementation Plan

While the selling agent(s) selected to handle the sale(s) will do most of the heavy lifting, it is important for the collector and her representatives to also decide who will monitor the agent's performance and be the point person for the numerous questions and issues that will arise during the sale process. For example, who is authorized to approve a private sale offer? To set reserves for an upcoming auction? To agree to a buyer's request for extended payment terms?

AVOIDING THE SCOUNDREL'S CORNER (PART 2)

The art market can be a perilous place for sellers to navigate. I want to conclude this chapter with three examples of potentially abusive business practices so that sellers can take steps to protect themselves.

Auction House Introductory Commissions

To win consignments, auction houses sometimes pay introductory commissions (IC) to people who can influence who the consignor selects to handle the sale. For example, a collector may be thinking about selling something from her collection. She is uncertain about how to proceed and who to contact. Hearing this, an art advisor offers to introduce her to the right auction house to handle the sale. The introduction takes place, which results some time later in the collector signing a consignment agreement with that auction house.

Unbeknownst to the collector, however, the advisor may have been sharing information about the collector with the auction house (e.g., what is motivating her to sell, whether she is a savvy deal negotiator, the type of

specialist team that will impress her). The advisor may be doing this because he has an agreement with the auction house to be paid a success fee based on the final hammer price. The more important the advisor's contribution to the auction house winning the consignment, the higher the IC he may receive.

Sometimes the consignor is aware of IC payments. But each auction house has its own policy regarding who is responsible for disclosing to the consignor that third-party commissions related to the sale of her property are being paid. Some stipulate that the IC recipient is responsible for disclosing this fee to the consignor, not the auction house. Other firms may include a reference to a third-party payment somewhere in the consignment agreement but will not disclose the size of the payment unless the consignor specifically asks about it.

Due to these disclosure practices, consignors may not be aware of the existence or magnitude of introductory commission payments or that information they thought confidential was being shared with the auction house. In these instances, the consignor is effectively paying the third party for services she never agreed to pay for. Moreover, the IC payment eats into the economics of the deal, because the consignor and auction house could have elected to share the fee paid to the third party in a different way.

Given these disclosure practices, what should collectors do to protect themselves? First, they should inform any auction house they are considering using that they must be informed of all third-party fee arrangements related to the sale of their property. Since an auction house is an agent for the seller, there should be no push back on this request. If there is, then the collector should immediately suspend discussions with the auction house. Second, this disclosure should be incorporated into the formal consignment agreement. More specifically, the auction house should provide representations and warranties that it will get the consignor's approval before making any payments to third parties related to the sale of the consignor's property.

Abusive Net-to-Seller Agreements

Earlier in this chapter, I mentioned the use of net-to-seller agreements as a way to compensate selling agents for their services. In this type of deal,

the consignor agrees to a price he is willing to take for his property (the so-called net to seller price), with all of the sale proceeds above this predetermined amount going to the selling agent. If the selling agent talks the consignor into accepting an artificially low net-to-seller price, this is abusive. But I want to talk about a different form of abuse involving a flat sales commission deal being combined with a net-to-seller agreement. This practice is sometimes called layering.

Suppose a collector signs an agreement with Dealer #1 to sell a work for a flat 10 percent commission. From the seller's perspective, she believes the most she will be paying the selling agent to work on her behalf is 10 percent of the final sale price. Shortly thereafter, Dealer #1 turns to another dealer to enlist his help selling the work. Dealer #2 may be a specialist in the work being sold, so he may have access to more buyers. Without informing the owner of the property that another dealer is now involved, Dealer #1 inks a separate net-to-seller deal with Dealer #2. For purposes of discussion, let's assume the dealers agree to a $1 million net-to-seller deal. Time passes and Dealer #2 finds a buyer willing to pay $1.5 million for the object. What happens now? After all the payments are made, the client receives $900,000 while the dealers pocket $600,000 in selling commissions. How in the world could that possibly happen?

Based on industry norms, once the buyer is identified, Dealer #1 would contact the seller and tell her the happy news that the dealer has been able to find a buyer willing to pay a strong $1 million price for the work. Based on this news, the seller agrees to move forward with the transaction. Dealer #2 then sends Dealer #1 the agreed upon net-to-seller price of $1 million and pockets $500,000 as his sales commission. Dealer #1 sends the consignor $900,000 and keeps $100,000 as his sales commission. Rather than paying a 10 percent sales commission, the consignor is really paying a 60 percent sales commission, equal to the $600,000 of commissions retained by the two dealers divided by the $1 million sale price the seller received. As an agent for the seller, Dealer #1 has an obligation to disclose all information on the deal to his client, including the existence of a third-party arrangement with Dealer #2. Because he failed to do so, the seller is completely unaware she has been taken advantage of.

One case where this type of agreement was litigated involved the sale of a drawing by Leonardo da Vinci.[2] Based on court records and press reports,

Accidia Foundation entered into an agreement with Daniella Luxembourg, a well-known dealer, to sell the work for a 10 percent commission. Luxembourg then enlisted the help of Simon Dickinson Fine Art, a well-known London dealer, to help sell the drawing. Dickenson signed a $6 million net-to-seller deal with Luxembourg. He ultimately found a buyer willing to pay $7 million for it. As per his agreement, he wired Luxembourg $6 million and retained $1 million. Luxembourg in turn transmitted $5.5 million to the owner and retained $500,000. Approximately a year after the sale, Accidia Foundation learned about the actual sale price and the sales commission earned by Dickenson. It filed suit seeking $1 million from Dickenson. Part of Dickenson's defense was that his compensation arrangements were common in the art world and that he did not have a fiduciary responsibility to the seller of the drawing. The court ruled, however, that Dickenson was an agent for the seller and, like Luxembourg, had a fiduciary responsibility to inform the seller of all financial arrangements. The court ruled that Luxembourg and Dickinson overcharged the client and were entitled to receive only 10 percent on the $7 million sale price, the commission rate the consignor initially agreed to with Luxembourg.

While selling agents have a fiduciary responsibility to their client, everyone in the art world is not fully aware of what this means. As a result, it probably makes sense for consignors to include language in their sale agreements that calls out the responsibility of the selling agent to inform them of, and gain their approval for, any third parties brought into the sale.

Sales to Related Parties

The art world is prone to whispers and gossip. From time to time, whispers pass about a selling agent making a killing by pushing a transaction through a third party in which he or she has a financial interest. For example, a consignor looking to sell something quickly enters into a sales agreement with a dealer. Knowing that speed is important, the dealer shortly thereafter tells the consignor he has found a buyer willing to move quickly, but the consignor will need to accept a lower price. The deal closes, with the dealer earning his sales commission. But the dealer fails to inform the seller that the buyer is really a third party in which the dealer has a financial interest.

For example, the dealer may have a separate company with another dealer friend that buys and sells art. At a later date, that company sells the work for a higher price, with each dealer then getting a portion of the markup.

Undisclosed deals with related third parties violate the selling agent's responsibilities to the original seller. But similar to abusive net-to-seller agreements, everyone in the art world may not fully understand their obligations to the consignor. Consignors should consider adding language to sale agreements saying that sales to third parties in which the dealer has a financial interest, or some sort of quid-pro-quo arrangement, are forbidden.

Unintended Consequences— Cultural Property, Endangered Species, and Taxes

Well-intentioned rules and tax laws can lead to unintended consequences. The art world is no different, though it has some surprising twists and turns for collectors.

ANDY WARHOL AS CULTURAL PROPERTY

Many countries limit trade in works of art that fall into country-specific definitions of cultural property.[1] But these restrictions no longer only apply to antiquities, Old Masters, and other "old art." They increasingly impact art made in the twentieth century. Because these rules are a restraint on trade, they can lower the value of art that must remain in the country and create potential title issues for collectors when sold abroad. While the United States has few restrictions on the import and export of art, rules in other countries can have surprising consequences for US residents.

Germany—Pushing Art Out the Door

Andy Warhol famously said, "Making money is art and working is art and good business is the best art." He probably loved that two of his early paintings were hanging in a casino in the German town of Aachen. On their way

to slot machines and poker tables, gamblers walked past *Triple Elvis*, a 1963 silk-screen painting of three life-size images of Elvis on a silver background, or *Four Marlons*, a 1966 silk-screen painting of four life-sized images of Marlon Brando on a motorcycle. Purchased in the late 1970s for $185,000, or what today would be close to $750,000, the paintings were part of a plan to glamorize an otherwise off-the-beaten track gambling parlor.[2] With the passage of time, the casino conglomerate that owned the Aachen operation fell on hard times. In 2014, the German state-owned bank that then controlled the company decided to sell the paintings. As assets of a troubled company, the sale was a reasonable action by the owners to raise funds. But protesters emerged claiming that this was a dangerous sale of cultural property owned by a state-run financial institution. The sale went ahead anyway, with the works selling for a staggering $151.1 million.

The sale, however, led the German culture minister to advocate for tough new rules to limit the export and sale of artwork.[3] In July 2016, the German parliament passed legislation at the minister's behest. Owners of works of art worth more than 150,000 Euros that are at least fifty years old now need an export license for the work to be shipped out of the European Union.[4] Officials in each of Germany's sixteen regions also now have the authority to declare a work in their region to be of national significance. They can then bar it from leaving and restrict sale to individuals or institutions in Germany. The rules apply to art by both deceased and living artists, and artists of all nationalities.[5] The culture minister indicated that if the rules were in place in 2014, she would have blocked the export of the two Warhol paintings.

Bureaucrats love rules but often overlook or ignore unintended consequences as they try to control markets. While the legislation is new, German-based collectors already are taking action to get art out of Germany. "The majority have already shipped their most valuable works outside of the country. Artworks now have an expiration date. This law serves as an added impetus for collectors to sell works once they near the date where export might prove difficult," said Daniel Hug, director of Art Cologne, in a recent interview with Artsy.[6] While German collectors are made worse off by these rules, who benefits? Collectors in the United States are likely to have smiles on their faces as art flows out of Germany and becomes available for sale.

Italy—a Thicket of Rules

In the land that many people believe invented bureaucracy, the fine art export rules do not disappoint. Artwork that is at least fifty years old and created by a now-deceased artist needs an export license to leave the country. As of 2017, this impacts art made before 1967. It applies to all deceased artists, not just artists of Italian heritage. So a collector in Milan with an Andy Warhol from 1965 needs an export license for it to leave the country. Aside from vacationing in Italy, Warhol is not typically associated with "Italian art"; his parents immigrated to the United States from Slovakia. He was born and raised in Pittsburgh.

The law forces Italian collectors to be on "death watch," because the export status of works in their collection can change overnight when an artist passes away. The rules also apply to art independent of its value, unlike in Germany. So every Warhol created before 1967 that is in Italy, be it a $5,000 print or a $5 million painting, needs an export license to leave the country. Securing a license is time consuming, plus it creates incentives for side deals and other forms of bad bureaucratic behavior. The Ministry of Culture is also permitted to declare an artwork of national importance. It can then block an artwork from leaving the country and limit its sale to only Italian residents or institutions. The laws also apply to expatriates living in Italy.[7]

Elena Quarestani, an Italian collector with a Salvador Dali painting, is dealing with the consequences of these rules. As reported by the *Guardian*, ". . . local officials in Milan have claimed that the portrait [by Dali] should be protected as a piece of Italian cultural heritage. That assessment has given the government the right to block an attempt by Christie's, the auction house, to sell the painting for Quarestani. It also blocked an offer by the Dali Foundation [based in Spain] to acquire the work. . . ."[8] What makes this ruling so arbitrary is that this is an early work by Dali that does not incorporate any motifs for which he is known. But for being by Dali, the painting would likely be worthless based on artistic merit alone. Works like this typically appeal only to connoisseur collectors of the artist or to an institution devoted to him, neither of which is likely to be found in Italy. Restricting the sale to Italian buyers is tantamount to forcing the owner to sell the work at a discount. But owners have no recourse to the government to be compensated for their loss.

As in Germany, US collectors benefit when Italian collectors move art out of the country. Consider Arte Povera, an important art movement that originated in Italy in the late 1950s and early 1960s. Many Italian collectors with works by these artists moved them out of the country before the fifty-year rule would apply. The availability of works on the international market made it easier for galleries to host shows devoted to Arte Povera, many of which occurred over the past five years in New York and London. The Italian rules created unintended buying opportunities for US collectors.

Collectors also need to be alert to potential title issues associated with the Italian laws. Because art is portable, some Italian owners may elect to spirit works out of the country without getting the needed approvals. Buyers in the United States could then inadvertently purchase a work that may be subject in the future to a claim by the Italian government. As a result, it is important for collectors acquiring work by Arte Povera artists made before 1967 to vet the provenance of the work to make sure needed export licenses were obtained. The same is true, unfortunately, for a buyer of an early Warhol that was in an Italian collection.

Mexico—the Markets for Work by Diego Rivera and Frida Kahlo

Like much of Europe, Mexico has comprehensive laws governing trade in fine art. But for certain artists, like Diego Rivera and Frida Kahlo, the government bans outright the export of their work.[9]

Under Mexican law, the government can declare an artist a national treasure. Work by the artist is then subject to the rules and regulations of either the National Institute of Anthropology and History (INAH) or the National Institute of Fine Art (INBA). In addition to care, maintenance, and restoration rules, both institutes require all work in the country by these artists to remain in Mexico. Sales are permitted to collectors or institutions within the country, but sales outside Mexico are forbidden. Violators are subject to criminal prosecution.

Diego Rivera went on the list when he died in 1957. Born in Mexico in 1886, Rivera had a long and prolific career. He moved to France in 1907 when he was twenty-one and stayed for fourteen years. He returned to

Mexico in 1921 and remained there but for travel abroad for major fresco commissions in San Francisco, Detroit, and New York and numerous gallery and museum shows.

Frida Kahlo, a young art student, met Diego when he was already an international art star. They married in 1929 when he was forty-two and she was twenty-two. They had a fractious and combustible relationship. Kahlo died in 1954 when she was forty-seven. During their lifetimes, Diego was the rock star while she was on the margins artistically. Her posthumous career took off in the 1980s when retrospectives of her work occurred outside Mexico and books and movies about her personal narrative increased her visibility. Because she traveled constantly with Diego and suffered from physical limitations due to a bus accident, Kahlo did not create much work. Carmen Melián, a leading advisor on Latin American art who previously ran the Latin American Department at Sotheby's, estimates that Kahlo completed around 150 paintings and about as many drawings. As Kahlo's popularity rose, so did calls within Mexico for the government to declare her a national treasure. Kahlo went on the list of protected artists in 1981.

Paintings by Rivera and Kahlo that must remain in Mexico sell for less when compared to prices achieved internationally for works of comparable quality. Melián estimates that a Rivera work restricted to the Mexican market would likely trade at a 20 to 30 percent discount. For Kahlo, the discount is likely closer to 40 percent. The larger Kahlo discount is due to her work being much more popular outside of Mexico. Collectors who covet her work bid up the price relative to what Mexican-domiciled collectors and institutions are willing to pay.

BUTTERFLY WINGS AND ANIMAL SKINS

While artists have used oil paint, marble, and bronze for centuries, nontraditional items like butterfly wings, animal skins, and stuffed animals have crept into the artist tool kit over the past one hundred years. For example, an iconic work by Meret Oppenheim from 1936 consists of a teacup, saucer, and spoon covered with the speckled tan fur of a Chinese gazelle. Titled *Object*, it is a very popular item in the collection of the Museum of Modern Art. More recently, Damien Hirst makes large

paintings covered with dead butterflies, while Anselm Kiefer uses animal skins in some of his paintings and sculptures.

But collectors owning work with unconventional materials can suddenly find themselves ensnared in complicated rules and regulations regarding the transport and sale of endangered and threatened species. First, a bit of history. In 1973, eighty countries signed an international agreement called CITES (the Convention on International Trade in Endangered Species of Wild Fauna and Flora) to limit trade in animals and plants whose survival was threatened. CITES was a framework governments used to create national laws. In the United States, CITES was incorporated into the Endangered Species Act signed into law by Richard Nixon on December 28, 1973.

The Endangered Species Act, however, is just one of many federal and state rules that restrict trade in endangered species. The Migratory Bird Treaty Act makes it illegal for anyone to take, possess, import, export, transport, sell, purchase, barter, or offer for sale any migratory bird, or the parts, nests, or eggs of such a bird without a valid federal permit.[10] The Bald and Golden Eagle Protection Act prohibits anyone from acquiring or trading bald eagles, including their parts, nests, or eggs. There are also state-based rules covering different types of fauna and flora, such as regulations created by the California Endangered Species Act (CESA).[11]

US collectors need to be in compliance with all of these rules and regulations. A famous example of a collector getting tripped up by them was Ileana Sonnabend, the gallerist and collector mentioned in Chapter 2. She owned an iconic Robert Rauschenberg work from 1959 that incorporates a stuffed bald eagle.[12] But the Bald and Golden Eagle Protection Act makes it illegal to possess bald eagles, whether dead or alive. The issue came to prominence after Sonnabend passed away in 2007 and her collection was valued for estate tax purposes. Because of the regulations, the estate deemed the Rauschenberg worthless. The IRS, however, valued it at $65 million and demanded $29 million in estate taxes. The estate challenged the judgment in tax court. The parties settled with the IRS dropping its demand for estate taxes in exchange for the estate donating the work to a museum but with the value of the gift being zero.

Compliance issues do not stop at US borders. Because CITES is a framework, country-specific implementation can result in stricter or looser

rules than those in the United States. This complicates things for collectors, because movement of artworks between countries must comply with rules from both the sending and receiving countries. For example, a US-based collector may buy a painting in London that incorporates butterflies in compliance with UK rules. But the United States may have a different list of protected butterflies. So if the work has one butterfly on the US-specific prohibition list, then the collector will not be able to bring it home.

When collectors are considering artwork that incorporates unconventional materials, they need to ask a lot of questions to understand whether any of the materials are subject to use prohibitions. The seller may provide them with written documentation, but the buyer should double- and triple-check them, because the seller's facts may be out of date (e.g., flora and fauna are regularly added to endangered and threated lists) or the seller may not fully reveal all information in a rush to get it sold. Because materials are part of the condition of the work, buyers generally have no recourse to get their money back if they later discover the work contained restricted materials.

Auction houses try to be especially transparent about the risks bidders take on when they buy something with restricted materials. For example, Phillips includes the following statement in its auction catalogues:

Before bidding for any property, prospective buyers are advised to make their own inquiries as to whether a license is required to export a lot from the United States or to import it into another country. Prospective buyers are advised that some countries prohibit the import of property made of or incorporating plant or animal material, such as coral, crocodile, ivory, whalebone, Brazilian rosewood, rhinoceros horn or tortoiseshell, irrespective of age, percentage or value. Accordingly, prior to bidding, prospective buyers considering export of purchase lots should familiarize themselves with relevant export and import regulations of the countries concerned. It is solely the buyer's responsibility to comply with these laws and to obtain any necessary export, import and endangered species licenses or permits. Failure to obtain a license or permit or delay in so doing will not justify the cancellation of the sale or any delay in making full payment for the lot. As a courtesy to clients,

Phillips has marked in the catalogue lots containing potentially regulated plant or animal material, but we do not accept liability for errors or for failing to mark lots containing protected or regulated species.[13]

GENEROSITY, TAXES, AND LEGACY PLANNING

Taxes impact the behavior of collectors and artists in some surprising ways. In the balance of this section, I share how the tax system in the United States rewards art investors but penalizes collectors, discourages living artists from donating their work to museums, spurs wealthy collectors to open private art museums as a tax-efficient way to collect art, and leads many families to avoid legacy planning around their art collection.

As you read this section, remember that the examples are offered for educational and informational purposes only. The examples reflect the tax code as of 2016.[14]

Art Investor or Collector?

Suppose many years ago a collector fell in love with a painting, bought it for $10,000, and hung it in his living room. Since then, the artist's career has taken off, and the painting is now worth $400,000. Lucky collector. But he now wants to sell it and use the proceeds to buy different artwork that is more consistent with his current tastes.

From the perspective of the government, selling the painting is a taxable event. Since the painting was held for more than one year, the collector needs to pay long-term capital gains tax on the $390,000 increase in value. At the federal level, the collector may be required to pay a combined 31.8 percent tax on the gain, leaving him with $276,000 after taxes to buy art.[15] The story ends there for collectors. But suppose the facts and circumstances change so the owner of the painting held it for investment purposes. Then it may be possible to defer paying capital gains taxes on the sale and have $400,000 to spend on art. Interesting news. How does it work?

The key is Section 1031 of the Internal Revenue Code. When investors sell property that has increased in value, for example an apartment building, they pay capital gains taxes in the year of the sale. But Section

1031 permits investors to *defer* paying the tax if they reinvest the proceeds in similar, like-kind property (i.e., another apartment building). Section 1031 Exchanges, also called Like-Kind Exchanges, have been part of the tax code for years and are frequently used by real estate investors. Investors in art can potentially use the 1031 exemption to defer paying capital gains taxes on a sale as long as they reinvest the proceeds in like-kind art. The Internal Revenue Service has not provided specific guidance on what "like kind" means for artworks. Tax advisors, as a result, tend to advise clients to exchange paintings for paintings, sculpture for sculpture, and drawings for drawings.

What defines an art investor? This is the critical question, because *only* investors can take advantage of 1031 Exchanges. There is no single fact or behavior that categorically determines whether someone is an investor. If the owner never sold anything meaningful from her collection and she displayed the artwork prominently in her home, then the IRS will most likely view her as a collector, not an investor. Investors own art principally to earn a profit, rather than for personal enjoyment. Tax advisors believe the IRS will view taxpayers more favorably as investors if they have regular collection appraisals done by professionals; take steps to increase the value of the collection by, for example, lending works to museums; keep detailed records of purchases and sales; seek advice from art experts on purchases and sales; and present themselves to galleries and auction houses as art investors.

Given the tax benefits associated with being an investor, many art world participants use like-kind exchanges when they make changes in their art collection. It has been a very important factor over the past ten years fueling art market turnover. The rules and regulations around like-kind exchanges are complex and need to be followed assiduously. As a result, a qualified tax advisor should be involved to help handle all the issues associated with using this important tax-planning tool.

Why Living Artists May Be Less Generous

Americans are extraordinarily philanthropic. The Charities Aid Foundation recently ranked the United States first among twenty-four countries based on the value of charitable giving when expressed as a percent of GDP.[16]

Some of this generosity is due to the US tax code rewarding charitable giving. When making a donation, donors can generally deduct the value of that contribution when calculating their income taxes. While the value of the deduction will depend heavily on the donor's specific circumstances, for those with high income, it is often times approximately equal to their marginal tax rate times the value of the donation. What does this mean? At the federal level, the highest tax rate on ordinary income is currently 39.6 percent.[17] So if someone donates a $500,000 painting to a museum, the value of that donation may reduce his federal income tax bill by up to $198,000 in the year of the donation. In economic terms, it means the contribution of the $500,000 painting did not really cost the taxpayer $500,000, but instead $302,000 after accounting for his tax savings.

While collectors enjoy this important tax benefit when donating art, the same is not true for artists. If artists donate something, they can only deduct the cost of the materials they used to create the work. So if a collector, for example, donates a Jasper Johns drawing worth $500,000, he can deduct the $500,000 gift and potentially reduce his federal income tax bill as discussed above. But if Jasper Johns the artist donates a $500,000 drawing, he can only deduct maybe $20, the cost of the paper and pencils he used to create it. His tax savings, as a result, are essentially zero. So by donating it, he is out $500,000 in value, while it costs the collector $302,000 to make the same type of donation. Not surprisingly, many artists do not make lifetime donations of their work to museums.

When an artist passes away, however, the rules change. The tax code now values the artist's work at fair market value, and it is subject to estate taxes. The executor will need to work with an appraiser to value all the art in the estate. This can be challenging, because each artwork is unique and varies in quality. Moreover, the appraiser needs to factor into the assessment the potential negative impact of a large number of works coming to market and the impact of the artist no longer being available to market works to buyers.

For commercially successful artists, their federal estate tax liabilities can be quite substantial. If the value of all of their assets, less debt, is greater than $5.45 million (the 2016 federal estate tax exemption), then the estate will have to pay 40 percent of the amount *above* the exemption amount in estate taxes.[18] Depending on where the artist lived, the estate could also be liable

for additional state-based estate taxes. As the value of art has increased, more artists are realizing they need a legacy plan. An artist foundation can be an important tool to help reduce estate taxes, because the estate can deduct the fair market value of work donated to the foundation, rather than just the cost of materials used by the artist. It can also provide a platform to continue promoting the artist's work.[19]

Because so much of the value of an artist's estate is likely to be made up of illiquid art assets, the IRS recognizes the estate will need time to raise funds. The IRS is generally willing to put the estate on an installment plan that can last for ten years or more. But for collectors, estate taxes have to be paid within nine months. In death, artists finally get a better deal than collectors.

Private Art Museums as a Tax-Efficient Way to Collect

Art museums in the United States live on the generosity of individuals. Most of the support art museums rely on for their annual operating budgets comes from individuals or foundations and trusts set up by them.[20] The Association of Art Museum Directors also estimates that more than 90 percent of the art objects in public art museums were donated by private individuals.[21]

Collectors enjoy important tax benefits when they donate art to public art museums, as described in the previous section. But in addition to public art museums, extremely wealthy collectors have another choice: create their own private operating foundation. For example, suppose a wealthy collector has a very large collection of prints by Andy Warhol, Frank Stella, James Rosenquist, and other artists. The collector is passionate about enabling art museums in underserved communities around the United States to use his collection for shows he will fully underwrite. Because this is a passion project that would be hard to implement and control through a public museum, the collector may instead elect to create a private operating foundation. Donations of artwork and cash to a private operating foundation enjoy the same tax benefits as donations to a public art museum. Furthermore, all the costs incurred to insure the collection, store it when is it not on tour, framing and conservation, plus staff costs associated with curating shows and running the foundation are tax deductible.[22]

More and more very wealthy collectors who want to realize a vision and create and shape a legacy are considering private operating foundations. It is also a very tax-efficient way to collect, because they can deduct for income tax purposes the fair market value of the collection they donate and ongoing operating costs. In addition, they can deduct new acquisitions they contribute to the foundation. Tom Hill is a recent example of a collector creating a private operating foundation. Hill and his wife will open a two-story public exhibition space in New York in the fall of 2017.[23] The foundation will host shows of their collection of twentieth-century and contemporary art, including fourteen works by Christopher Wool, the artist profiled in the beginning of Chapter 4. They also have a collection of Renaissance and Baroque bronzes that will be on display. They plan to partner with the Frick Museum, the Studio Museum in Harlem, and the Metropolitan Museum of Art to run arts education programs for New York City school kids in their new exhibition space.

Private art museums have been an important part of the American cultural landscape for years. The list of museums that either started out as a private foundation or remain that way today include the Whitney Museum of American Art, the Guggenheim Museum, the Frick Collection, the Amon Carter Museum of American Art, the Phillips Collection, the Barnes Foundation, the Ronald Lauder Neue Galerie, the Isabella Stewart Gardner Museum, and the Crystal Bridges Museum of American Art.

Like anything involving money and taxes, there can be abuses. The tax status and behaviors of private operating foundations regularly attract IRS and congressional scrutiny. The Senate Finance Committee, for example, announced at the end of 2015 a review of whether private art museums provide enough public benefits to justify their tax-exempt status.[24] Robert Storr, the retiring dean of the Yale School of Art, expresses the concern of many: "I'm not against it [private art museums], but it's got to be done well. If there's to be a public forgiveness for taxes there should be a clear public benefit, and it should not be entirely at the discretion of the person running the museum or foundation."[25]

What does this ongoing scrutiny mean for collectors thinking about setting up a private operating foundation? Tax and legal experts typically advise:

- *Access and outreach.* Provide frequent and regular access to the collection. Promote the museum and how the public can access it. Advertise. Run education programs and other events that draw in the public. Keep attendance records so there is a clear record of public use and engagement.
- *Location and signage.* The collection should be displayed in a separate facility with clear and distinct signage that the museum is open to the public.
- *Use of property.* Once an artwork is donated, it is no longer an asset available for personal use. Do not temporarily loan a work back or create a rental program where the donor pays the foundation a fee to use a work of art. Do not use the museum for personal events.

IRS scrutiny of private museums will likely increase due to the recent Senate Finance Committee investigation. When the Committee turned over its findings to the IRS in June 2016, Orrin Hatch, the committee chair, said:

> As Congress lays the groundwork for a comprehensive overhaul of the tax code, we must learn as much as we can about how the tax code works in practice, including how certain entities are using tax-exempt rules to found and run art museums. Under the law, these non-profits must provide a significant public benefit to merit tax-exempt status. And while most museums work every day to meet this standard, it is clear there are a number that should do more.[26]

Legacy Planning

Planning how to distribute a collection passionately assembled over a lifetime can bring up difficult questions about mortality, family dynamics, and taxation. No wonder so many collectors keep the topic "stuffed in a drawer." Even those who embark on a journey to figure out what to do can run into surprising roadblocks.

Understanding and Managing Resentment

Tom and Hillary spent a lifetime collecting. They love the thrill of the hunt and being part of the art-world community. They continue to be

active collectors but at a much diminished pace from their peak collecting years. They have three adult children, all with their own independent lives. Their children enjoy the collection, but it is more about the value of it than a love or deep appreciation for the artworks themselves. None of the children have homes or lifestyles that are consistent with owning valuable art. Moreover, they all harbor different levels of resentment toward their parents for all the time and money they spent collecting. The children keep their views about their parents' "pride and joy" tucked away, but every indication is that they will sell the collection immediately once their parents pass. Two museums where Tom and Hillary are active have their eyes on some of the works in the collection. A ground war already broke out between the museum directors who are each trying to position their institution for important bequests. Tom and Hillary's children caught wind of this, which only increased their sense of resentment and concern about how the collection will be treated when their parents pass away.

Generosity That Backfires

Beth and John are active collectors. They have two sons, both of whom like art and have since become collectors in their own right. A number of years ago, when the sons were adults, Beth and John elected to gift a painting to each of them. Because the sons are intensely competitive with each other, the parents knew it was important to do this in a transparent way so that neither son would feel the other got a better deal. Beth and John gave their sons copies of their collection appraisal document. They were told they could select something, but it had to be worth no more than $250,000. Not surprisingly, both of them picked objects worth close to the $250,000 value limit; luckily it was not the same object. The sons were very grateful. An implicit, but not explicit, part of the parents' gift was that the sons would not sell the works. Ten years later, one painting was struggling to maintain its original value while the other was worth multiples of that amount. The son with the more valuable painting decided to sell it. The son with the less valuable painting cried foul and demanded his brother share sale proceeds with him, which he refused to do. The aggrieved son then approached his mother, who was the only surviving parent at the time and asked her to

adjust her will to compensate him for his brother's actions. No good deed goes unpunished.

Who to Trust When It Comes Time to Sell a Collection

Seymour, a self-made businessman, has assembled a valuable collection in multiple categories with his wife. They are very philanthropic and have arranged their estate so that the entire collection will be sold after they have both passed away to fund charitable causes that are important to them. Until that time, they intend to live with the collection. Their children, who are not collectors, applaud their parents' plan to donate much of their wealth to charity. Seymour is confident that his trust and estate lawyers did a great job planning the estate, but he is concerned about how that team will execute the plan to sell the collection. Given the size and scope of it, selling the collection will be a long and complicated task. Because every dollar raised from the sale will go to charity, Seymour wants to make sure someone schooled in the art world will act on their behalf as a fiduciary to maximize sales proceeds and minimize sale costs. He is deeply concerned about who to trust for this important future assignment.

These stories illustrate the need for collectors to have a legacy plan for their art collection that they understand and believe in. Here are some closing thoughts on how to create one.

The first step is a candid assessment of the *family's goals and attitudes* toward the art collection. The type of questions to be answered include: How important is it to keep the collection intact during the collector's lifetime? After the collector passes? What promises, either implicit or explicit, have been made to family members, museums, or other institutions? Are potential heirs ready and able to take responsibility for the collection, or are they primarily interested in what it is worth and how it will be distributed to them?

Next is to understand *collection value and risk*. Collectors need to get fair market value (FMV) estimates for each item in their collection.[27] Professionals should be brought in to provide this information. It is also important to identify where there is valuation risk in the collection. For example, which artists in the collection have peaked in value versus artists who may see meaningful appreciation over the next five years? Having a perspective

on risk is important, because it can influence which works to sell, gift, or donate.[28]

Armed with this information, collectors need to step back and think about a *collection dispersal plan independent of taxation*. Taxation will no doubt influence the ultimate plan, but collectors can get wrapped up on tax issues too early in the process. It is generally better for them to first think through what they would ideally like to accomplish with the collection. Their tax, legal, and financial advisors can then help them weigh alternative methods to achieve it.

Legacy planning can bring up uncomfortable issues that some collectors and their families may prefer to avoid. But deferring decisions about the fate of a collection can lead to disagreements and bad feelings among the heirs as well as higher estate taxes than would be the case with advance planning. The worst outcome is when the wishes of the collectors are not implemented after they pass because the heirs did not understand what they wanted done or the sale was entrusted to unqualified or unscrupulous sales agents. Although there is no way to make legacy planning simple, it is important to remember that only three things can be done with the collection during either the collector's lifetime or posthumously: sell it, donate it, or gift it. You can't take it with you.

Making Their Way—New and Prospective Collectors

This chapter is for those who would like to collect art but are not sure where to begin. The stories below trace the journeys of three new collectors who bought work that was personally meaningful to them and within their financial reach. I hope the stories stimulate you to pursue your own art collecting passion.

A TOE IN THE WATER

April and John, Chicago natives in their mid-forties, were interested in collecting art but found the contemporary art-buying experience to be intimidating and off-putting. April, who runs a business, and John, who is a partner in a management consulting firm, are no shrinking violets. They are intelligent, driven, and thoughtful people with an awareness of Modern and Contemporary art from spending time in museums. As part of a home renovation, they set aside $75,000 to buy contemporary art. But they were not sure where to begin. A decorator was helping them select furniture, rugs, and other items, but they wanted the art to be more than just decoration. It had to reflect their interests and tastes and be something they felt comfortable sharing with friends and family. With two children and demanding jobs, they did not have time to visit art fairs or spend weekends at galleries. They also needed to find things within six months so they could "declare victory" on the renovation.

While April and John are financially comfortable, they certainly did not want to spend $75,000 on art that could become worthless and unsaleable. Like many collectors, they wanted to buy things that had the potential to increase sharply in value over time. But they understood this would require spending more time looking at art and taking more risk than they were prepared to do. A close collector friend introduced them to his art advisor. However, after one conversation, they were disappointed and bemused to learn that $75,000 was not enough for the advisor to be interested in helping them. Despite the art advisor's response, they found two affordable ways to fill their home with artwork by important artists.

Artists have been making prints since the Middle Ages, a practice many contemporary artists continue to this day. A print is a unique work of art the artist creates in collaboration with a publisher, and then issues for sale in a limited edition. Jasper Johns, for example, created hundreds of prints over the past forty years using different techniques like lithography, silk screen, and etching. After the artist creates and approves the image, a finite number of copies are made of it. Johns then signs each print with his name and a notation indicating the number the print represents in the total edition (e.g., 5/75 where the first number refers to print number and the second number indicates the total number of prints in the edition). Rembrandt, Picasso, Warhol, Lichtenstein, Richter, Kusama, and scores of other living and now-deceased artists have created limited-edition prints. It is an affordable way to buy art by important artists. Prints are sold in both the primary market (an artist creates a new print that is sold through the publisher and galleries) and the secondary market (auction house sales devoted to reselling prints or galleries selling a print on consignment from a collector).

April and John found buying prints at auction to be the best option for them. They had a lot of works to choose from, because the major auction houses, regional auction firms, and online auction specialists like Paddle8 and Artsy hold numerous print sales every year. All the auction catalogues were available online, so it was easy to learn about what was coming up for sale. They also liked that many of the prints for sale were by well-known artists they already knew. They believed these works had a better chance of maintaining their value over time. Because of the sheer volume of prints offered at auction, they also learned that many sell for less than what similar

work would cost at a gallery. They liked the idea of potentially getting "a deal." They focused on prints that cost less than $10,000. They bid in multiple auctions and bought prints by artists like Jasper Johns, Sol LeWitt, and Robert Rauschenberg. For them, it was a very pleasant buying experience.

After their print-buying spree, they decided to keep going, but in a different area. A committed *Vogue* subscriber, April was delighted to learn that limited-edition photography by top *Vogue* photographers like Irving Penn, Helmut Newton, Richard Avedon, Bruce Weber, and Annie Leibovitz are sold in galleries and at auction. Like contemporary prints, fashion photography is sometimes less expensive at auction. April used one of the auction pricing services mentioned in Exhibit 5.1 to research the type of fashion photography being sold at auction and what it typically sold for. She was soon having conversations with photo specialists about upcoming items and putting in bids.

While April and John were happy buying at auction, many people do not have the time or interest in scouring multiple auction catalogues, dealing with the intricacies of auction bidding, and then having to arrange for pickup and shipment. For them, buying prints from established publishers like Gemini and Paragon Press, or a new publisher like Twyla, is a better solution.

SEARCHING FOR WHAT IS AROUND THE CORNER

Jim and Travis have been interested in art for years: Travis was an art history major in college while Jim grew up in Europe and spent time with his family visiting art museums. While interested in art, neither of them grew up in collecting families. Art was something you visited in museums, not what you put on the walls in your home.

They started thinking about buying art after seeing what some of the senior partners at each of the firms where they worked were collecting. Because Jim works in private equity and Travis in marketing, many of their senior colleagues were collectors. When the couple moved to a new home and needed to decorate it, they decided to start collecting. Because they tend to approach things in an analytic way, they spent time batting around different ideas of what to collect, including Old Masters and prints. They decided

to focus their energies on learning about and collecting work by young art-ists. It would certainly be more affordable than buying "blue chip" art, some of which they could afford. But more importantly, they did not want to buy the type of art they felt their senior partners were buying: expensive works to display in their homes to signal their wealth. They talked about Warhol being one of the last artists they would collect. Not because Warhol is boring or unimportant, but because he has become too much a trinket of wealth for them.

The first couple of years, they bought little but looked a lot. Because they live in New York, it was easy to spend Saturday in Chelsea galleries and Sunday visiting Lower East Side galleries. When they bought, they generally spent less than $10,000 on a work. Because they were buying emerging artists, this was a meaningful number. They only bought things both of them liked. In addition to looking, they also subscribed to *Artforum*, *ARTnews*, and the *Art Newspaper* to be aware of artists the critics were talking about.

With time, they gained confidence in their eyes. They started buying more frequently, perhaps six to eight works a year. They were also willing to spend more but generally capped things at $25,000. They asked the galler-ies where they bought work to introduce them to the artists. They enjoyed spending time with them and talking about their work. They soon had a large network of gallery directors and artists who were part of their lives. Jim sometimes referred to the artists in their collection as being their sports team. They tracked their shows and reviews and kept up to date on their comings and goings.

After six years of collecting, they stepped back to reflect on what they had acquired. They realized they owned a lot of interesting and challeng-ing art, but they felt there were no themes or central tendencies that knit it together. They debated whether this was a real problem or just a reflection of buying work by emerging artists. It was enough of a "collecting crisis" to cause them to take a break and just enjoy what they had. Over time, when they thought about the works they liked the most in their collection, it always came back to abstract work involving a lot of color done by artists they had gotten to know. Some artists in their collection were already fading from the scene and were unlikely to remerge, but a handful were doing well critically

and professionally. To move forward, they decided to focus their time and energy on the second group. They bought more work by them, which was also much more expensive now. It was a bit like doubling down on success as a way to create a theme in their collection. They also asked these artists their opinions on other up-and-coming artists who were doing interesting work. These tips became an important way for the couple to re-engage with the art world and identify new artists to start following. All of a sudden, Jim and Travis were back in the game.

IN PRAISE OF CONNOISSEUR COLLECTORS

Audrey Hepburn once said, "As you grow older, you will discover that you have two hands, one for helping yourself, the other for helping others." This encapsulates beautifully the arc of a connoisseur collection assembled by Henry Buhl.

Buhl was a New York–based wedding photographer in the 1980s and early 1990s. "I collected little, little things, nothing over $2,000."[1] But in 1993, a friend told him about a photograph of Georgia O'Keeffe's hands that was available for sale. Smitten by its beauty, it was the first purchase in what became a collection of the history of photography told through more than one thousand photographs of hands. As Buhl explained:

> Everyone asks me, "Why hands?" As a photographer in the late 1980s, I had been sporadically purchasing photographs and had no specific objective. Howard Greenberg, a trusted advisor and early mentor on collecting photography, had been urging me to focus on one subject or on one period. In 1993 a friend introduced me to Doris Bry, Georgia O'Keeffe's longtime secretary and confidant who owned an Alfred Stieglitz gelatin-silver print of O'Keeffe (*Hands with Thimble*, 1920). Bry wanted to sell her print . . . The picture was one of the most beautiful images I had ever seen—and still is. It motivated me to look at other photographers' images of hands, which ultimately inspired the theme of The Buhl Collection.

My first selections on this theme seemed obvious, including works by Irving Penn, Richard Avedon, Diane Arbus, Robert Mapplethorpe,

Man Ray, Imogen Cunningham, Paul Strand, Ruth Bernhard, and Andy Warhol. As time passed, I grew more open to purchasing great images by lesser-known and even anonymous artists.

I also became interested in works representative of the various ways photographic prints are made, including gelatin silver, platinum, chromogenic, lithograph, daguerreotype, tintype, and inkjet. Perhaps the most enriching part of collecting is how it has awakened me to the immense variety of the creative process no matter what the parameters or themes or focus may be. That has been one of the most surprising and satisfying parts of the process.

I recently learned that Goethe wrote, "The most happy man from all over the world is the collector." I must agree because I feel blessed to be able to collect. . . .[2]

After fourteen years of collecting, sometimes buying more than one hundred photographs a year, Buhl stopped in 2007. "I ran out of money."[3] A few years later, he announced that since his children were not interested in the collection, it was time to sell it. Sotheby's held an auction of more than four hundred works from the collection in 2012. Proceeds from the sale went to the Association of Community Employment Programs for the Homeless, a nonprofit Buhl founded shortly before he began collecting. The nonprofit provides job training and ongoing support to homeless men and women throughout New York City. Audrey Hepburn is no doubt smiling.

Buhl's approach to collecting is impressive. He took a single idea and pursued it passionately, similar to Frances and Michael Baylson's collection of Matisse art books and printed materials that I talked about in Chapter 3. Maybe Buhl's collecting style will inspire others to create their own photography collections, perhaps telling the story of the history of modern dance, the audacity of the 1960's American Space program and its impact on society, or euphoric moments of athletic achievement.

In addition to photography, there are many themes new collectors could pursue to build a connoisseur collection. Some ideas to consider include the following:

The Bauhaus

In 1919, the Bauhaus school opened in Weimar, a small town located in central Germany near Leipzig. Until it was forced to close in 1933 by the Nazis, the school's teachers included many of the most important twentieth-century innovators in fine art, architecture, and design: Wassily Kandinsky, Josef and Anni Albers, Walter Gropius, Ludwig Mies van der Rohe, Theo van Doesburg, Marcel Breuer, and László Moholy-Nagy. So much of the art, design, and architecture we live with today reflects the ideas first developed at the Bauhaus. The legacy of the school could be the basis for many new collections. For example, perhaps a collection of drawings by Bauhaus architects of their most famous buildings or a collection of works of art tracing the merging of art, craft, and technology, which was a core Bauhaus belief.

Social Justice

In the twenties and thirties, abstract art became the predominate style of many "forward looking" artists. But at the same time, another group rejected abstraction and focused instead on attacking the status quo through works of art depicting workers and laborers. Some of the important artists associated with what is now called the American Social Realist movement include Ben Shahn, Jacob Lawrence, William Gropper, and Philip Evergood. Today, many young artists are once again creating works of art inspired by social justice. Perhaps there is an opportunity to create a collection that traces the history of the social realist movement and its impact on artists today.

The Hairy Who

What happens when you combine surrealism and a touch of the grotesque to create fascinating paintings and drawings of people and the weird environments in which they live? The Hairy Who. This loose confederation of artists, which includes Jim Nutt, Gladys Nilsson, and Karl Wirsum, showed together in Chicago in the 1960s. Because the art world loves labels, there are

two other groups of artists who broadly work in a similar vein: the Chicago Imagists (including Ray Yoshida, Roger Brown, and Ed Paschke) and the Monster Roster (including Leon Golub, Nancy Spero, H. C. Westermann, and June Leaf). All of these artists are worth a look and could form the basis for a collection of alternative views of America.

* * *

I hope the stories and ideas in this chapter inspired you to make art, and perhaps collecting, a bigger part of your life. Enjoy.

APPENDIX

A Peek behind the Curtain

The purpose of this appendix is to provide consignors who have especially valuable property with information on advantageous deal structures they may be able to negotiate with auction houses.

ENHANCED HAMMER DEALS

An enhanced hammer deal is a sweetener that goes beyond the "zero percent, all-in deal" discussed in "Auction House Deal-Making" in Chapter 6. In addition to not paying a seller's commission or any supplementary fees, the consignor receives a portion of the buyer's premium (BP) paid by the successful bidder. Enhanced hammer deals are quoted in percentage terms, for example, a 104 deal. This means the consignor receives the hammer price (100 percent), plus she is rebated four percentage points of buyer's premium (4 percent), for a total deal value of 104 percent of the hammer price.

Enhanced hammer deals can range from 101 to almost all of the buyer's premium being rebated back to the consignor.

Here's an example. Suppose a collector negotiated a 104 deal with Sotheby's to sell a painting with a presale estimate of $800,000 to $1 million. The painting sells for a hammer price of $920,000. The buyer pays $194,000 in buyer's premium on top of the hammer price, for a total purchase price of $1.114 million. The buyer's premium, when expressed as a percent of the hammer price, equals 21.1 percent.[1] The consignor gets four points of the buyer's premium. In dollar terms, she receives a check from Sotheby's for $956,800, equal to the $920,000 hammer price plus $36,800 of rebated BP.

For selling the work, Sotheby's earns an effective commission rate of 17.1 percent (21.1 percent less the rebate).

The more valuable the property, the higher the potential enhanced hammer the consignor may be able to negotiate with an auction house. While there is no firm dollar threshold, consignors with an object worth at least $1 million probably could have negotiated some sort of enhanced hammer deal in 2015 and 2016. The threshold and size of enhanced hammer deals vary auction season by auction season depending on the competitive pressures that exist at that moment in time between the different auction providers. For example, the major Postwar and Contemporary Art auctions take place each spring and fall in New York. Christie's, Sotheby's, Phillips, Bonhams, Wright, and other auction houses all need property to fill their sales. One company may be looking to gain market share and is willing to do aggressive enhanced hammer deals to win property. Another firm may already have a lot of property to sell from estates it signed, so it is willing to back off that season from doing additional enhanced hammer deals. Another firm may find itself short of property at the last minute and suddenly be willing to do aggressive deals. Because of this, getting the best deal requires negotiating simultaneously with multiple firms.

What type of deals were consignors getting for especially valuable property in 2015 and 2016? While doing research for this book, I interviewed many collectors, art advisors, and lawyers on both sides of the Atlantic who were active consignors during this period. Some shared with me the enhanced hammer deals they were able to negotiate for valuable Postwar and Contemporary and Impressionist and Modern property. For objects valued between $7 and $20 million, many were able to negotiate enhanced hammer deals between 107 and 110 percent. For property worth even more, they were sometimes able to get deals as high as 112 percent.[2] But there were also consignors with property of similar value who received far less attractive enhanced hammer deals. This was primarily due to differences in the negotiating skills of the consignor and his or her advisors, rather than the desirability of the property being sold.

What is a reasonable commission rate for an auction house to earn? Auction houses incur a lot of costs to perform their important function, including specialists to source and vet property, catalogues and websites, and

auction rooms and exhibition spaces. But for property sold under a basic or enhanced hammer deal, they do not have any capital at risk. They work as a broker, similar in many ways to the services provided by real estate brokers. What do luxury residential real estate brokers earn for their services? Sellers of luxury Manhattan real estate in 2015 and 2016 could probably negotiate a 5 percent commission rate on property worth between $5 and $10 million and perhaps 4 percent on property worth more than $20 million.[3] How do these commission rates compare with the effective commission rates earned by auction houses for selling valuable property? Based upon the enhanced hammer deals mentioned in the previous paragraph, auction houses in 2015 and 2016 were willing to sell high-value property for commission rates of 4 percent or less, sometimes substantially less. For example, consider a consignor with a 110 deal for a piece of property that hammered for $20 million. Using Sotheby's BP formula, the successful bidder paid an additional 13.25 percent in buyer's premium. But after the rebate to the consignor, the auction house only earned an effective commission rate of 3.25 percent.

While the real estate analogy seems to hold at the very top end of the market, not so for property worth less. During this time period, a consignor of a $400,000 painting may have been able to negotiate a "zero percent, all-in deal." But the auction house would keep all of the buyer's premium, which at this level equals 22 percent.[4] Real estate agents in the New York market, in contrast, would only charge 6 percent to sell an apartment with that value. It will be interesting to see if the effective commission rate auction houses can charge for this type of property declines over time due to competitive pressures from online channels.

A final note: consignors sometimes want to create an incentive for the auction house to sell their work for the highest price possible. Success fees, sometimes referred to as tiered enhanced hammers, can be used to create this incentive. For example, suppose a consignor has a valuable painting with an auction estimate of $10 to $15 million. In 2015, she may have been able to negotiate a flat 110 EH deal but agree to pay the auction house a two-point success fee on the incremental hammer price above $15 million. Incentive fees can encourage the auction house to make sure the work is displayed well during the preview period and receives good placement in the catalogue, among other potential marketing benefits.

GUARANTEE DEALS

Sellers are sometimes scared to sell at auction. They worry the object may not sell, and it becomes "tainted" in the eyes of the marketplace. They worry the auction estimates may be too low, dragging the confidential reserve price down with it, so the work ends up selling for a song. But they also feel an auction can expose the work to the largest number of potential buyers, increasing the chance it sells well. Cognitive dissonance is a common affliction among collectors considering selling at auction.

For decades, auction houses have provided some sellers with a solution to this dilemma: consign the property with a guarantee. While this tool is generally only available to consignors of property worth in excess of $1 million, auction houses sometimes lower their minimums for the right property and the right deal. In the balance of this section, I describe how a basic guarantee deal works. I then highlight some important variations in how guarantees can be structured to meet specific consignor needs.

Basic Guarantee Deal

Suppose a collector wants to sell a Picasso painting, but he wants to know with certainty that it will sell for a good price. After negotiating with multiple auction houses, he signs a consignment contract with the following terms:

- *Price guarantee of $10 million.* This is the minimum amount of money the auction house guarantees it will remit to the seller after the auction. The consignor is entitled to this minimum price no matter what happens in the sale. The risk of selling the work is now transferred to the auction house.
- *80/20 upside split.* The painting will hopefully sell for a hammer price of more than $10 million. If it does, then the upside split determines how this amount will be divided between the consignor and the auction house. In this particular deal, 80 percent of the upside goes to the consignor, and the remaining 20 percent goes to the auction house.

- *$8 to $12 million auction estimate.* The auction house is communicating to potential buyers that it believes this Picasso painting will sell for a hammer price of somewhere between $8 and $12 million.
- *$8 million reserve price.* The confidential reserve price can be no higher than the low end of the auction estimate. This rule always applies, independent of whether a lot is guaranteed. To attract bidders, the auction house in this example sets the low end of the auction estimate below the guarantee amount. This can be risky, because the auction house is obligated to sell the work to bidders at the $8 million reserve price.

The auction now takes place. Because the lot is guaranteed, the auction house would add a notation to that effect in the sale catalogue. Let's see what happens to the consignor and the auction house under three different hammer price scenarios[5]:

- *$12 million hammer price.* The consignor and auction house are both probably pretty happy with the outcome. The consignor gets $11.6 million from the auction house, equal to the $10 million guarantee amount plus 80 percent of the $2 million upside. The auction house is also happy because it made $2,090,000 on the sale, equal to the 20 percent upside ($400,000) plus buyer's premium of $1.69 million paid by the successful bidder on top of the $12 million hammer price.
- *$10 million hammer price.* The consignor and auction house probably feel OK but not great about the sale. The consignor gets the minimum guarantee amount, but he was probably hoping the painting would sell for more. The auction house makes $1,450,000 in buyer's premium, but no upside.
- *$8 million hammer price.* The seller is probably very happy he sold with a guarantee, while the auction house has egg on its face because it lost money on the sale. In this scenario, the consignor still gets $10 million from the auction house. But the buyer of the painting pays $9,210,000, which equals the $8 million hammer price plus buyer's premium. The auction house, however, has to dig into its own pockets for $790,000 to close the gap on the guarantee amount.

When a consignor sells with a guarantee, he is effectively buying an insurance policy from the auction house. Because insurance is not free, the consignor pays for it in some way. In the case above, the "insurance premium" he is paying is equal to the upside split the auction house will retain. Because the auction house has capital at risk in a guarantee deal, its incentives to make sure the work sells well are higher than would be the case with just an enhanced hammer deal.

Variations on a Theme

A guarantee deal is defined by two things: the guarantee price and the upside split. Let's look at how consignors over the years have sculpted these variables to meet different needs.

Estate Situation

A consignor may be concerned about a work selling because she needs sale proceeds to pay estate taxes. While she has every reason to believe the work will sell well, she may want to buy a low-cost insurance policy to mitigate the risk of it not selling. In this case, she may be able to negotiate a deal with a low guarantee amount while simultaneously retaining most of the upside. Using the Picasso example above, maybe this could be structured as a $6 million guarantee with 96 percent of the upside retained by the consignor. Because the auction house is taking on far less risk, it may be happy to write this insurance policy in order to get the work into a sale.

High Reservation Price

Some consignors have a specific dollar number in mind that, if they can be assured of getting it, they will consider selling. This can happen with collectors who own masterworks coveted by the market. Consignors in this position may be able to negotiate a guarantee deal with a very high guarantee amount but with more of the upside going to the auction house. For example, suppose someone owns a painting by Jean-Michel Basquiat that he loves and has no interest in selling. If he can get an extraordinary price for it, say $15 million, he may be willing to sell it. An auction house may try to

structure a deal where the consignor is guaranteed $15 million with 50 percent of the upside over this amount going to the auction house.

Unicorns
This is a deal that combines a guarantee with an enhanced hammer. Rarely seen, it did make some appearances in 2015 and 2016. How does it work? Using the basic Picasso guarantee example above, the deal is sweetened to include an enhanced hammer if the painting sells for a hammer price equal to or greater than the $10 million guarantee amount. For example, suppose the consignor had both a $10 million guarantee deal and a 105 enhanced hammer deal. If the painting sold for a $12 million hammer price, then the consignor would get an additional five points of the buyer's premium. Deals like this are rare but from time to time occur when competitive pressures among auction houses are at a feverous pitch.

HOUSE VERSUS A THIRD-PARTY GUARANTEE

A house guarantee is when an auction house assumes all the risk of the guarantee. A third-party guarantee is when the auction house partners with a third party to take on some or all of this risk. The third party needs to be compensated for its risk taking. Let's continue to use the Picasso example above to see how a third-party guarantee works.

Suppose the auction house has entered into the Picasso guarantee deal as described above but now wants to lay off the entire risk to a third party. It will likely offer the third-party guarantor two forms of compensation. First, the auction house will pay the third party a financing fee equal to some negotiated percent of the guarantee amount, perhaps 5 percent of the $10 million guarantee amount. This financing fee eats into the buyer's premium that the auction house hopes to collect from the successful bidder. Additionally, the third party will receive some of the upside split the auction house negotiated into the deal. For example, the auction house may offer to pass fifteen points of the twenty-point upside to the third party, keeping 5 percent for the house. But sometimes the third party demands all of the upside, leaving the auction house with just the potential to earn buyer's premium, less the financing fee.

When the auction takes place, the third-party guarantor can elect to sit on his hands or he can choose to be an active bidder. If he is the successful bidder, then most third-party guarantee contracts stipulate that the guarantor will only receive the financing fee and none of the upside. If this is the case, he can elect to net the financing fee against what he is now obligated to pay the auction house for the work. Some collectors like being offered the opportunity to be a guarantor, because it can be a way to lower the all-in cost of acquiring that object. If the guarantor does not bid, or he bids but is not the successful bidder, then he also gets his portion of the upside.

AVOIDING THE SCOUNDREL'S CORNER (PART 3)

How can buyers of works with a third-party guarantee be taken advantage of by their advisors? Auction houses are required to disclose when they have a financial interest in an object being offered for sale. This disclosure is made in the auction catalogue associated with the sale. These disclosure requirements are in place to make sure potential bidders understand that auction house staff, who always act as sellers' agents, have an even stronger incentive with guaranteed lots to promote the work to potential bidders.

But when auction houses guarantee a lot in partnership with a third party, the name(s) of the third-party guarantor(s) remain private. This has the potential to create a conflict of interest, because the third-party guarantor may also be advising clients to purchase the work in which she has a financial interest, without the clients knowing about the conflict.

To help mitigate this problem, auction houses have disclosure policies around third-party guarantees. Christie's, for example, has the following policy:

> Third party guarantors are required by us to disclose to anyone they are advising their financial interest in any lots they are guaranteeing. However, for the avoidance of any doubt, if you are advised by or bidding through an agent on a lot identified as being subject to a third party guarantee you should always ask your agent to confirm whether or not he or she has a financial interest in relation to the lot.[6]

Because this disclosure is left up to the third-party guarantor, it is unclear whether it happens in practice. To make matters more complicated, auction houses will sometimes make sale-room announcements just as an auction is about to begin that a lot has a last-minute third-party guarantee on it. But this makes it impossible for bidders to query their advisors. For all they know, the person they asked to bid on their behalf up to a certain hammer price may now have a direct financial interest in that lot. To prevent these conflicts of interest from occurring, it is important for bidders to have written agreements with their advisors that clearly stipulate that the advisor has a fiduciary responsibility to the bidder. But because the names of third-party guarantors are not disclosed, there is no way for bidders to independently confirm that their advisors are in compliance with their written agreement.

End Notes

Chapter 1:

1. Javier Pes, Jose Da Silva, and Emily Sharpe, "Visitor Figures 2015: Jeff Koons Is the Toast of Paris and Bilbao." *The Art Newspaper*, March 31, 2016. The top ten museums were the Louvre (8,600,000), British Museum (6,820,686), Metropolitan Museum of Art in New York (6,533,106), Vatican Museums (6,002,251), National Gallery in London (5,908,254), National Place Museum in Taipei (5,291,797), Tate Modern (4,712,581), National Gallery of Art in Washington, DC (4,104,331), State Hermitage Museum (3,668,031), and Musee d'Orsay (3,440,000).

2. To learn more about the state of museums worldwide, a good place to start is a five-part series published by the *Economist* in 2013. You can find the series by searching for the lead article: "Temples of Delight," *The Economist* (US), December 21, 2013.

3. "Art Museums By the Numbers 2015." Association of Art Museum Directors. January 7, 2016.

4. Ibid, p. 6.

5. My profile of CJ is based on a studio visit and interview I did with her in August 2016.

6. Matthew Giles, "Swizz Beatz Wants to Change the Art World," *Vulture*, November 25, 2014.

7. Daniel Scheffler, "Waxing Lyrical," *Cultured*, April/May 2016, 172–75.

8. A 2011 show at the Pushkin Museum in Moscow titled *Inspiration Dior* explored the links between the House of Dior and artworks dating back to the nineteenth century.

9. Rory Carroll, "James Turrell: 'More People Have Heard of Me through Drake than Anything Else'" *The Guardian*, November 11, 2015.

10. Based on data published in Javier Pes and Emily Sharpe, "Visitor Figures 2014: The World Goes Dotty Over Yayoi Kusama," *The Art Newspaper*, April 2, 2015.

I used total attendance, rather than average attendance per day, to select the top shows.

11. For more on the ownership structure of the DIA, see Chapter 8 in Nathan Bomey's excellent book *Detroit Resurrected: To Bankruptcy and Back* (New York: W. W. Norton & Company, 2016). Many museums receive funding from the municipality in which they are located, but the municipal government does not own the collection. By way of example, the Brooklyn Museum, the Whitney Museum, and the Met Museum all receive funding from the City of New York. But if New York City declared bankruptcy, the city would not have a claim on the art owned by these institutions.

12. Ibid, *Detroit Resurrected*, p. 123.

13. Email exchange with Buckfire, July 18, 2016.

14. I created this list by starting with names of popular living artists culled from a variety of sources. I then used Instagram to find the official Instagram site for each artist.

15. For some artists, the number shown is a sum of multiple hashtags (e.g., #picasso and #pablopicasso). I created this list by starting with names of approximately fifty artists culled from lists of the most famous paintings in the world, art history books, etc. This table shows the top ten names from my initial list.

Chapter 2:

1. Anna Jozefacka, "Index of Historic Collectors and Dealers of Cubism: Gianni Mattioli," The Metropolitan Museum of Art, January 2015.

2. Amy Qin, "Chinese Taxi Driver Turned Billionaire Bought Modigliani Painting," *The New York Times*, November 10, 2015.

3. Patti Waldmeir, "Lunch with the FT: Wang Wei," *London Financial Times*, January 29, 2016.

4. Clare McAndrew, *TEFAF Art Market Report 2016* (Helvoirt: European Fine Art Foundation, 2016).

5. Ibid, TEFAF, p. 15.

6. Ibid, TEFAF, p. 83.

7. Ibid, TEFAF, chapter 2.

8. Ibid, TEFAF, p. 173.

9. Ibid, TEFAF, p. 205.

10. Ibid, TEFAF, p. 210

11. Luisa Kroll, "Inside The 2015 Forbes 400: Facts and Figures About America's Wealthiest." *Forbes*, September 29, 2015.

12. Data on educational attainment is collected by the US Department of Labor, Bureau of Labor Statistics. The information referenced in the text is available on their website at https://www.census.gov/hhes/socdemo/education/data/cps/historical/.

13. A recent entrant to the art-backed lending market is Athena Art Finance, a nonbank financial institution.

14. For more on Bellini's time in Constantinople, see Caroline Campbell, Alan Chong, Deborah Howard, J. M Rogers, and Sylvia Auld. *Bellini and the East* (New Haven, CT: Yale University Press, 2005) and Julian Raby's article "A Sultan of Paradox: Mehmed the Conqueror as a Patron of the Arts." *Oxford Art Journal* 5, no. 1 (1982): 3–8.

15. I decided to make an educated guess on what this number may be. Artnet published a study of the top one hundred living artists based on total sales at auction from January 1, 2011, to October 15, 2015. The artists at the bottom of the list had total sales of approximately $21 million, or approximately $4 million a year over the period of the study. While this is the resale market, I think it is safe to assume that all of these artists are making at least $1 million a year selling new work. But what about artists not on this list? Assume an artist has a gallery show every other year and that the artist splits sales fifty/fifty with the gallery. She would need to sell $4 million of new work every other year in order to take home on average $1 million a year. My guess is that no more than five hundred artists in total meet this hurdle.

16. The acceptance rates are from Peterson's, the online guide to undergraduate and graduate programs.

17. Holland Cotter, "To Bump Off Art As He Knew It," *The New York Times*, February 12, 2009.

18. Ibid, TEFAF, p. 43.

19. For more on the sordid tale of collusion, see Christopher Mason, *The Art of the Steal: Inside the Sotheby's-Christie's Auction House Scandal* (New York: G.P. Putnam's Sons, 2004).

20. Compensation arrangements with art advisors vary widely. Some charge an hourly fee, perhaps with a monthly retainer, while others charge project-based fees. Some may prefer to work on a commission basis, perhaps charging 10 percent on the purchase price of all work that a collector buys over a specified time period. There is no right answer, except for the advisor and client to talk through compensation arrangements and document them to avoid tears later in their relationship.

21. Meryle Secrest, *Modigliani: A Life* (New York: Alfred A. Knopf, 2011).

22. Ibid, p. 70.

23. Eileen Kinsella, "Who Are the Top 100 Most Collectible Living Artists?" *Artnet News*, October 27, 2016.

24. Based on information from gallery websites as of July 2016.

25. Alfred Taubman wrote a memoir about his life in business, including his Sotheby's experience. *Threshold Resistance: The Extraordinary Career of a Luxury Retailing Pioneer* (New York: Collins, 2007).

26. Sotheby's Third Quarter 2015 Earnings Call Outline, November 9, 2015, p. 7. Available on the Sotheby's Investor Relations website.

Chapter 3:

1. Peter Plagens, "Which is the most influential work of art of the last 100 years?" *Newsweek*, June, 23, 2007.
2. We all fall in love with certain literary devices. The prologue to *Coming Apart*, Charles Murray's provocative book from 2012, was my inspiration for how to tell the story of Ethel and Robert Scull.
3. Such as the Sidney Janis Gallery, Pace Gallery, Andre Emmerich Gallery, Cordier and Ekstrom, Grace Borgenicht Gallery, Fourcade and Droll, and Marlborough Gallery.
4. The painting is now in the collection of the Birmingham Museum of Art.
5. The best book on the history of the Scull's collection is Judith Goldman, *Robert & Ethel Scull: Portrait of a Collection* (New York: Acquavella Galleries, 2010).
6. For example, Israel Shenker, "Amy Vanderbilt Instructs Scull's Angels in Etiquette," *The Telegraph*, September 25, 1973.
7. Tom Wolfe, *The Pump House Gang* (New York: Farrar, Straus & Giroux, 1968), chapter 9.
8. Goldman, *Robert & Ethel Scull*, p. 18.
9. For Ethel's take on events, read Marie Brenner, "The Latter Days of Ethel Scull," *New York Magazine*, April 6, 1981, p. 22–26.
10. Goldman, *Robert & Ethel Scull*, p. 10.
11. For a description of the film and its making, see Baruch Kirschenbaum, "The Scull Auction and the Scull Film," *Art Journal* 39, no. 1 (Fall 1979), p. 50–54.
12. Barbara Rose, "Profit Without Honor," *New York Magazine*, November 5, 1973, p. 80–81.
13. Carol Vogel, "Works by Johns and De Kooning Sell for $143.5 Million," *The New York Times*, October 12, 2006.
14. Kelly Crow, "Billionaire Ken Griffin Paid $500 Million for Pollack, De Kooning Paintings," *The Wall Street Journal*, February 25, 2016.
15. The Baylson's shared the story behind their collection in an essay published in John Bidwell, *Graphic Passion: Matisse and the Book Arts* (University Park, PA: Pennsylvania State University Press, 2015).
16. Ibid, p. 3.
17. Ibid, p. 6.
18. Ibid, p. 6–7.
19. Brian Moylan, "Jho Low: Manhattan's Mysterious Big-Spending Party Boy," *Gawker*, November 10, 2009.
20. Louise Story and Stephanie Saul, "Jho Low, Well Connected in Malaysia, Has An Appetite for New York," *The New York Times*, February 8, 2015.

21. Katya Kazakina, "Flashy Malaysia Financier Said to Sell Picasso at Loss," *Bloomberg.com*, February 12, 2016.

22. Tom Wright, "Malaysian Financier Jho Low Tied to 1MDB Inquiry," *The Wall Street Journal*, July 9, 2015.

23. "Follow the Money, If You Can," *The Economist*, March 5, 2016.

24. United States of America v. Real Property, United Sates District Court for the Central District of California, *CV 16-5371*, filed July 20, 2016, p. 6.

25. Bradley Hope, John R. Emshwiller, and Ben Fritz, "The Secret Money Behind 'The Wolf of Wall Street,'" *The Wall Street Journal*, April 1, 2016.

26. Kelly Crow and Bradley Hope, "1MDB Figure Who Made a Splash in Art Market Becomes a Seller," *The Wall Street Journal*, May 19, 2016.

27. Third Point reported in its February 26, 2016, 13D filing that it spent $294,295,244 to acquire 6,660,925 shares of Sotheby's stock. In its October 2013 13D filing, it referenced earning $10,064,347 on a swap deal. After netting out the swap gain, Third Point paid $42.67 per share to acquire its stake in Sotheby's.

Chapter 4:

1. See Jerry Saltz, "This Is The End," *Arts Magazine*, September 1988, 19–20, for a review of Wool's first show of word paintings.

2. Jerry Saltz, "Zombies on the Walls: Why Does So Much New Abstraction Look the Same?" *New York Magazine*, June 16, 2014.

3. Peter Schjeldahl, "Writing On The Wall," *The New Yorker*, November 4, 2013, p. 108–09.

4. Hans Werner Holzwarth, Eric Banks, and Christopher Wool, *Christopher Wool* (Cologne, Germany: Taschen, 2012), p. 97. From the essay by Jim Lewis, "There are about 75 word paintings by Christopher Wool, and while they form a complete—and probably closed—corpus there are variations among them, differences in size and method, in theme and ostensible content."

5. For more on the controversy around Modigliani catalogue raisonnés, see Patricia Cohen, "A Modigliani? Who Says So?" *The New York Times*, February 2, 2014, and Marc Spiegler, "Modigliani: The Experts Battle," *ARTnews*, January 2004.

6. Art forgers are skilled not only in painting fakes but also in creating fake documents and narratives. Wolfgang Beltracchi had a long career as a forger of German Expressionist and Surrealist paintings, supported by his wife Helene. For one of their scams, they staged a photo shoot where Helene impersonated her grandmother, the supposed owner of the fake paintings that were hanging on the wall behind her. The black-and-white photographs were then printed slightly out of focus on prewar developing paper. To learn more about this and other scams perpetuated by the couple, see Joshua Hammer, "The Greatest Fake-Art Scam in History?" *Vanity Fair*, October 10, 2012.

7. Donald Judd, "Reviews and Previews: New Names This Month – Yayoi Kusama," *ARTnews*, October 1959.

8. This quote is from the website GoodReads.

9. Leaving the Magritte market aside, when a work of art is submitted to an authentication committee, the owner typically signs a contract and waiver. This gives the committee the right to inspect the work and render its opinion. It also releases the committee from any claims the owner may subsequently make against the committee if the owner disagrees with its judgment. Some committees stipulate they will only make affirmative statements about an object and reserve the right to return the work to the owner with no statement whatsoever either confirming or denying its authenticity. Other authentication committees take a much tougher stance on fakes, including reserving the right to stamp the back of the work with a statement saying it is not authentic, retain the work indefinitely, or destroy it. In France, the legal rights of authentication committees are enshrined in law. But this is not true in the United States. As a result, some authentication committees have disbanded to avoid legal risk they felt they were taking on when rendering opinions (e.g., the Andy Warhol and Keith Haring Foundations).

10. Liyan Chen, "Billionaire Art Collector Wilbur Ross Loves Magrittes, Paid $100 Million for His Own," *Forbes*, October 8, 2013.

11. Based on an Artnet database search.

12. Collectors could also buy a gouache by the artist. Many are finely crafted and involve imagery that is on par with some of his best paintings. There is far greater parity in value between his works on paper and paintings than for almost any other artist.

13. Jonathan Laib, Charlotte Perrottey, and Charlie Adamski, *Ruth Asawa: Objects & Apparitions* (New York: Christie's, 2013), p. 5, in the essay by John Yau titled "Ruth Asawa: Shifting the Terms of Sculpture."

14. Daniell Cornell, *The Sculpture of Ruth Asawa: Contours in the Air* (San Francisco: Fine Arts Museums of San Francisco, 2006).

15. Museum of Modern Art, "MoMA Presents the Most Comprehensive Retrospective to Date of Contemporary Painter Elizabeth Murray," News release, October 2005.

16. Per Pace Gallery website about the artist.

17. Fair market value (FMV) has a precise definition. As defined by the Internal Revenue Service, it is the price a willing buyer and a willing seller would agree to in an open market, where neither is required to act and both have reasonable knowledge of the relevant facts. FMV is different from the replacement, or insurance value, of an artwork. Because the insurance value is what it would cost to replace the work immediately, it is generally higher than the FMV.

18. Matisse, for example, was an especially prolific draftsman who made thousands of drawings. They range in quality from the great to the mediocre and

are priced accordingly. In 2014 and 2015, ninety-seven drawings by the artist were for sale in New York and London auctions held by Sotheby's, Christie's, and Phillips. A large charcoal drawing from 1939 of a sleeping young woman with an elaborately embroidered Romanian blouse sold in November 2015. It encapsulated many of the motifs for which the artist is best known. It sold for $3.8 million, the highest price paid during this two-year time period for a drawing by the artist. At the other end of the spectrum, twenty-one drawings sold for less than $50,000. They were smaller, workaday pieces with an awkwardness rather than the lithe, effortless quality for which the artist is known.

Chapter 5:

1. Galleries will sometimes permit a client to trade in a lower value work (at its current fair market value) to help finance the purchase of a more valuable work.

2. At Phillips, for example, buyers pay an additional 25 percent on the hammer price up to and including $200,000; on the incremental hammer price between $200,001 and $3 million, buyers pay an additional 20 percent and 12 percent thereafter.

3. Information on limited warranties are available on auction house websites and in the endnotes to auction catalogues.

4. One minor exception: some regional auction houses may charge buyers an extra fee for bidding online, which is odd because generally doing something online costs less.

5. The lawsuit was filed on August 26, 2013, in the New York Civil Supreme Court, Michael P. Schulhof, as executor of the Estate of Hannelore B. Schulhof, versus Lisa Jacobs individually and doing business as Lisa Jacobs Fine Art. All of the documents associated with this case are available online by going to the New York State Unified Court System website (https://iapps.courts.state.ny.us/webcivil/ecourtsMain) and searching for either Schulhof, Michael P. vs. Jacobs, Lisa, or the index number for the case, which is 157797/2013.

6. Affidavit of Plaintiff Michael P. Schulhof, as executor, in Support of Motion for Summary Judgment, filed on August, 1, 2016, p. 4.

7. I have relied on Joseph Berger's account of what happened as reported in "House Painter Is Charged in Long Island Art Thefts," *The New York Times*, May 6, 2013.

8. Josh Saul, "House Painter Gets Slap on Wrist in Art Thefts," *New York Post*, November 7, 2014.

9. Schulhof affidavit, p. 5.

10. Ibid, 18.

11. District Judge Paul G. Gardephe issued a preliminary ruling on September 30, 2013, where he references this important letter. See p. 56 of his ruling.

12. United States Attorney's Office for the Southern District of New York, "Art Dealer Pleads Guilty in Manhattan Federal Court to $80 Million Fake Art Scam, Money Laundering, and Tax Charges," News release, September 16, 2013.

13. Laura Gilbert and Bill Glass, "Former Director of Scandal-Beset Knoedler Gallery Breaks Her Silence," *The Art Newspaper*, April 18, 2016. See the update section at the end of the article.

Chapter 6:

1. "Andy Williams: An American Legend," Christie's press release, New York, February 8, 2013.

2. Many articles have been written about *Accidia Foundation v. Simon C. Dickinson Limited*. I drew heavily on the following article for a description of the facts in the case: Jo Laird, Burke Blackman, and Peter J. Schaeffer, "Dealing in Hidden Risk: Agency and Fiduciary Liability in the Dealer-seller Relationship," *Lexology*, August 28, 2012.

Chapter 7:

1. Forms of regulation include export licensing rules, preemptive rights that give public museums the right to buy artwork, and rules that restrict sales of cultural property to individuals or institutions in the domestic market. For more on this topic, see Clare McAndrew, *Fine Art and High Finance: Expert Advice on the Economics of Ownership* (New York: Bloomberg Press, 2010), pp. 161–96.

2. The purchase price was reported in "Controversial Sale from NRW: Warhol Images Bring 150 Million." *Spiegel Online*, November 13, 2014.

3. For more on the topic, see an excellent article by Alexander Forbes and Isaac Kaplan, "What Germany's Strict New Regulations Mean for the International Art Market," *Artsy*, July 12, 2016.

4. If shipped inside the EU, then the thresholds are 300,000 Euros and the work must be at least seventy-five years old.

5. Because many German artists protested the proposed rules, the government added provisions to the legislation at the last minute granting living artists the right to approve whether artworks they created are added to the export ban list.

6. Forbes and Kaplan, "What Germany's Strict New Regulations Mean," in the section of the article titled "A Mass Exodus of Artwork."

7. Julia Halperin and Ermanno Rivetti, "Time for Italy to Reverse Its Art Export Laws," *The Art Newspaper* (London), October 2014, p. 1.

8. Stephanie Kirchgaessner, "The Reasoning Was Crazy - How Italy Blocked the Sale of a Dali Painting," *The Guardian*, December 7, 2015.

9. Hugo Lopez Coll, Luis Torres, and Guillermo Miranda, "In Love with Diego or Frida? A Brief Look at Mexican Art Regulations," *Greenberg Traurig Blog*, November 26, 2014.

10. See the US Fish and Wildlife Service website for more details on the law.

11. For historical works, there are different federal, state, and international rules governing the transport and sale of art and objects, such as antiquities, Native American and pre-Columbian objects, elephant ivory, and rhino horn.

12. Patricia Cohen, "Art's Sale Value? Zero. The Tax Bill? $29 Million," *The New York Times*, July 22, 2012.

13. Phillips Conditions of Sale, paragraph 11, *Export, Import and Endangered Species Licenses and Permits*, as printed in the 20th Century and Contemporary Art Evening Sale catalogue from May 8, 2016.

14. For more on art and taxes, see Ramsay H. Slugg, *Handbook of Practical Planning for Art Collectors and Their Advisors* (American Bar Association, 2015) and Ralph E. Lerner and Judith Bresler, *Art Law: The Guide for Collectors, Investors, Dealers, and Artists*. 4th ed. (New York: Practising Law Institute, 2013).

15. The US federal income tax rate on long-term capital gains from the sale of artwork is 28 percent, higher than the 15 and 20 percent tax rates applied to long-term gains on financial assets like stocks and bonds. In addition, high-income taxpayers are subject to the 3.8 percent Medicare contribution tax on net investment income. At the federal level then, the collector may have to pay a combined 31.8 percent tax. But the capital gains tax bill may not stop there, depending on where the collector lives. If a New York State resident, the collector could be liable for an additional 8.8 percent capital gains tax.

16. *Gross Domestic Philanthropy: An International Analysis of GDP, Tax and Giving*, Report, January 2016.

17. If the taxpayer lives in a state with an income tax, then his combined federal and state marginal tax rate will be higher. His tax savings from charitable donations will then be even larger.

18. Assuming the artist did not have a spouse at the time of death. If the artist was married, then the estate can pass tax free to the spouse. The spouse would then get the art at a fair market value as of the artist's death. The spouse's estate would then be subject to estate tax when he or she passes away.

19. To learn more about artist foundations, see the Aspen Institute Artist-Endowed Foundation Initiative website at http://www.aspeninstitute.org/policy-work/nonprofit-philanthropy/artist-endowed-foundations.

20. I estimated this number using data from the Association of Art Museum Directors, *Art Museums by the Numbers* (2015), p. 4. The following categories sum to 44 percent: Individual and Family Memberships, Individual and Family Contributions, Foundations and Trusts, Benefit Events, Admissions, Restaurants and Catering, and Museum Store. In addition, I assumed that at least half of the 21 percent of funding coming from Total Endowment Income is the result of individual and family capital contributions.

21. Association of Art Museum Directors, "Art Museums, Private Collectors, and the Public Interest," News release, 2007 (https://aamd.org/sites/default/files/document/PrivateCollectors3.pdf).

22. This example is inspired by Jordan Schnitzer, a print collector and philanthropist based in Oregon.

23. Robin Pogrebin, "A Billionaire Is Opening a Private Art Museum in Manhattan," *The New York Times*, July 28, 2016.

24. Patricia Cohen, "Tax Status of Museums Questioned by Senators," *The New York Times*, November 29, 2015.

25. Patricia Cohen, "Writing Off the Warhol Next Door," *The New York Times*, January 10, 2015.

26. Julian Halperin, "US Senate Committee Submits Private Museum Findings to Internal Revenue Service," *The Art Newspaper*, June 2, 2016.

27. This is the value at which a willing buyer and willing seller would agree to transact over a reasonable time period. FMV is different from an insurance appraisal, which is an estimate of the immediate retail replacement value of an object. FMV estimates, which are generally lower than insurance estimates, are what the IRS will look to when examining the value of an estate.

28. For example, suppose you have two artworks both with a FMV of $100,000, but one is most likely fully valued while the other may see appreciation over the next five years due to an upcoming museum retrospective. If the collector is looking to gift assets to get them out of the estate, then the collector may want to gift the artwork with greater appreciation potential.

Chapter 8:

1. Julie Belcove, "Henry Buhl's Hands-On Approach to Collecting Photographs," *Sotheby's Magazine*, November 6, 2012.

2. From Henry Buhl's preface to the book by Jennifer Blessing, Kirsten A. Hoving, and Ralph Rugoff, *Speaking with Hands: Photographs from the Buhl Collection* (New York: Solomon R. Guggenheim Museum, 2004), pp. 7–8.

3. Belcove, "Henry Buhl's Hands-On Approach to Collecting Photographs."

Appendix:

1. The buyer's premium was calculated using Sotheby's BP formula, in effect as of the summer of 2016. It equals 25 percent of the first $200,000 of hammer price plus 20 percent of the hammer price between $200,000 and $920,000.

2. For an interesting example of a consignor being rebated all of the buyer's premium, see Graham Bowley, "The (Auction) House Doesn't Always Win," *New York Times*, January 16, 2014. The article discusses the enhanced hammer deal Peter Brandt negotiated for the sale of a Jeff Koons sculpture in 2013.

3. Based on interviews with NY residential real estate brokers conducted in June 2016.

4. Using the Sotheby's BP formula on a $500,000 hammer price.

5. The calculations are based on the Sotheby's buyer's premium in effect as of February 1, 2015: 25 percent of the first $200,000 of hammer price, 20 percent of hammer price between $200,000 and $3 million, and 12 percent for the amount of hammer price over $3 million.

6. This language was taken from the Special Notice section for a Georgia O'Keeffe painting titled *Lake George Reflection* that Christie's was offering for sale on May 19, 2016.

Bibliography

"2015 Top 200 Collectors." *ARTnews*. April 2015.

Adam, Georgina. *Big Bucks: The Explosion of the Art Market in the 21st Century*. Surrey, England: Lund Humphries, 2014.

Association of Art Museum Directors. "Art Museums By the Numbers 2015." Report. January 7, 2016.

—————. "Art Museums, Private Collectors, and the Public Interest." News release, 2007.

Belcove, Julie. "Henry Buhl's Hands-On Approach to Collecting Photographs." *Sotheby's Magazine*, November 6, 2012.

Berger, Joseph. "House Painter Is Charged in Long Island Art Thefts." *The New York Times*, May 6, 2013.

Bidwell, John. *Graphic Passion: Matisse and the Book Arts*. University Park, PA: Pennsylvania State University Press, 2015.

Blessing, Jennifer, Kirsten A. Hoving, and Ralph Rugoff. *Speaking with Hands: Photographs from the Buhl Collection*. New York: Solomon R. Guggenheim Museum, 2004.

Bomey, Nathan. *Detroit Resurrected: To Bankruptcy and Back*. New York: W. W. Norton & Company, 2016.

Bowley, Graham. "The (Auction) House Doesn't Always Win." *The New York Times*, January 16, 2014.

Brenner, Marie. "The Latter Days of Ethel Scull." *New York Magazine*, April 6, 1981, 22–26.

Campbell, Caroline, Alan Chong, Deborah Howard, J. M Rogers, and Sylvia Auld. *Bellini and the East*. New Haven, CT: Yale University Press, 2005.

Carrol, Rory. "James Turrell: 'More People Have Heard of Me through Drake than Anything Else'" *The Guardian* (London), November 11, 2015.

Ceroni, Ambrogio. *Tout L'œuvre Peint De Modigliani*. Paris: Flammarion, 1972.

Charities Aid Foundation, "Gross Domestic Philanthropy: An International Analysis of GDP, Tax and Giving." Report. January 2016.

Chen, Liyan. "Billionaire Art Collector Wilbur Ross Loves Magrittes, Paid $100 Million For His Own." *Forbes*, October 8, 2013.

Christie's. "Andy Williams: An American Legend." News release, New York, NY, February 8, 2013.

Cohen, Patricia. "A Modigliani? Who Says So?" *The New York Times*, February 2, 2014.

————. "Art's Sale Value? Zero. The Tax Bill? $29 Million." *The New York Times*, July 22, 2012.

————. "Tax Status of Museums Questioned by Senators." *The New York Times*, November 29, 2015.

————. "Writing Off the Warhol Next Door." *The New York Times*, January 10, 2015.

Coll, Hugo, Luis Torres, and Guillermo Miranda. "In Love with Diego or Frida? A Brief Look at Mexican Art Regulations." *Greenberg Traurig Blog*, November 26, 2014.

"Controversial Sale from NRW: Warhol Images Bring 150 Million." *Spiegel Online*. November 13, 2014.

Cornell, Daniel. *The Sculpture of Ruth Asawa: Contours in the Air*. San Francisco: Fine Arts Museums of San Francisco, 2006.

Cotter, Holland. "To Bump Off Art As He Knew It." *The New York Times*, February 12, 2009.

Crow, Kelly. "Billionaire Ken Griffin Paid $500 Million for Pollack, De Kooning Paintings." *The Wall Street Journal*, February 25, 2016.

Crow, Kelly, Sara Germano, and David Benoit. "New Masters of the Art Universe." *The New York Times*, January 24, 2014.

Crow, Kelly, and Bradley Hope. "1MDB Figure Who Made a Splash in Art Market Becomes a Seller." *The Wall Street Journal*, May 19, 2016.

Findlay, Michael. *The Value of Art: Money, Power, Beauty*. Munich: Prestel, 2012.

"Follow the Money, If You Can." *The Economist*. March 5, 2016.

Forbes, Alexander, and Isaac Kaplan. "What Germany's Strict New Regulations Mean for the International Art Market." Artsy. July 12, 2016.

Gilbert, Laura, and Bill Glass. "Former Director of Scandal-Beset Knoedler Gallery Breaks Her Silence." *The Art Newspaper*, April 18, 2016.

Giles, Matthew. "Swizz Beatz Wants to Change the Art World." *Vulture*. November 25, 2014.

Goldman, Judith. *Robert & Ethel Scull: Portrait of a Collection*. New York: Acquavella Galleries, 2010.

Halperin, Julia. "US Senate Committee Submits Private Museum Findings to Internal Revenue Service." *The Art Newspaper*, June 2, 2016.

Halperin, Julia, and Ermanno Rivetti. "Time for Italy to Reverse Its Art Export Laws." *The Art Newspaper* (London), October 2014.

Hammer, Joshua. "The Greatest Fake Art Scam in History." *Vanity Fair*, October 10, 2012.

Holzwarth, Hans Werner, Eric Banks, and Christopher Wool. *Christopher Wool.* Cologne, Germany: Taschen, 2012.

Hope, Bradley, John R. Emshwiller, and Ben Fritz. "The Secret Money Behind 'The Wolf of Wall Street.'" *The Wall Street Journal*, April 1, 2016.

Horowitz, Noah. *Art of the Deal: Contemporary Art in a Global Financial Market.* Princeton, NJ: Princeton University Press, 2011.

Jozefacka, Anna. "Index of Historic Collectors and Dealers of Cubism: Gianni Mattioli." Metropolitan Museum of Art. January 2015.

Judd, Donald. "Yayoi Kusama." *ARTnews*, October 1959.

Kazakina, Katya. "Flashy Malaysia Financier Said to Sell Picasso at Loss." Bloomberg.com. February 12, 2016.

Kinsella, Eileen. "Who Are the Top 100 Most Collectible Living Artists?" Artnet News. October 27, 2015.

Kirchgaessner, Stephanie. "The Reasoning Was Crazy – How Italy Blocked the Sale of a Dali Painting." *The Guardian*, December 7, 2015.

Kirschenbaum, Baruch. "The Scull Auction and the Scull Film." *Art Journal* 39, no. 1 (Fall 1979): 50–54.

Kroll, Luisa. "Inside The 2015 Forbes 400: Facts And Figures About America's Wealthiest." *Forbes*, September 29, 2015.

Laib, Jonathan, Charlotte Perrottey, and Charlie Adamski. *Ruth Asawa: Objects & Apparitions.* New York: Christie's, 2013.

Laird, Jo, Burke Blackman, and Peter J. Schaeffer. "Dealing in Hidden Risk: Agency and Fiduciary Liability in the Dealer-seller Relationship." Lexology, August 28, 2012.

Lerner, Ralph E., and Judith Bresler. *Art Law: The Guide for Collectors, Investors, Dealers, and Artists.* 4th ed. New York City: Practising Law Institute, 2013.

Mason, Christopher. *The Art of the Steal: Inside the Sotheby's-Christie's Auction House Scandal.* New York: G.P. Putnam's Sons, 2004.

McAndrew, Clare. *Fine Art and High Finance: Expert Advice on the Economics of Ownership.* New York: Bloomberg Press, 2010.

———. *TEFAF Art Market Report 2016.* Helvoirt: European Fine Art Foundation, 2016.

Moylan, Brian. "Jho Low: Manhattan's Mysterious Big-Spending Party Boy." *Gawker.* November 10, 2009.

Murray, Charles A. *Coming Apart.* New York: Crown Forum, 2012.

Museum of Modern Art. "MoMA Presents the Most Comprehensive Retrospective to Date of Contemporary Painter Elizabeth Murray." News release, October 2005.

Pes, Javier, and Emily Sharpe. "Visitor Figures 2014: The World Goes Dotty Over Yayoi Kusama." *The Art Newspaper*, April 2, 2015.

Pes, Javier, Jose Da Silva, and Emily Sharpe. "Visitor Figures 2015: Jeff Koons Is the Toast of Paris and Bilbao." *The Art Newspaper*, March 31, 2016.

Plagens, Peter. "Which Is the Most Influential Work of Art of the Last 100 Years?" *Newsweek*, June 23, 2007.

Pogrebin, Robin. "A Billionaire Is Opening a Private Art Museum in Manhattan." *The New York Times*, July 28, 2016.

Prendergast, Canice. "The Market for Contemporary Art." University of Chicago Working Paper. November 2014.

Qin, Amy. "Chinese Taxi Driver Turned Billionaire Bought Modigliani Painting." *The New York Times*, November 10, 2015.

Raby, Julian. "A Sultan of Paradox: Mehmed the Conqueror as a Patron of the Arts." *Oxford Art Journal* 5, no. 1 (1982): 3–8.

Rose, Barbara. "Profit Without Honor." *New York Magazine*, November 5, 1973, 80–81.

Rozell, Mary. *The Art Collector's Handbook: A Guide to Collection Management and Care*. Surrey, England: Lund Humphries, 2014.

Saltz, Jerry. "Christopher Wool's Stenciled Words Speak Loudly - and Not Everyone Wants to Listen." *New York Magazine*, November 11, 2013.

————. "This Is The End." *Arts Magazine*, September 1988, 19–20.

————. "Zombies on the Walls: Why Does So Much New Abstraction Look the Same?" *New York Magazine*, June 16, 2014.

Saul, Josh. "House Painter Gets Slap on Wrist in Art Thefts." *New York Post*, November 7, 2014.

Scheffler, Daniel. "Waxing Lyrical." *Cultured*, April/May 2016, 172–75.

Schjeldahl, Peter. "Writing on the Wall." *The New Yorker*, November 4, 2013, 108–09.

Secrest, Meryle. *Modigliani: A Life*. New York: Alfred A. Knopf, 2011.

Shenker, Israel. "Amy Vanderbilt Instructs Scull's Angels in Etiquette." *The Telegraph*, September 25, 1973.

Silver, Vernon, and James Tarmy. "The 350,000 Percent Rise of Christopher Wool's Masterpiece Painting." Bloomberg.com. October 9, 2014.

Slugg, Ramsay H. *Handbook of Practical Planning for Art Collectors and Their Advisors*. American Bar Association, 2015.

Spiegler, Marc. "Modigliani: The Experts Battle." *ARTnews*, January 2004.

Storr, Robert. *Elizabeth Murray*. New York: Museum of Modern Art, 2005.

Story, Louise, and Stephanie Saul. "Jho Low, Well Connected in Malaysia, Has An Appetite for New York." *The New York Times*, February 8, 2015.

Sylvester, David, and Sarah Whitfield. *René Magritte, Catalogue Raisonné*. Houston: Menil Foundation, 1992.Resch, Magnus. *Management of Art Galleries*. Ostfildern: Hatje Cantz, 2014.

Taubman, A. Alfred. *Threshold Resistance: The Extraordinary Career of a Luxury Retailing Pioneer.* New York: Collins, 2007.

"Temples of Delight." *The Economist,* December 21, 2013.

Thompson, Don. *The $12 Million Stuffed Shark: The Curious Economics of Contemporary Art.* New York: St. Martin's Griffin, 2010.

—————. *The Supermodel and the Brillo Box: Back Stories and Peculiar Economics from the World of Contemporary Art.* New York: St. Martin's Griffin, 2015.

Thornton, Sarah. *33 Artists in 3 Acts.* New York: W. W. Norton & Company, 2015.

—————. *Seven Days in the Art World.* New York: W.W. Norton & Company, 2009.

United States Attorney's Office for the Southern District of New York. "Art Dealer Pleads Guilty in Manhattan Federal Court to $80 Million Fake Art Scam, Money Laundering, and Tax Charges." News release, September 16, 2013.

United States of America v. Real Property (United Sates District Court for the Central District of California) (CV 16-5371, Dist. file).

Vogel, Carol. "Works by Johns and De Kooning Sell for $143.5 Million." *The New York Times,* October 12, 2006.

Wagner, Ethan, and Thea Westreich Wagner. *Collecting Art for Love, Money and More.* New York: Phaidon Press, 2013.

Waldmeir, Patti. "Lunch with the FT: Wang Wei." *Financial Times,* January 29, 2016.

Whitfield, Sarah. *René Magritte: Newly Discovered Works: Catalogue Raisonné.* Brussels: Mercatorfonds, 2012.

Winkleman, Edward. *Selling Contemporary Art: How to Navigate the Evolving Market.* New York: Allworth Press, 2015.

Wolfe, Tom. *The Pump House Gang.* New York: Farrar, Straus & Giroux, 1968.

Wright, Tom. "Malaysian Financier Jho Low Tied to 1MDB Inquiry." *The Wall Street Journal,* July 9, 2015.

Acknowledgments

I owe a debt of gratitude to all the people who offered me advice, insight, and encouragement while I was writing this book. I also want to thank all the people I interviewed over the past two years for their time and ideas. Because these interviews were off the record, I appreciate your candor and trust in me to maintain your anonymity and accurately represent your experiences. I want to thank the people who devoted time and effort to reading parts of the manuscript while it was in draft form. Your comments and suggestions helped to improve the quality of the book immeasurably.

I am grateful to my agent, Carol Mann, for taking a chance on me. Tad Crawford, Kelsie Besaw, and Jerrod MacFarlane at Allworth Press have been a pleasure to work with. Thank you for making the book publishing process clear and understandable to a first-time author.

I could not have embarked on this book without the support and encouragement of my wife and my daughters, Abby and Lizzy. Thank you, Lizzy, for your help on early drafts, and Abby, for the countless times you helped me figure out better ways to express my ideas.

Index

Books from Allworth Press

The Art World Demystified
by Brainard Carey (6 x 9, 308 pages, paperback, $19.99)

The Artist-Gallery Partnership
by Tad Crawford and Susan Mellon (6 x 9, 216 pages, paperback, $19.95)

Business and Legal Forms for Fine Artists, Fourth Edition
by Tad Crawford (8½ x 11, 160 pages, paperback, $24.95)

The Business of Being an Artist, Fifth Edition
by Daniel Grant (6 x 9, 448 pages, paperback, $27.50)

Create Your Art Career
by Rhonda Schaller (6 x 9, 208 pages, paperback, $19.95)

Fine Art Publicity
by Susan Abbott (6 x 9, 192 pages, paperback, $19.95)

How to Start and Run a Small Gallery
by Edward Winkleman (6 x 9, 256 pages, paperback, $24.95)

Legal Guide for the Visual Artist, Fifth Edition
by Tad Crawford (8½ x 11, 304 pages, paperback, $29.95)

Making It in the Art World
by Brainard Carey (6 x 9, 256 pages, paperback, $19.95)

New Markets for Artists
by Brainard Carey (6 x 9, 264 pages, paperback, $24.95)

The Profitable Artist
by Artspire (6 x 9, 240 pages, paperback, $24.95)

Selling Art without Galleries
by Daniel Grant (6 x 9, 256 pages, paperback, $19.95)

Selling Contemporary Art
by Edward Winkleman (6 x 9, 360 pages, paperback, $19.99)

Where Does Art Come From?
by William Kluba (5½ x 8¼, 192 pages, paperback, $19.99)

To see our complete catalog or to order online, please visit *www.allworth.com*.